MARC CHAGALL

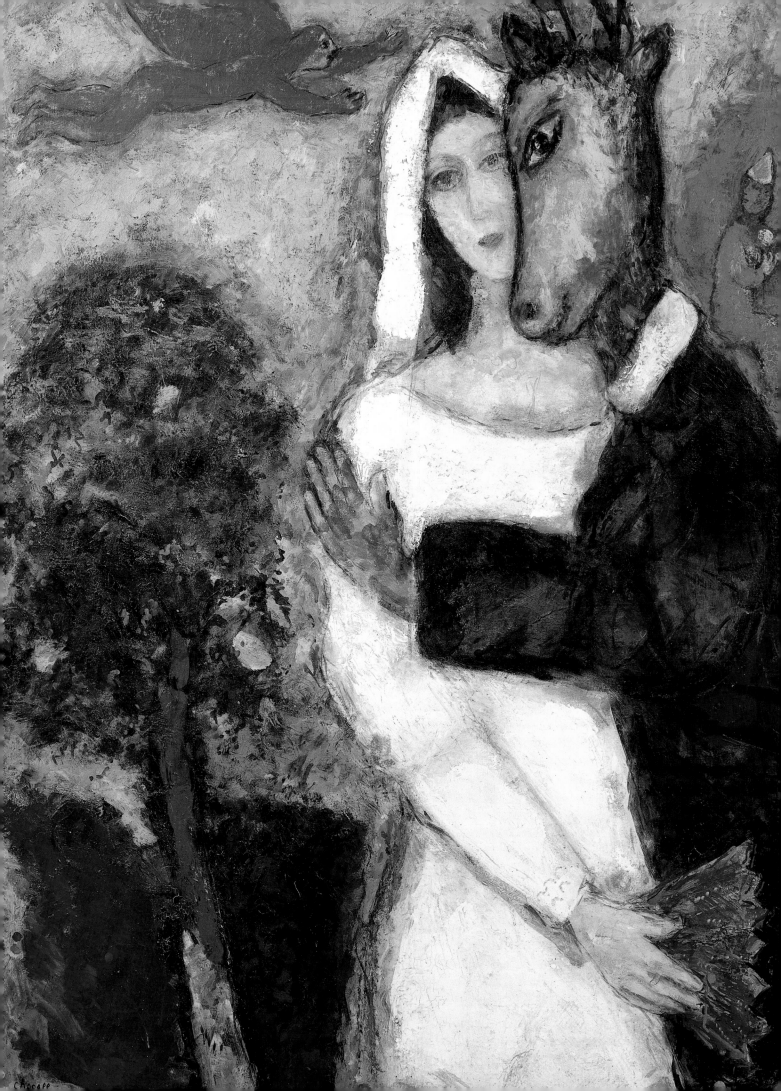

MARC CHAGALL

SAN FRANCISCO MUSEUM OF MODERN ART

IN ASSOCIATION WITH

HARRY N. ABRAMS, INC., PUBLISHERS

MIDSUMMER NIGHT'S DREAM, 1939, detail (pl. 84)

This catalogue is published by the San Francisco Museum of Modern Art in association with Harry N. Abrams, Incorporated, New York, on the occasion of the exhibition *Marc Chagall*, on view at the San Francisco Museum of Modern Art from July 26 to November 4, 2003.

The exhibition was conceived by Réunion des Musées Nationaux, Paris, with the Musée National Message Biblique Marc Chagall, Nice, and co-organized with the San Francisco Museum of Modern Art. The exhibition is sponsored by

Additional support has been provided by the Helen Diller Family Supporting Foundation of the Jewish Community Endowment Fund, Phyllis and Stuart G. Moldaw, and the French American Cultural Foundation. Transportation generously provided by American Airlines.

Library of Congress Cataloging-in-Publication Data
Marc Chagall.
 p. cm.
Published on the occasion of an exhibition on view at the San Francisco Museum of Modern Art from July 26 to Nov. 4, 2003.
 Abridged version of French title: *Chagall connu et inconnu.*
 ISBN 0-8109-4621-1 (hardcover) – ISBN 0-918471-70-2 (paperback)
1. Chagall, Marc, 1887—Exhibitions. I. Chagall, Marc, 1887– II. San Francisco Museum of Modern Art. III. Chagall connu et inconnu.
N6999.C46A4 2003
709'.2—dc21

2003009344

Hardcover edition copublished by
 Harry N. Abrams, Inc.
100 Fifth Avenue
New York, NY 10011
 www.abramsbooks.com

Abrams is a subsidiary of

LA MARTINIÈRE
GROUPE

DIRECTOR OF PUBLICATIONS: Chad Coerver
EDITOR: Karen A. Levine
DESIGNER: Bob Aufuldish, Aufuldish & Warinner
PUBLICATIONS ASSISTANT: Jason Goldman
Translations from the French by Alison Anderson and Amanda Coulson
Printed and bound in Germany by Dr. Cantz'sche Druckerei

COVER: *Angel with Palette*, 1927–36, detail (pl. 102)
BACK COVER: Chagall working on a sketch for *Introduction to the Jewish Theater*, Moscow, November 1920

CONTENTS

SPONSORS' STATEMENTS

Bank of America is proud to join with the San Francisco Museum of Modern Art to present the first comprehensive retrospective of the work of Marc Chagall in nearly twenty years.

It is a fitting tribute to San Francisco—also a city of light and inspiration—that the only venue outside Paris for this extraordinary exhibition is the San Francisco Museum of Modern Art. SFMOMA's presentation includes early works from Chagall's life in his native Russia and from his World War II years in the United States, as well as from his lengthy, inventive periods in France—in all, more than one hundred and fifty pieces, many of which have never before been displayed in the United States.

"Art is not a tender or fragile thing," President Lyndon Johnson said nearly forty years ago. "It has struggled toward light from the manifold darkness of war and conflict and persecution." There is no better proof of this than Chagall's body of work. Through the dangers and dislocations of the Russian Revolution and two world wars, the artist managed to convey an unfailing sense of hope and delight in human existence, using his paintings to portray what he believed to be a brighter, more spiritual world.

Great works of art educate and enlighten us, yet by necessity they are often preserved in ways that limit opportunities for large audiences to experience them. For Bank of America and the Bank of America Foundation, sponsorship of this fifteen-week exhibition represents an investment in education and enrichment for the people of a city and a region close to the heart of our own history.

LIAM E. McGEE
President, Bank of America California
President, Bank of America Consumer Bank

Visa USA is proud to sponsor the San Francisco Museum of Modern Art's presentation of *Marc Chagall,* offering Bay Area audiences a unique opportunity to experience masterworks by one of the most beloved artists of our time.

At a moment when avant-garde movements were revolutionizing the art world, Chagall chose to remain unconfined by the boundaries of modernism. While the decision to remain true to his own artistic vision may have distanced him from his contemporaries, Chagall's inimitable style has withstood the test of time, earning him widespread acclaim and a rightful place among the great artists of the twentieth century.

Visa USA applauds Chagall's commitment to his own artistic vision as well as his deep belief in the ability to pursue one's goals and the freedom to experience all that life has to offer. In our own way, Visa helps individuals pursue the things most important to them by offering a variety of payment products and services. We are proud of the role we can play in how people choose to live their lives in unique and meaningful ways.

Visa USA's longstanding relationship with the San Francisco community is very important to us, and we are honored to assist in bringing *Marc Chagall* to SFMOMA, its only American venue. In doing so, we celebrate the artistic freedom embodied by Chagall and the imaginative spirit that lives in each of us.

CARL PASCARELLA
President and CEO
Visa USA

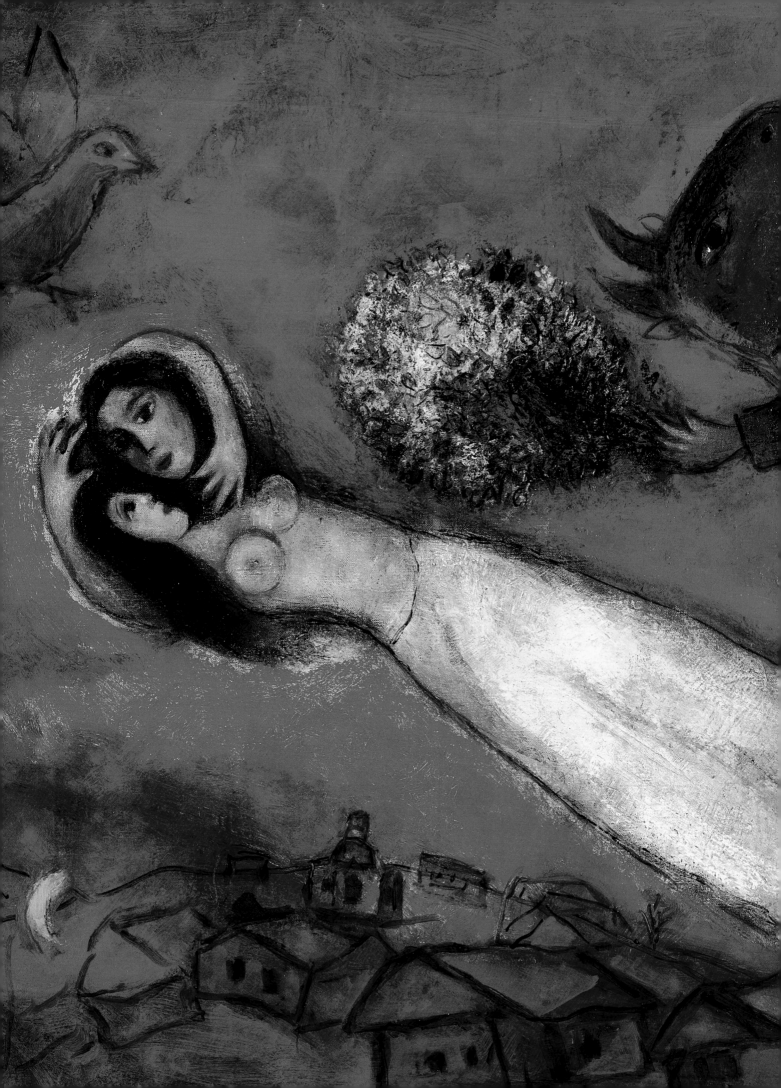

DIRECTOR'S FOREWORD

In recent decades the international art world has come to be characterized by an exciting form of visual cacophony. The once-dependable march of competing avant-gardes and successive meccas of artistic activity—Paris, New York, Berlin—has given way to the emergence of a remarkable diversity of approaches from every corner of the globe. Individual artists are no longer bound by geography, social status, or genre, even as many of them continue to reference these categories in their work. Given these dynamic circumstances, there seems no better time to reassess the art of Marc Chagall, one of the twentieth century's most relentlessly independent painters. As curator Jean-Michel Foray sets forth so elegantly in this volume, Chagall's Russian-Jewish identity and his experiences of exile led him on a distinctly personal journey, one that would embrace and respond to such wide-ranging influences as the vernacular traditions of his native Russia, the legacy of the great painters of Renaissance Europe, and the stylistic innovations of Cubism, Suprematism, Surrealism, and other avant-garde movements. Impressively prolific and diverse, the resulting body of work—which ranges from painting, works on paper, and theatrical decor to stained glass, ceramics, and mosaics—is richly deserving of further study.

The San Francisco Museum of Modern Art is proud to join with the Réunion des Musées Nationaux (RMN), Paris, and the Musée National Message Biblique Marc Chagall, Nice, to bring this significant retrospective of Chagall's work to the United States. Presenting some of the artist's greatest masterpieces alongside a number of paintings and studies never before seen by American audiences, *Marc Chagall* is the most definitive exhibition of Chagall's work to appear in this country in nearly twenty years. Under the skillful guidance of Foray—the director of the Nice museum and one of the world's foremost Chagall experts—this retrospective and its accompanying catalogue offer a fresh critical perspective on the artist's life and practice, one that is certain to bring generations of new admirers to Chagall's exceptional oeuvre.

A presentation of such historic magnitude would not have been possible without the enthusiastic cooperation of the Chagall family, the close collaboration of countless museum colleagues, and the extraordinary generosity of our sponsors and lenders. Representing the Chagall family, the artist's granddaughters, Meret Meyer Graber and Bella Meyer; his grandniece, Aline

LOVERS IN THE RED SKY, 1950, detail (pl. 83)

Zelter; and their families have inexhaustibly devoted precious time and resources to the exhibition (we are additionally grateful to Madame Meyer Graber for the compelling illustrated chronology of the artist's life that she has compiled for the catalogue). I know that the Chagall family joins me in thanking the exhibition lenders—twenty-eight institutions and private collectors from around the world—who have so willingly agreed to share their valuable artworks with San Francisco audiences.

SFMOMA's partners at the RMN in Paris were essential in bringing this project to fruition. I would like to extend my gratitude to Francine Mariani-Ducray, director of the Musées de France; Sophie Aurand, general director of the RMN; and David Guillet, my counterpart at the Galeries nationales du Grand Palais, the exhibition's originating venue. Exhibition curator Jean-Michel Foray deserves special thanks, as does his assistant Émilie Augier; Ute Collinet, general secretary of the RMN; Bénédicte Boissonnas, Marion Mangon, and Stéphanie de Brabander in the Department of Exhibitions; Jean Naudin and Marion Tenbusch in Registration; and Florence Le Moing in Communications.

I would also like to take this opportunity to thank members of SFMOMA's staff for their dedication to this demanding and complex project. Ruth Berson, deputy director, programs and collections, provided the crucial transatlantic lifeline to the RMN and the Chagall family. Curator Janet Bishop and curatorial associate Suzanne Feld ably organized the San Francisco presentation, an enormous feat involving extensive research and the coordination of countless details. Although I cannot acknowledge every staff member who lent time and expertise to the exhibition, I would like to single out a few for special recognition. Paula DeCristofaro, paintings conservator; Alina del Pino, senior museum preparator; Kent Roberts, exhibitions design manager; Heather Sears, associate registrar; and Marcelene Trujillo, assistant exhibitions director, oversaw key aspects of the conservation, transport, and installation of Chagall's work. Elaine McKeon, chair of SFMOMA's Board of Trustees; Patricia McLeod, director of development; and Stacey Silver, associate director of development, corporate partnerships, helped locate the vital funding to make the exhibition possible. In the Museum's Education Department, Deborah Lawrence Schafer, manager of interactive technology audience services, supervised the development of Antenna Audio's informative audio guide, and Peter Stevenson, manager of adult interpretive programs, implemented a series of lectures and screenings to accompany the exhibition. Cara Storm, director of marketing; Polly Winograd Ikonen, director of communications; and Sandra Farrish Sloan, senior public relations associate, helped ensure that the exhibition reached local and national audiences, while John O'Neill, head of visitor services, and his team gracefully welcomed increased numbers of Museum visitors during the run of *Marc Chagall.*

The exhibition catalogue, painstakingly produced under the guidance of Chad Coerver, the Museum's director of publications, was made possible with the kind assistance of Béatrice Foulon, director of publications at the RMN, and Marie Lionnard, the editor of the French edition. Faced with a daunting schedule, Karen Levine edited the volume with great care and insight, while Bob Aufuldish of Aufuldish & Warinner created the book's thoughtful and elegant design. Terril Neely, acting graphic design manager, made significant contributions to the catalogue's design and production, and former publications assistant Jason Goldman lent invaluable editorial skills and support to the project. Thanks are due to Alison Anderson and Amanda Coulson for

their sensitive translations from the French, and to Eric Himmel at Harry N. Abrams, Inc., the catalogue's copublisher, for his early enthusiasm for the publication.

Finally, I would like to acknowledge Liam E. McGee, president of Bank of America California and Bank of America Consumer Bank, and Carl Pascarella, president and CEO of Visa USA, whose support was crucial to making SFMOMA *Marc Chagall*'s only American venue. The exhibition was also made possible by a gift from longtime SFMOMA trustee Stuart G. Moldaw and his wife Phyllis, generous friends of the Museum. Thanks are due to Phyllis Cook of the Jewish Community Endowment Fund for her work with the Helen Diller Family Traveling Exhibition Grants for Exceptional Exhibits on Jewish Themes; to the French American Cultural Foundation; and to American Airlines for vital transportation assistance. Last but not least, the patronage of Howard Leach, United States ambassador to France, and Jean-David Levitte, French ambassador to the United States, has been instrumental in furthering a rich tradition of cooperation and cultural exchange between our two countries.

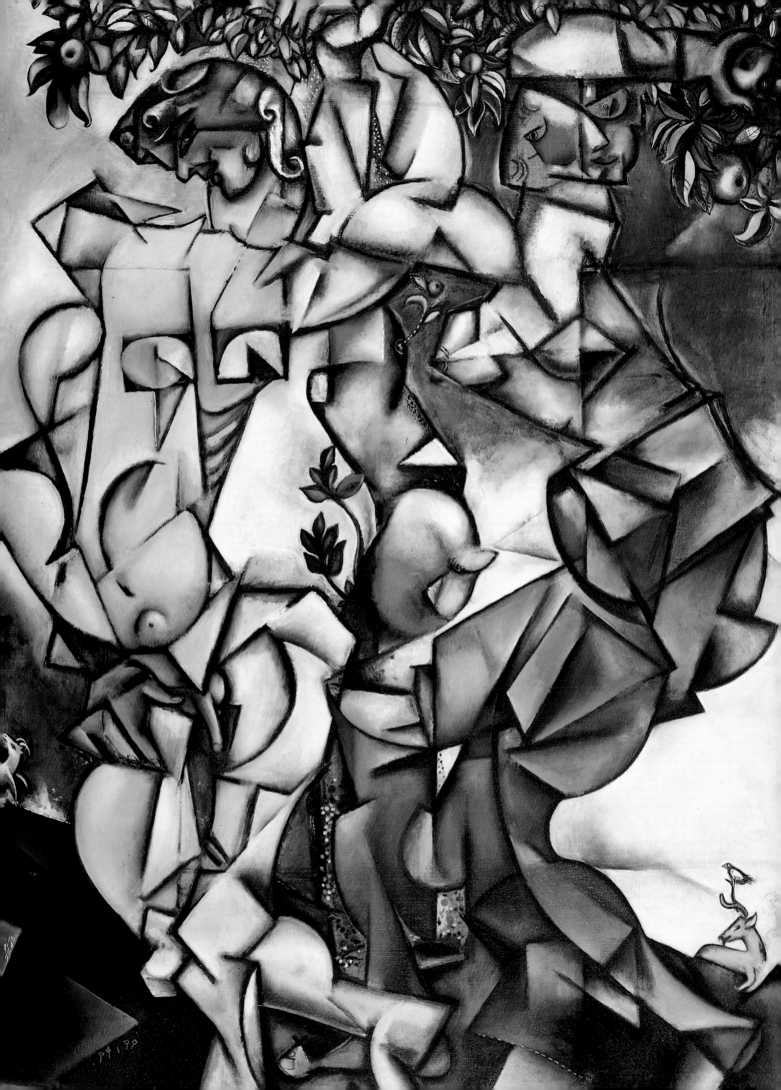

CHAGALL

AND MODERNISM

INTRODUCTION: **JEAN-MICHEL FORAY**

TEMPTATION (ADAM AND EVE), 1912, detail (pl. 2)

How can you be yourself in someone else's culture? When Marc Chagall arrived in Paris in 1911, he must have asked himself this question, for he clearly did not feel at home there. Although he never said as much, his paintings did; most of the work created during his first stay in Paris, between 1911 and 1914, evokes—often by simple allusion—his hometown of Vitebsk and scenes from Russian life. His homesickness, the nostalgia of the émigré, suggests a failure to adapt. Chagall could not quite bring himself to be a modern painter.

As a friend of Guillaume Apollinaire, Blaise Cendrars, and Robert Delaunay, however, Chagall could have embarked on a respectable career as a cubist or quasi-cubist artist. He might have flirted quite happily with the avant-garde movement of 1910–11, and then settled into the time-honored practice of peaceful academic instruction—not unlike the life he had known in Russia. He could also have followed the example of several predecessors and attempted to develop an authentically Jewish art. After 1917 and his encounter with Kazimir Malevich, he might have become a Suprematist or Constructivist. But a certain fundamental ambivalence—to be modern yet not altogether modern, to be Jewish yet not altogether Jewish—kept him from pursuing any of those paths.

Chagall was not yet thirty years old, and the numerous self-portraits we have from 1908 on show a young man who is self-confident, even haughty on occasion, a young man who is sure of his destiny as an artist. One thing is almost certain: Chagall was already aware of the impact he could have on the art of his time. The profusion and variety of these self-portraits are such that they reveal, in addition to their origins in a formal studio practice, a true self-esteem and yet a desire for affirmation—the artist is using self-portraiture as a means of observing and measuring his own ambition. It is also clear that at such moments—by choosing the self-portrait genre, by betraying a consciousness of his appearance, by representing himself as both complacent and exalted—Chagall is expressing his intuition that henceforth, art will no longer be the product of a larger cultural context, but shall originate in the subjectivity of the individual artist. By placing himself at the center of the artwork, he asserts that he is no longer a mere executor (of the wishes of the church, of those in power, of the academy, of the viewer); he has taken command of his production.

Thus, from the moment he arrives in Paris, Chagall does not hesitate to instill his first works with a very personal combination of elements. He borrows from Cubism, from Futurism, from whatever is new in art, to create compositions whose themes remain quite Russian (weddings, livestock vendors, motherhood). He delights in mingling his memories of icons or academic compositions, visible in the vignettes set into a number of his canvases, with formal principles borrowed from Cubism. The artist's practice transforms the question of identity—"How can you be yourself in someone else's culture?"—into another problem: "How can I join modernism with a Russian-Jewish vernacular culture?" The question of identity, the fear of losing one's identity, is central to the work—this is the dilemma that will determine the strategies of identification and adaptation that form the basis of Chagall's art.

STRATEGIES OF IDENTIFICATION

The first major works from Chagall's Paris period, from 1911 and 1912 to be precise, reflect the convergence of two cultures. From this point of view, the most spectacular painting is *Calvary* (1912; pl. 1). Initially titled *Dedicated to Christ,* the canvas combines a Christian theme, a vaguely cubist formal technique, and an assortment of marginal scenes that recall the composition of icons. All of this

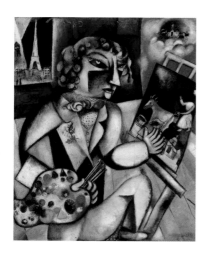

FIG. 1 *Self-Portrait with Seven Fingers,* 1912–13

oil on canvas

49 ⅝ x 42 ⅛ in. (126 x 107 cm)

Stedelijk Museum Amsterdam, long-term loan from the

Netherlands Institute of Cultural Heritage

is brought together in a monumental format—proof in and of itself of the importance Chagall attached to the work. A painting like this ignores the principles of Cubism yet takes on its allure in order to align itself with modernity—a modernity, moreover, that long ago abandoned the explicit subject of the picture, the Crucifixion. Themes of this nature contradict the mechanisms of Cubism, specifically the analysis and construction of the image, for they endow the work with the very type of allegorical significance that turn-of-the-century art was trying to suppress.

This is the source of the misunderstanding between Chagall and modern art—this inability on the part of the artist to conceive of his work as an opaque, self-sufficient surface. The art must have a second meaning—it must refer to something other than itself; it must speak about the world, or the artist. In every one of Chagall's early works, there is a "verbal" element, whether the composition offers a humorous illustration of a Jewish proverb or simply provides a condensed narrative. *Self-Portrait with Seven Fingers* (1912–13; fig. 1)—which also illustrates a Yiddish expression—contains, in a medallion at the upper right corner of the painting, an image representing the artist's memories of Vitebsk. It is in his later projects, however, that Chagall's taste for the second meaning would best be revealed: he would become the perfect, faithful illustrator of literary works by Nikolay Gogol and Jean de La Fontaine as well as Paul Eluard and Louis Aragon.

In short, everything that the turn-of-the-century avant-garde was working to deconstruct or reject, Chagall would reintroduce in his painting, generating a distinctive fusion of sources and models. This would continue throughout his career. While modern art was casting aside all religious significance, Chagall (like his contemporary Georges Rouault) continued to create pictures with explicit religious content: *Calvary; The Apparition* (1917–18; pl. 3); *The Fall of the Angel* (1923–47; pl. 92); *White Crucifixion* (1938; pl. 98); and *Yellow Crucifixion* (1943), inspired by the Gauguin painting of the same name. Beginning in the 1930s, he began to produce biblical illustrations, an endeavor that would occupy him well into the 1960s. Likewise, just as modern art was turning its back on genre scenes, Chagall returned to Russia in 1914 and embarked on a series of paintings depicting the members of his family and the craftsmen of Vitebsk.

Ultimately, Chagall felt a deep need to affirm his identity as an artist, both among artistic circles in Paris and then, after 1918, among the abstract painters of Vitebsk. His increasing awareness that art was the result of individual, subjective choices placed the issue of identity at the heart of his

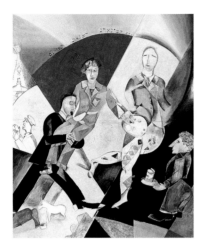

practice, enabling him to take a stance that opposed modernist orthodoxy: he became familiar with avant-garde techniques, then used and diverted them for his own purposes. In short, Chagall's creative process implied that the artist must be critical of stylistic conformity and establish his own identity, but that he must also, on occasion, align himself with that same orthodoxy—the better to make it his own. This is what enabled Chagall to create such an ingenuous combination of utterly diverse elements, drawn from the traditions of Judaism and Christianity, the aesthetic principles of icons and Cubism, the academic technique he learned from Yury Pen, and the experience he gained at the La Ruche artists' collective and studio complex in Paris.

But there is another message in some of Chagall's work after 1917, particularly in paintings such as *The Apparition:* the artist's inspiration can be of divine origin. Although this belief had no place in the Parisian studios of the early twentieth century and ran counter to the doctrine of the day (particularly in Russia in 1917), it is essential to understanding Chagall. His awareness of the central position of the artist as the origin and foundation of the work went hand in hand with his certainty that this new status implied a certain responsibility to the viewer.

In Chagall's major decorative ensemble for the State Jewish Chamber Theater in Moscow, the main character on the largest of the panels, *Introduction to the Jewish Theater* (1920; pl. 34), is none other than the artist himself (fig. 2). With an ample gesture, palette in hand, Chagall introduces the viewer to a joyful, dancing world—a celebration. The work is his response to everything that originally drew him to art: Cubism, Suprematism, abstraction, the rebirth of Jewish culture in Russia. It is an aesthetic manifesto, the proclamation of a new Jewish art form. The artist, the tools of his trade in hand, creates the entire fantasy unfolding before our eyes; but beyond that, it is also he who endows Jewish folklore with as great a universal significance as, say, Christian iconography. His role, therefore, is not merely that of entertainer; he is a messenger, or the interpreter of his own message, and this is what allows him to figure so prominently in the composition. He asserts himself as the origin and justification of the work.

With its arcing panorama mingling past and present, theater actors and family members, what Chagall learned in Vitebsk and what he learned in Paris, *Introduction to the Jewish Theater* translates a fundamental tenet of Judaism, messianism, into visual form. Because it conveys an entire artistic and aesthetic world, Chagall's mural for the little Jewish Theater of Moscow may be read as

a lighthearted representation of the process of messianic recapitulation—the end of time where all things come together—as applied to the theater and the visual arts. The Hasidic dances that Chagall used as a model for this panel provided him with a simple illustration of the role of art: the pleasure granted by the artwork also contributes to an elevation of the soul, and this constitutes the basis of the artist's responsibility. Throughout his career, right up to the Vence years, Chagall would never deviate from this conviction.

Chagall's concept of art enabled him to incorporate into his work everything that culture had to offer—the cultures of Judaism and Russia as well as that of modernism. Such a concept places the artist in a messianic role: nothing in the world can remain foreign to him; through his art he can grasp everything. This, too, goes some way toward explaining the frequently noted stylistic break in Chagall's work, which coincided with his definitive move to France in 1924. The change in his pictorial style has encouraged overeager critics to distinguish an auspicious Russian phase from an "academic" French period. In fact, Chagall set out to absorb French culture the moment he arrived in France: he illustrated the *Fables* of La Fontaine in more than a hundred and fifty gouaches; he created applied landscapes as he came to know the French countryside; and he immersed himself in French taste, particularly in the floral still lifes he painted in a post-impressionist manner. Through his art he found ways to adapt and to recast his identity, particularly in his work on the Bible and through his positive emphasis on the figure of the artist.

These strategies would lead Chagall to refuse the mantle of the modern artist who remains in step with the times, loyal to the dominant artistic movements. The series of rejections on which he built his oeuvre—the rejection of Cubism in 1912, of Suprematism and abstraction in 1919, and of Surrealism in 1924—resulted from his conception of art as a means of interpreting the world. For Chagall, art adds a second meaning to the primary significance of a text or pictorial theme, a belief that is amply clear in his illustrations for the *Fables* or the Bible. His compositions, therefore, often rework the classic subjects of traditional iconography (the Crucifixion, the Madonna), for which they serve as super-illustrations. Chagall used the developments of modernism to restore the very thing modernism had suppressed—the allegorical significance of the work. He had total faith in the power of the image.

RESTORATIONS

In the theater there are actors, characters, and roles to be played. They are not exactly interchangeable. However one might try to make them coincide, a gap remains, just like the one that exists between what is shown in an allegorical sculpture (for instance, a female figure draped in classical robes standing before the pediment of a palace) and what is signified (Law or Justice). When confronted with the statue, we do not recognize what is literally before us: a female figure against a background that is unrelated to the actual setting. Yet once we have decoded what we see, we decide that this is indeed the Law and that this is indeed its natural place. Allegorical meaning cloaks the figure that embodies it with a sort of veil, a cultural accretion, hiding it from us in the same way that a role conceals an actor and makes us forget the actual person. Chagall loved the stage—both the theater and the circus—and his work continually portrays clowns and acrobats as representatives of the artist, characterized by the same clever discrepancy, the same playfulness. He used allegory—in which, in the words of Walter Benjamin, "any person, any object, any relationship can mean absolutely

anything else"[1]—in order to steer his work among Jewish and Russian culture, his religious faith, his desire to speak of the world, and a necessary modernism. As André Breton pointed out in *Surrealism and Painting*, Chagall was a master of metaphor:

> The two movements—Dada and Surrealism—that were to bring about the fusion of poetry and the plastic arts were seriously at fault, in the early years, in giving insufficient credit to Chagall. . . . Today Chagall's work can be judged more impartially. His positive explosion of lyricism dates from 1911, the moment when, under his sole impulse, metaphor made its triumphal entry into modern painting. Chagall employed this metaphor to achieve the final overwhelming of spatial planes initiated long since by [Arthur] Rimbaud and at the same time to liberate the object from the laws of weight and gravity and to abolish the barriers surrounding the elements and the animal and vegetable kingdoms. In Chagall's hands, metaphor was endowed immediately with an added plastic dimension through the hypnagogic image and the eidetic (or aesthetic) image, embodying the special characteristics attributed by the artist to the latter type of image, the formal analysis of which was only to be accomplished at a later date. This work is surely the most resolutely magical of all time.[2]

Chagall was an artist of allegory—that extended metaphor—despite the fact that the mission of modern art, from Manet onward, was to suppress allegory. What abstract artists disliked in allegory was, of course, excess—added meaning, an arbitrary significance that distorts the essence of the work.[3] And Chagall abounds in meaning. In the same way that he delighted in placing small scenes in the margins of his paintings (indeed, beginning in 1911 he anticipated the technique of photomontage through his compilation of fragments), Chagall loved to superimpose meanings, crowding into a shared space scenes that were in no way interrelated; this tendency sometimes gives his works a surrealistic appearance, as in *Time is a River without Banks* (1930–39; pl. 87). He borrowed from modernism the suspension of cohesion between the sign and the signified, replacing it with a new, more fluid cohesion. Figures in his work often acquire more than one meaning and belong to a sort of visual polyphony: a Madonna can also be a bride, a donkey can be a rabbit, a clock can take on the wings of a bird—as can a fish.

Chagall never questioned the image, because he always believed in it. Nor did he question the relationship between painting and photography—photography never seemed to him to pose a threat to painting. Nor did he ever conceive that painting might disappear one day, and he never used it in the way that contemporary artists do today—that is, as a means of talking about the modern world without borrowing the instruments of that world's power. Chagall simply painted, as Picasso did, without asking himself any questions about the medium itself. But he always constructed his pictures as complex scenes, meeting places where several stories could come together. Memories, recurrent iconographic themes (such as Vitebsk Cathedral or the Crucifixion), and the explicit motif of the painting are all brought together in the space of the composition. As visual elements, they can be organized into a coherent whole, as in *The Fall of the Angel*, but they can also be detached from one another, as in *White Crucifixion*. Each element has its own meaning, which it brings to the painting rather in the way that an actor brings his own identity to the stage, altering the theatrical experience as a whole through the timbre of his voice and his presence. Consequently, Chagall's works have no

unity, or have it only rarely, and are therefore in total contradiction with the majority of modern art, which is generally characterized by a strong thematic unity. Chagall's works are composed images, not unlike ex-votos onto which pious people unquestioningly place sacred significance while endowing them with the features of the deceased; they also resemble rebuses, lining up signs that only make sense when they are read all together. Around the central figure of Jesus in *White Crucifixion,* for example, are images of war and violence that must be read one after the other—the sum of which, were one to narrate the scenes rather than see them, would require an extremely long text.

The blending of the visual and the verbal, the very aspect of allegorical painting rejected by modernism, is a distinguishing feature of Chagall's art. From the very start of his artistic career he practiced this cross-breeding of visual and verbal, which even today causes him to be viewed with suspicion by proponents of the modernist creed. And yet his pictures move us, perhaps first and foremost because they are based on an ideal concept of the role of art: in this instance, to move and to teach. Indeed, they extend, in the words of Stendhal, "a promise of happiness," but they also offer an interpretation of the world. As in history paintings of classical themes, the restoration of allegory enables Chagall's art to maintain its connections to the world, be it the world of dreams and impulses or the real world, that of pogroms and wars. This link was severed by an entire faction of modern art, as if artists had deliberately abandoned all discourse, not only about the state of the world, but also about their own destinies. Chagall's strength is that he worked against the all-inclusive impulse of modernism: he used art, in a naive and spontaneous way, as an instrument rather than an end in itself.

Within the context of modern art, Chagall's oeuvre seems atypical, even marginal. He remained aloof from the major artistic movements of the twentieth century, brushing up against them briefly but never adhering to any of them. It is a body of work that places the artist (the person of the artist—what he is thinking and feeling) at its center, thereby going against the grain of the dominant art movements, which sought to neutralize the creator. As a result, it demonstrates that the emergence of impersonal art in the twentieth century served only to suppress what was patently clear: that the sole origin of the work would henceforth be the subjectivity of the artist. In response to the social solitude that such a position necessarily implied, Chagall, through his work, strove to resituate art within a community, even if that meant transgressing the boundaries of modern art as a whole.

NOTES

1 Walter Benjamin, *The Origin of German Tragic Drama,* trans. John Osborne (London: New Left Books, 1977), 175.

2 André Breton, *Surrealism and Painting* (London: MacDonald, 1972), 63–64.

3 For more on allegory and its repression in modern art, see Craig Owens, "The Allegorical Impulse," in Brian Wallis, ed.,
 Art after Modernism (New York: The New Museum of Contemporary Art, 1984), 203–35.

MARC CHAGALL

1887–1985

A TWO-PART CHRONOLOGY: **JAKOV BRUK** AND **MERET MEYER GRABER**

CHAGALL AT LA COLLINE, SAINT PAUL, FRANCE, 1977

CHAGALL IN SAINT PETERSBURG, JUNE 17, 1910

JAKOV BRUK

MARC CHAGALL, 1887–1922

1887

Chagall is born on July 7 in Vitebsk, Russia, in a neighborhood called Peskovatiki (fig. 3) inhabited primarily by Jews of modest background. At birth he is given the name Movcha (Moses); he will later call himself Marc in Paris.

His father, Khatskel-Mordechai (Zakhar) Chagall (ca. 1863–1921), and his mother, Feiga-Ita Chernina (ca. 1870–1915; fig. 4), are both originally from Liozno, a village located twenty-five miles from Vitebsk. They are cousins and marry in 1886; some months later they move to Vitebsk before the birth of Marc, their first child. As many members of the family remain in Liozno, Chagall goes there often as an adolescent.

The Chagall family belongs to the petite bourgeoisie. Khatskel works as a clerk in a herring factory, while Feiga-Ita manages the family grocery. The family (fig. 5) expands rapidly: after Marc come Anna (1888–1946), David (1893–1918), Zina (1894–1947), Lisa (Léa, 1896–1975), Maria (Mania, ca. 1900–1948), Rosa (1901–1917), Maroussia (Mariaska, 1902–1992), and Rebecca (1905–1906).

In his "Autobiographical Notes," preserved in the Manuscript Department of the State Tretiakov Gallery in Moscow, Chagall would write very movingly of his parents: "My father, from his youth, was a clerk in the herring factory, where throughout the years before the Revolution he labored for a pittance. He was a timid man by nature, gentle and peace-loving, religious, and he had little in common with 'typical' Jews— he was more like a peasant from Belorussia. My mother was a simple woman; she was illiterate [like her father], but full of energy, and she died at the age of forty-five. I owe everything to her. I cannot think of a more concise way to describe this extraordinary woman. Although she is dead, the treasure of her talent is alive in me. She loved me, pitied me.... She would correct my work, and for me her opinion had a decisive importance."[1]

THE LATE 1890S

In 1897 the Chagalls request a building permit and move from Peskovatiki to Zadvinye, a neighborhood located on the right bank of the western Dvina River. At 29 Pokrovskaya, on a plot measuring approximately two thousand square feet, they build a single-story stone house, a shop, a second house, and two wooden outbuildings around a back courtyard. The Chagall family will live there until 1923. (During the Nazi occupation the wooden houses will be torched, and all that will remain of the stone house are the walls. Rebuilt after the war, this building has served as the Marc Chagall house-museum since 1997.)

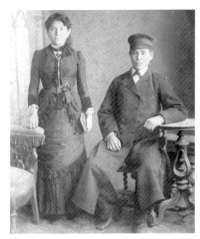

FIG. 4

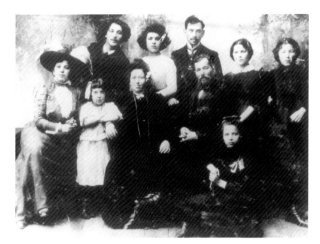

FIG. 5

FIG. 3

As a child, Chagall studies for several years at the Jewish school, the *cheder,* where he acquires the rudiments of Jewish education. He takes singing and violin lessons and helps the cantor at the synagogue. "My entire family belonged to the Hasidic community," the artist would recall. "Music and religion played an important role in my childhood and left a profound mark upon my work, as did everything that was part of that world."[2]

1898–1905

In the summer of 1898 Chagall takes the entrance exams for Vitebsk's four-year college, where, he would later note, "it was no easy task for [my] mother to have [me] admitted, because Jews were subject to restrictions or had to pay a fee of fifty rubles."[3] He starts at the college in the fall of 1900 and studies wood turning and carpentry; poor marks oblige him to repeat his second year. Chagall and his classmate Ossip Zadkine are passionate about art and decide they want to become artists.

1906

On finishing his studies, Chagall takes a job retouching negatives for the photographer A. Meschaninov, the brother of sculptor Oscar Meschaninov. For a few months he attends the school of Yury (Yehuda) Pen (fig. 6); this "honest, hard-working artist, my first professor,"[4] would leave a lasting impression. "I spent several months in his studio. Pen was so kind that he didn't make me pay for my studies."[5] Other students at Pen's studio include Ilya (Rouvim) Masel and Mikhail Libakov. "We would walk through town with our albums and draw the poor little Jewish houses," recalls Masel. "When Chagall joined our class all three of us made sketches of the narrow streets of Vitebsk."[6] Avikdor (Victor) Mekler, also one of Pen's students, suggests to Chagall that he continue his training in the capital, and in the winter of 1906–07 the two young men (fig. 9) leave for Saint Petersburg.

1907

Chagall finds himself in Saint Petersburg with neither a residence permit nor the means to support himself. The money his father has given him will not last long. "Twenty-seven rubles evaporated and I couldn't even afford to eat ten kopecks' worth of *zrazy* [sliced or rolled stewed meat]. There were days when I collapsed from exhaustion and hunger."[7]

As he had in Vitebsk, in his first months in Saint Petersburg Chagall works as a photo retoucher for Mordecai Ioffé, a photographer, painter, and close friend of Pen;

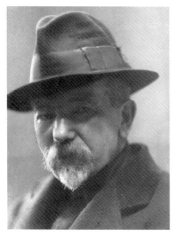

FIG. 6

FIG. 7

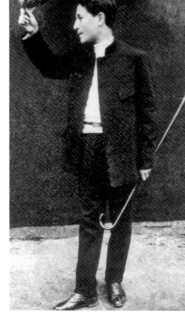

FIG. 8

he also makes a living as a sign painter.

On first arriving in the capital, Chagall fails the entrance exam for Baron Stieglitz's School of Arts and Crafts (which would have given him, as a student, a Saint Petersburg residence permit). Now there is only one possibility left: to try to get into the drawing school of the Imperial Society for the Protection of Fine Arts. Although this school will give him no residency rights or diploma, it does not require a certificate or entrance exam for admission. Chagall enrolls directly in the third drawing class (drawings for decorations), and in April 1907 he is awarded a stipend of six rubles. Between September 1, 1907, and September 1, 1908, he receives a scholarship of fifteen rubles a month for his work. The school is directed by Nicholas Roerich, and G. Bobrovsky is Chagall's professor for the seventh drawing class.

FIG. 9

1908

It is probably thanks to Pen that Chagall contacts the sculptor Il'ya Gintsburg, who refers him to Baron David Ginzburg, an eminent Asian scholar and philanthropist. The baron offers the young artist a monthly allowance of ten rubles. The name Chagall is becoming known among Jewish intellectuals in Saint Petersburg. Grigory Goldberg, a lawyer, officially hires Chagall as a servant, which gives him the right to reside in the capital. Naum Germonte, a Saint Petersburg arts patron and the owner of a sawmill in Narva, provides Chagall with an allowance. Another supporter of the young painter is Max Vinaver, a well-known lawyer and one of the directors of the Jewish journal *Voskhod.* In addition to introducing Chagall to distinguished men of letters such as Leopold Sev, Maxim Syrkin, and Solomon Pozner, Vinaver allows him to move into the journal's editorial office at 25–13 Zakharyevskaya (Chagall will use this return address on several letters in 1908).

In June Chagall is called up for military service. He petitions the czar for an extension of his deferment, and Goldberg, Baron Ginzburg, M. Villier, and Roerich back his request. On September 30 the director of the military deferment bureau asks Roerich for "information concerning the extension of deferment from military service, for a length of time to be determined as required, by the student Moïsseï (Movcha) Chagall (Chagallov) from the school under your direction." In his reply, Roerich asserts that Chagall "has shown brilliant results at school," and a deferment of two years is granted.[8]

In August Chagall leaves for Vitebsk, where he paints a number of compositions from nature (*View from the Window, Vitebsk* and *Portrait of Maroussia*), before returning to Saint Petersburg in September. Toward the end of the year Chagall

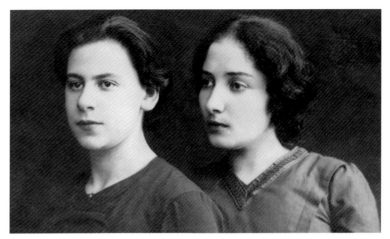

FIG. 10

leaves the school of the Imperial Society for the Protection of Fine Arts, and for a time attends S. Saidenberg's private academy of drawing and painting, where Yury Annenkov is a classmate. In December Baron Ginzburg withdraws his support, and Chagall finds himself sinking into dire poverty, a situation exacerbated by his commitment to help his sister Anna (after her marriage she settles in Saint Petersburg, where she studies at a Jewish professional school). Despite these difficulties, he continues to work prolifically. In 1908 he paints his first major canvas, *The Dead Man* (acquired by Sev), which Chagall will come to see as the starting point of his artistic career.

1909

Chagall goes to Vitebsk and Liozno for the summer, finding inspiration in nature (the watercolor *The Courtyard in Liozno*) and continuing to paint (*The Wedding*). Zadkine spends his summer vacation in Vitebsk and will later recall: "His room was cluttered with paintings all over the walls and piled up in every corner. The paintings resembled signs for a dressmaker's studio, a hair salon, or a tobacconist, but there was nevertheless something primitive and natural about them, something that was astonishing, touching, and made you smile."[9]

In the fall Chagall makes the acquaintance of Bella (Berta) Rosenfeld at the home of Thea Brachmann, a friend from Vitebsk (fig. 10). Bella is seventeen years old, the youngest daughter of Frida-Alta Leviente and Shmul-Neoukh Rosenfeld, a rich Vitebsk merchant and the owner of several jewelry shops. A graduate of the Marinskaya, one of the best high schools in Vitebsk, Bella is pursuing her studies in history, philosophy, and literature at the famous Guerrier girls' school in Moscow.

In Saint Petersburg, thanks to a recommendation from Sev, Chagall enrolls in the private Zvantseva School, where painting is taught by Léon Bakst (fig. 11) and drawing by Mstislav Dobuzhinsky. Chagall's tuition (thirty rubles a month) is reportedly paid by Bakst,[10] who introduces his students to contemporary French art, the Fauves, and the work of Henri Matisse. Chagall's studies with Bakst are a turning point: "At school with Bakst and Dobuzhinsky, my fate was sealed. Bakst changed my life. I will always remember him."[11] Meyer Sheykhel, Nadezhda Lermontova, Julia Obolenskaya, and Nikolay Tyrsa are among his fellow students. Chagall also begins an enduring friendship with Alexander Romm.

1910

Chagall collaborates with Bakst on set designs for Serge Diaghilev's Ballets Russes (for the second "Russian Season" in Paris in 1910, Bakst designs the sets for

FIG. 11

FIG. 12

Schumann's *Carnaval* and Rimsky-Korsakov's *Sheherazade*). Chagall contributes two paintings—including *The Dead Man*—to the Zvantseva School exhibition held on the premises of the journal *Apollon* from April 20 to May 10.

On April 17 Bakst leaves for Paris. Alone at school without his professor, Chagall is distraught. At the end of the month he writes to Bakst, expressing his respect and attachment, and begins to wait impatiently for a reply.

Naum Germonte invites Chagall to spend May and June in Narva. The artist then returns to Saint Petersburg, where he stays with Grigory Goldberg at 18–3 Nadezhdinskaya; on July 7 he goes to Vitebsk, having failed to resolve the problem of his return to school.

Before leaving for Paris, Bakst has appointed Kuz'ma Petrov-Vodkin as his successor at the school; in September Chagall decides not to go back to Saint Petersburg. He stays in Vitebsk until the end of the year, working on a number of drawings (family portraits, interiors, scenes of Vitebsk and Liozno) and paintings (*The Birth, The Sabbath, The Studio*). Chagall and Bella announce their engagement. At the end of the year the artist receives a letter from Bakst (sent from Paris on November 10). In the winter Chagall returns to Saint Petersburg.

1911

Chagall moves in with Goldberg and spends a lot of time with the Romms. Vinaver buys two paintings (including *The Wedding* [pl. 12]) and offers Chagall a scholarship of 125 francs per month so that he can study abroad.

In April the artist takes part in the second Youth Union exhibition.

At the beginning of May Chagall sets off for Paris via Berlin. In Paris he meets Mekler, with whom he will stay in the early stages, as well as N. Tarkhov, and he strikes up a friendship with the art critic Jakov Tugendhold. He then moves into a studio at 18, impasse du Maine. He often meets up with Bakst, who continues to support him.[12]

Paris and French art make a great impression upon Chagall: "I found myself in the midst of contemporary European artists. At the Louvre I was captivated by Manet's *Olympia*, and by Courbet and Delacroix, and I came to understand what Russian art was, and the West. I was captivated by the moderation and taste of French art."[13]

At the end of June, Romm arrives in Paris. Together he and Chagall visit the academies of La Grande Chaumière and La Palette, where André Dunoyer de Segonzac and Henri Le Fauconnier are instructors. Chagall paints *I and the Village;*

FIG. 13

To Russia, Donkeys and Others; and *Dedicated to My Fiancée.* He proposes his paintings for inclusion in the Salon d'automne, but all of them are turned down. In November he submits three canvases—*The Birth, Interior II,* and *The Dead Man*—to the World of Art society in Saint Petersburg for an exhibition to be held in January 1912. *The Dead Man* is the only painting selected; the same work is also chosen for the Moscow exhibition *Donkey's Tail* in March and April of the same year.

1912

In the winter Chagall moves to a studio at 2, passage de Dantzig, part of the La Ruche complex, where Fernand Léger, Amedeo Modigliani, Alexander Archipenko, Chaim Soutine, Ossip Zadkine, and David Shterenberg also reside. Immersed in his work, Chagall socializes only with poets, developing close ties with Blaise Cendrars, Max Jacob, André Salmon, and Guillaume Apollinaire. He shows several paintings (*To Russia, Donkeys, and Others; Dedicated to My Fiancée;* and *The Drunk*) at the Salon des indépendants and sends three works, including *Calvary* (pl. 1), to the Salon d'automne (according to Romm, an entire wall in the Cubism room was placed at Chagall's disposal). The first serious critiques of Chagall's work are published by Jakov Tugendhold in *Paris-Nouvelles* and by L. Koenig in *Freind,* a Yiddish newspaper in Saint Petersburg.

Chagall sends two canvases (*The Drunk* and *The Shepherd*) to the exhibition *Contemporary French Painting* at the Art Salon, 11 Bolshaya Dmitrovka in Moscow. At the end of year, Chagall sends several gouaches from his series *Impressions of Russia* to the World of Art exhibition society, but they are rejected. "I created them in Paris because I wanted to remember Russia," he writes to Mstislav Dobuzhinsky. "These are not typical works; I chose the most modest ones for a Russian exhibition."[14] Romm arrives in Paris at the end of the year and stays until spring 1913.

1913

Between March and May, Chagall has two paintings—*The Birth* and *Temptation (Adam and Eve)* (pl. 2)—and a series of drawings—*Impressions of Russia*—on show at the Salon des indépendants. Several minor exhibitions (his first solo shows) are organized at the Académie libre and the school of Marie Vassilieff at 21, avenue du Maine, as well as at the editorial offices of the journal *Montjoie,* published by Riciotto Canudo. In the spring Chagall also sends three works to the exhibition *La Cibel* in Moscow.

In March Apollinaire introduces Chagall to Herwarth Walden, a renowned collector of avant-garde art and the founder of the Berlin gallery Der Sturm. In

FIGS.

13. Chagall in front of the fountain of the Observatoire,
Paris, June 1911

14. Postcard sent by Chagall to Alexander Romm, December 1911.
Recto: photograph of the impasse du Maine, the street where
Chagall's Paris studio is located; verso: text of postcard

FIG. 14

September Chagall sends three canvases (*Dedicated to My Fiancée; To Russia, Donkeys, and Others;* and *Calvary*) to the first autumn salon in Germany, held at Walden's gallery. *Calvary* is purchased by Bernard Köhler, a collector from Berlin.

1914

In the spring Chagall exhibits *The Violinist, Motherhood,* and *Self-Portrait with Seven Fingers* (fig. 1) at the Salon des indépendants. A portion of the exhibition is then transferred to the Amsterdam Salon, where Chagall's works are acquired by a collector named Regnault.

In March the journal *Kievskaya Mysl* publishes an article by Anatoly Lunacharsky titled "Marc Chagall" (part of the series *Young Russians in Paris*), and in May *Apollon* presents an article by Tugendhold (using the pseudonym Sillart) about the Salon des indépendants. These are the first critical appraisals of Chagall to appear in Russia.

In April Der Sturm presents works by Chagall and Paul Klee and in May pieces by Chagall and Alfred Kubin. In February and May the gallery's journal publishes the futurist poems of Cendrars and Apollinaire, which are dedicated to Chagall.

In mid-May Chagall leaves Paris for Berlin. At the beginning of June, Der Sturm opens the first major solo exhibition devoted to the artist, with forty paintings and one hundred and sixty gouaches, watercolors, and drawings from his Parisian period. On June 15 Chagall leaves Berlin for Vitebsk to see Bella and to attend his sister Zina's wedding. His intention is to stay for only three months, but the outbreak of World War I prevents him from returning to Paris.

Settling in with his parents, Chagall starts work on his *Vitebsk* series (*The Newspaper Vendor, Above Vitebsk, The Jew in Green, The Feast Day* [*Rabbi with Lemon*], etc.) and devotes a series of drawings to the war. In the fall he contacts Alexander Benois in the hopes of taking part in the World of Art exhibition, to no avail.

1915

In March, with Tugendhold's support, Chagall is able to send twenty-five paintings from his *Vitebsk* series to *The Year 1915*, an exhibition at the Mikhailova Salon in Moscow. The show introduces the artist to a wider audience and to Russian critical circles. On March 28 and 29, articles by Abram Efros and Tugendhold appear in the Moscow newspaper *Russkiye Vedomosti.* "Perhaps it is from the depths of the naive, inviolate provinces ... that new forces shall emerge, and Russia will open the way for them," writes Tugendhold. "Today, at any rate, Chagall is one of the great hopes of

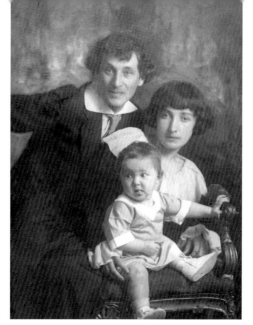

FIG. 15

Russian art."[15] Well-known collectors such as Ivan Morozov and Kagan Chabchai purchase examples of his work.

Chagall's mother dies at the beginning of the summer. On July 25 Chagall and Bella celebrate their wedding. Afterward they leave for the countryside and the village of Zaolche, a few miles from Vitebsk. There Chagall paints *The Poet Reclining* (pl. 5) and *Window in the Country;* after returning to Vitebsk he paints *The Birthday* and begins several works in the *Lovers* series (pls. 31–32).

In lieu of joining the military, Chagall performs the equivalent of civil service at the Central Bureau for War Economy, run by Bella's brother Jakov Rosenfeld. In September he and Bella leave for Saint Petersburg (which would be known as Petrograd from 1914 to 1924). They stay with Grigory Goldberg and then rent an apartment at 7–12 Perekouny Pereulok, where they will live until their return to Vitebsk in 1917. In the literary and artistic circles he frequents, Chagall meets important poets and artists such as Aleksandr Blok and Vladimir Mayakovsky. He also befriends the writer and literary critic Isidor Elyashev, who publishes under the pseudonym Baal-Makhshoves ("Master of Thoughts").

1916

At the end of 1915, Chagall joins the Jewish Society for the Encouragement of Fine Arts (JSEFA), founded in Saint Petersburg in November 1915 (Max Vinaver is its president and Il'ya Gintsburg is in charge of the visual arts section).

In April an exhibition of sixty-two works Chagall created in Vitebsk is organized at Nadezhda Dobychina's Art Bureau, including *Around the Town of Vitebsk, The Clock,* and *The Praying Jew (Rabbi of Vitebsk).* Chagall and Dobychina become very close friends, and the latter will become one of the primary collectors of Chagall's work.

On May 18 Ida is born. Chagall spends the summer with his wife and daughter in Zaolche, where he paints *Bella and Ida at the Window, Strawberries,* and *Lilies of the Valley.*

In November Chagall exhibits forty-five works at the Jack of Diamonds, including the *Vitebsk* series as well as *The Birthday, The Mirror, Acrobat* (pl. 14), and *Lovers in Blue.*

In December Chagall takes part in the exhibition *Contemporary Russian Art* at the Art Bureau, presenting four *Lovers* paintings and sixty-nine drawings, including twenty pages from his Parisian journal of 1912 and illustrations for Der Nister's *Jewish Fairy Tales.*

In February *Apollon* publishes an article by Tugendhold titled "Marc Chagall"; in December Efros's "Chagall, Al'tman, Falk" appears in the Jewish journal *Novy Put.*

FIGS.

15. Chagall, Bella, and Ida, Saint Petersburg, 1917

16. Bella posing for *Bella with White Collar,* 1917

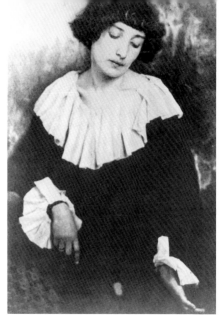

FIG. 16

1917

In January, in Saint Petersburg, Chagall designs the sets for Nikolay Evreinov's play *A Thoroughly Joyful Song*, performed at the artistic cabaret The Players' Rest.

In March Chagall joins the Youth Union; in April he is appointed to represent the group at the Artists Union, which, following the February Revolution, assembles painters, sculptors, architects, musicians, and writers in Saint Petersburg.

In March and April Chagall takes part (both as an artist and as a member of the jury) in the exhibition *Paintings and Sculptures by Jewish Artists*, organized by the JSEFA at the Lemercier Gallery in Moscow. Forty-four of his works—fifteen canvases and twenty-nine drawings—are on display. The other members of the jury are Natan Al'tman, Boris Anisfeld, Isaak Brodsky, and Moses Maymon.

Chagall spends the summer in Vitebsk and Zaolche, painting scenes of Vitebsk and interiors of the dacha, the portrait *Bella with White Collar* (pl. 24), *The Cemetery* (pl. 15), and *Cemetery Gates* (the latter works are probably linked to the sudden death of his sister Rosa at age sixteen from typhoid fever).

In the fall Chagall shows seven of his views from the dacha in the exhibition *Studies* at the Art Bureau. He is also commissioned by Saint Petersburg's Jewish community to paint murals for a Jewish professional school located in a building near the great synagogue (although the commission will never be completed, the sketches for *Purim* and *The Feast of the Tabernacles* will be preserved).

On December 2 Chagall represents the JSEFA at a meeting organized by two major Jewish groups in Saint Petersburg: the Society for the Dissemination of Teaching among Jews and the Society for the Protection of the Health of the Jewish Population. The purpose of the meeting is to discuss the creation of a series of didactic pictures for Jewish schools illustrating everyday Jewish life, holidays, and crafts (in 1918, in the context of this project, Chagall will be asked to portray "children with their families").

Kletskin, a Judaica publisher in Vilna, releases two Yiddish books introduced and illustrated by Chagall: *Tales* by Der Nister and *The Magician* by Isaak Loeb Peretz. Because of the Revolution, the Central Bureau for War Economy is dissolved, and Chagall returns to Vitebsk with his wife and child.

1918

The Chagalls rent a small two-room apartment on Pokrovskaya, across from the family home, where one room is set aside as a studio.[16] Here Chagall works and gives lessons to his first Vitebsk students. His father and sister Maria still live at home,

Еврейский Камерный театр

Художник Марк Шагал

FIG. 20

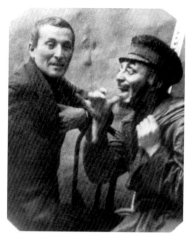

FIG. 21

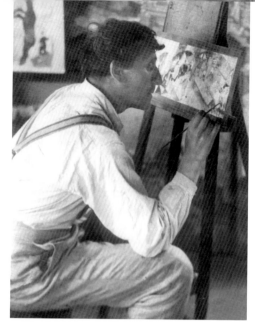

FIG. 22

1920

Early in the year, Chagall addresses a request to Narkompros for a donation of works by Russian artists to the Museum of Contemporary Art in Vitebsk (he heads the commission charged with acquiring pieces by Vitebsk artists). The museum opens in the same building as the art school in late summer.

The second exhibition of work by students and teachers is held in February; Chagall opens his second free studio at the same time.

In May he participates in an exhibition of Russian painters held in Pskov, where he shows fifty-seven Saint Petersburg works (twenty-one paintings and thirty-six drawings).

On May 25 Chagall's students decide to leave his studio for Malevich's. As a result of this conflict, Chagall leaves for Moscow at the beginning of June; his resignation from the school is officially confirmed on June 19.

At the end of November, upon the recommendation of Abram Efros, Chagall is invited to work at Moscow's State Jewish Chamber Theater. The artist moves from Saint Petersburg to Moscow, where he lives at 12 Bolshoi Chernyshevsky Pereulok. He designs the costumes and sets for the first Moscow production of the *Sholem Aleichem Evening,* which consists of three short plays—*Agents, It's a Lie,* and *Mazel Tov*—directed by Alexander Granovsky. Opening night is January 1, 1921. Chagall befriends the actors Solomon Michoels (fig. 21) and Benjamin Zuskin. The last forty days or so of the year are devoted to a mural series for the ninety-seat theater: "I painted seven major scenes, one of which measured 112 by 310 inches (*Introduction to the Jewish Theater* [pl. 34], *Music* [pl. 36], *Dance* [pl. 35], *Drama* [pl. 38], *Literature* [pl. 37], *Love on the Stage* [pl. 33]) and a frieze, *The Wedding Table* [pl. 39]."[20]

1921

In February Chagall asks the management of the Jewish Theater for permission to "organize the exhibition and viewing of works (theater panels) by all who so desire."[21] In June Narkompros holds the twenty-third exhibition of the central visual arts section; Chagall's Jewish Theater murals are included.

As part of his collaboration with Moscow theaters, Chagall is asked to design the stage sets for a production of Shalom Ansky's *The Dybbuk* at Yevgeny Vakhtangov's Habima Theater; the stage sets and costumes for *Comrade Khlestakov,* a play by D. Smolin, for the Theater of Revolutionary Satire; and, for the first studio of Konstantin Stanislavsky's Art Theater, the sets for John Millington Synge's *The Playboy of the Western World.* All of his designs are rejected.

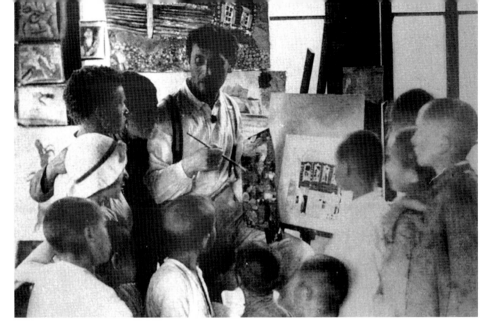

FIG. 23

As co-organizer, with Robert Falk, Natan Al'tman, David Shterenberg, and Solomon Nikritin, of the Moscow section of the Culture League, Chagall contributes an article titled "Leaves" to the first issue of the league's Yiddish journal, *Strom;* he also designs the cover.

On September 14 Chagall sends congratulations to Pen on the twenty-fifth anniversary of his artistic activity.

Throughout nearly the entire year, Chagall teaches at the Jewish Camp for War Orphans at Malakhovka, approximately eighteen miles from Moscow (fig. 23). Founded in 1919 by Anatoly Lunacharsky (fig. 24), the camp provides shelter to more than one hundred children, aged eight to sixteen, who survived Anton Denikin's pogroms in the Ukraine. The camp comprises three collective homes and is run according to principles of self-management and self-service; Yiddish is the lingua franca. Chagall teaches at the school of the Third International. Other professors work with him, including the writer Der Nister, the composer Yeheskel Engel, and the writer and literary critic Dobrushin. The Jewish Theater sponsors the camp, and Solomon Michoels is a frequent visitor.

FIG. 24

1922

At the beginning of the year Chagall moves with his family from Malakhovka to Moscow, settling at 2–8 Sadovo-Samotechnaya (not far from Bella's parents, who left Vitebsk when their property was nationalized). He begins preparations to go abroad. Lunacharsky offers his help.

In March and April Chagall shows thirty-nine graphic works and theater designs, including the panels from the Jewish Theater, in a Culture League exhibition titled *Natan Al'tman, Marc Chagall, David Shterenberg.*

Chagall completes his memoirs, *My Life,* which he probably began writing in 1915 or 1916. According to a contemporary account, "the artist read them to private circles in Moscow."[22]

Chagall provides the illustrations and cover design for *Sadness,* a collection of Yiddish poems by David Hoffmann published in Kiev.

At the beginning of the summer Chagall leaves Russia for good—his family remains in Moscow but will join him several months later. He has received an invitation to visit Lithuania from Jurgis Baltrusaitis, the ambassador of Lithuania in Moscow. When Chagall leaves for Kaunas he takes with him his entire body of work. During an evening organized in his honor, Chagall reads excerpts from the manuscript of *My Life.* He then leaves Kaunas for Berlin in order to search for canvases he

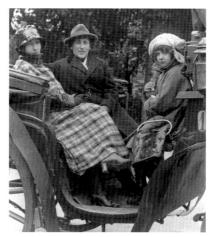

FIG. 25

left at Herwarth Walden's Der Sturm gallery before the war; a lengthy lawsuit will be required to get them back.

In October Chagall shows three paintings and seven drawings in the first exhibition of Russian art to be organized by the visual arts section of Narkompros at the new Van Diemen Gallery in Berlin.

FIG.

25. Bella, Chagall, and Ida, Berlin, 1923

NOTES

1. Marc Chagall, "Autobiographical Notes (Curriculum Vitae)," no. 2073, fol. 31, Manuscript Department, State Tretiakov Gallery, Moscow; translated by Ida Chagall in *Marc Chagall, Les Années russes, 1907–1922* (Paris: Musée d'art moderne de la Ville de Paris, 1995), 246.

2. Édouard Roditi, *Dialogues on Art* (London, 1960), quoted in *The Bulletin of the Marc Chagall Museum* 7 (2000): 9.

3. Chagall, "Autobiographical Notes."

4. Chagall to Yury Pen, September 14, 1921, quoted in *Recueil Chagall* (Vitebsk, 1996), 197.

5. Roditi, *Dialogues on Art.*

6. Ilya Masel, "Memoirs," no. 2108, fol. 4, pp. 7–8, Manuscript Department, State Tretiakov Gallery.

7. Chagall, "Autobiographical Notes."

8. Op. 1, no. 879, fol. 448, pp. 215–16, Central History Archives, Saint Petersburg.

9. A. Lissov, *Zadkine à Vitebsk,* quoted in *Recueil Chagall,* 138.

10. Julia Obolenskaya, "At the Zvantseva school under the direction of L. Bakst and M. Dobuzhinksy (1906–10)," no. 75, fol. 5, p. 17, Manuscript Department, State Tretiakov Gallery.

11. Chagall, "Autobiographical Notes."

12. A. Nurenberg, "Marc Chagall," no. 34, fol. 34, Manuscript Department, State Tretiakov Gallery.

13. Chagall, "Autobiographical Notes."

14. No. 338, fol. 115, Manuscript Department, State Russian Museum, Saint Petersburg.

15. Jakov Tugendhold, "A New Talent," *Russky Vedomosti* (29 March 1915); quoted in *Marc Chagall, Les Années russes, 1907–1922,* 242.

16. According to Franz Meyer, "Chagall and Bella stayed in her parents' house on the Smolenskaja" (Franz Meyer, *Marc Chagall* [New York: Harry N. Abrams, Inc., 1964], 255).

17. See Alexander Romm, "Marc Chagall's Different Roles," *Nezavissimaya Gazeta* 252 (30 December 1992).

18. *Izvestiya, News from Vitebsk* (30 January 1919), an organ of the Soviets of peasants, workers, and soldiers of the Red Army of the region of Vitebsk.

19. Aleksandra Shatskikh, *Vitebsk, The Artistic Life, 1917–1922* (Moscow, 2001), 43.

20. Chagall, "Autobiographical Notes."

21. No. 99, fol. 584, p. 37, Manuscript Department, Bakhrushin Theater Museum, Moscow.

22. P. Ettinger Rossica, *Parmi les collectionneurs* 34 (1923): 37.

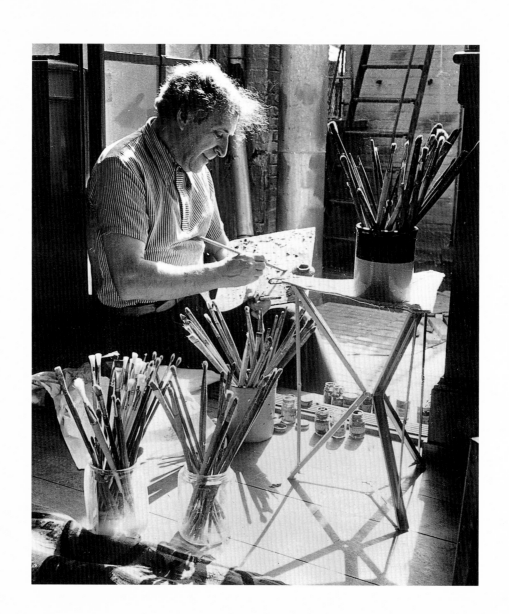

CHAGALL WORKING IN HIS NEW YORK STUDIO, 1942

MARC CHAGALL, 1922–1985

1922–23

From summer 1922 to fall 1923—a period interrupted by short trips to the Black Forest, the Thuringian Forest, and Bad Blankenburg—Chagall, Bella, and Ida live in a succession of four apartments in Berlin. The artist has no real studio at his disposal.

The publisher Paul Cassirer expresses an interest in releasing an illustrated edition of Chagall's memoirs, *My Life;* the artist produces twenty copper plates for the volume in Joseph Budko's studio, and twenty engravings are then completed under the supervision of Chagall and master printmaker Hermann Struck. Given the difficulties of translating the artist's poetic language into German, the portfolio of twenty engravings is published without Chagall's memoirs. The first edition containing the full text of *My Life* will not come out until 1931, in Bella's French translation.

"Berlin, after the war, had become a sort of caravansary, a meeting ground for all those who were going back and forth between Moscow and the West."[1] Chagall's best friends in Berlin include Doctor Elyashev, Pavel Barchan, Moses Kagan, Chaim Bialik, Frida Rubiner (translator of the Russian monograph by Efros and Tugendhold), the painters George Grosz, Karl Hofer, Jankel Adler, David Shterenberg and his wife Nadezhda, Ludwig Meidner, and Alexander Archipenko. Despite the measure of fame he enjoys, Chagall does not feel at ease in Berlin and nurtures hopes of moving to Paris.

1923–25

Chagall receives a letter from Blaise Cendrars, informing him that the publisher and art dealer Ambroise Vollard (fig. 27) will be contacting him to request illustrations for books. On June 12, 1923, a criminal lawsuit is filed against the art dealer Herwarth Walden, who had retained several works by Chagall and sold them without the artist's knowledge. On July 5 Chagall requests a six-month extension of his residence permit from the Berlin-Charlottenburg police, and in August he applies for a French visa. On September 1 the Chagall family arrives in Paris and takes up residence in a damp room at the Hôtel Médical in the Faubourg Saint-Jacques, where they stay for the first few months.

When Vollard finally contacts Chagall, he suggests that the artist provide illustrations for a children's book by the Comtesse de Ségur. He ultimately agrees with Chagall's alternative proposal to illustrate Gogol's *Dead Souls;* the project will comprise 107 etched plates produced between 1923 and 1925.

In a letter addressed to the senior magistrate examining the Walden suit, Chagall expresses his desire to "find the guilty parties," having "found [my] studio

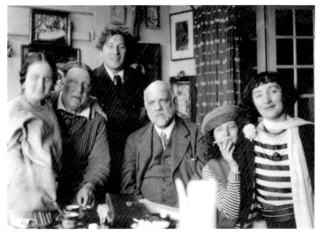
FIG. 27

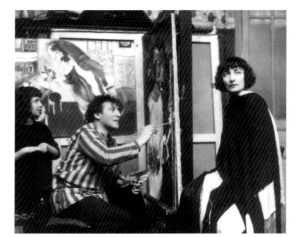
FIG. 28

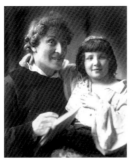
FIG. 26

completely empty." He has learned "that certain individuals entered [my] house and all [my] paintings were handed over by [I know not whom] to Monsieur Blaise Cendrars, to whom [I] had written a letter, asking him to watch over [my] interests" after Chagall left Paris in 1914.[2] In the meantime, it seems that Gustave Coquiot, Tristan Tzara, and other art dealers are now in possession of the missing paintings.

An abundant exchange of correspondence indicates the partial resolution to the Walden suit; in the end, three works are returned to Chagall: *I and the Village, The Cattle Dealer,* and *To Russia, Donkeys, and Others.*

Thanks to a home exchange with Eugène Zack at the beginning of 1924, the Chagall family is able to move into a studio at 10, avenue d'Orléans, where they stay until the end of 1925. Chagall immediately begins painting again. In order to forge a new identity in France, between 1923 and 1926 the artist draws on his past pictorial vocabulary, creating replicas and variations on earlier works as well as new, more radiant compositions that reflect a fresh sense of freedom.

In Paris Chagall meets up with old friends, former teachers, and patrons such as Léon Bakst, André Levinson, and Max Vinaver. He also makes new acquaintances, including Gustave Coquiot, Jeanne Bucher, Jacques Guenne, Florent Fels, Yvan and Claire Goll (fig. 29), and Louis Marcoussis. He receives numerous requests to collaborate on art journals and exhibits fifty works at the Galerie Le Centaure in Brussels. At the end of 1924, Pierre Matisse organizes an exhibition of 122 works at the Galerie Barbazanges Hodebert in Paris.

"I want an art of the earth, not only of the head,"[3] Chagall asserts, expressing his need to find himself through the nature, landscape, and light of France. Frequent stays in L'Isle-Adam on the Oise River (recommended by the Delaunays); in Ault, then part of Normandy; and on Bréhat Island in Brittany have a particular impact on Chagall. Through Fels, a Belgian critic, Chagall discovers the region between the Seine and the Oise, in particular the tiny village of Montchauvet, where he will create a large number of landscapes in 1925.

Two exhibitions are organized in Cologne and in Dresden. In December the Chagalls leave the apartment on avenue d'Orléans and move into a house in Boulogne-sur-Seine at 3, allée des Pins.

1926–27

At the beginning of 1926, Chagall's first New York exhibition, which includes more than one hundred works, is held at the Reinhardt Galleries.

Chagall spends most of the year in the French countryside, mainly near Toulon

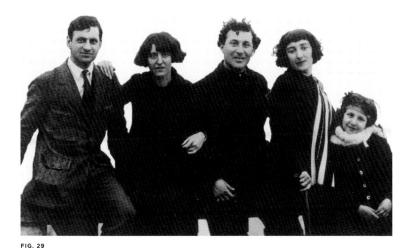

FIG. 29

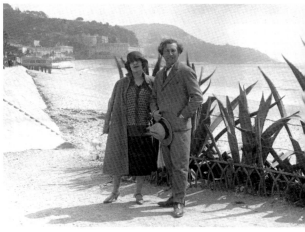

FIG. 30

in Le Mourillon, a small fishing village on the Mediterranean coast not far from the home of Georges and Marguerite Duthuit-Matisse in Fort Saint-Louis. The artist visits Nice for the first time and is enchanted by its light and vegetation (fig. 30). The Chagall family also stays for several months in Chambon-sur-Lac in the Auvergne, in a house on the village square overlooking the church. Here Chagall paints approximately thirty preliminary gouaches for the engravings Vollard will publish in the volume *Fables of La Fontaine.*

More than thirty works are exhibited at the Galerie Katia Granoff in Paris. Chagall contributes five engravings as illustrations for his friend Marcel Arland's novel *Motherhood;* fifteen engravings for *The Seven Deadly Sins* by Jean Giraudoux, Paul Morand, Pierre Mac Orlan, André Salmon, Max Jacob, Jacques de Lacretelle, and Joseph Kessel; and drawings inspired by Alban Chambon for Gustave Coquiot's *Provincial Suite.* In late 1926 the Galerie Katia Granoff presents *Work from the Summer of 1926.*

FIG. 31

While Chagall is still at work on the *Fables,* Vollard conceives a new project on the theme of the circus; consequently, the two spend many evenings together at the Cirque d'Hiver Bouglione. In 1927 Chagall creates nineteen gouaches titled *The Vollard Circus.* Every day after his walk in the Bois de Boulogne, Vollard stops in to visit Chagall. He introduces the artist to Georges Rouault, Pierre Bonnard, Maurice de Vlaminck, and Aristide Maillol. Chagall befriends Christian Zervos (through whom he will occasionally socialize with Pablo Picasso), Tériade, Pablo Gargallo, and Pierre Chareau, and he also makes new friends in Belgium.

Chagall's Bauhaus friends (Walter Gropius, Paul Klee, Vasily Kandinsky, László Moholy-Nagy, Lyonel Feininger, Alphonse Mucha, and Oskar Schlemmer) encourage the artist to renew his support for the Bauhaus, informing him that they want to make him a member of the circle. Correspondence and contact with friends back in Russia have continued; some family members even come to Western Europe. When Alexander Granovsky and his Jewish Theater troupe play at the Théâtre de la Porte Saint-Martin, Chagall and Bella spend every evening at the theater and give receptions for their actor friends (fig. 31); they retain particularly close ties with Solomon Michoels. Chagall donates ninety-six engravings from *Dead Souls* to the State Tretiakov Gallery in Moscow.

A contract with Bernheim-Jeune, the French family of dealers and publishers, enables Chagall to ensure a living. He becomes a founding member of the Association of Artists and Printmakers. From May to September the Chagalls stay in Châtel-Guyon in the Auvergne, where Bella and Ida take the waters and Chagall

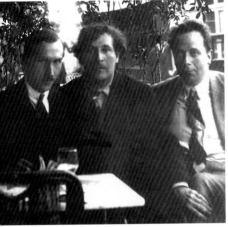

FIG. 32

FIG. 33

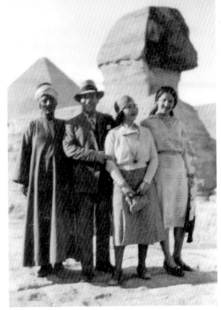

FIG. 34

meets Chaim Soutine. They also spend time in Saint-Jean-de-Luz, near Biarritz. In November Chagall and Robert Delaunay set off on a six-day car trip that takes them through Montauban, Albi, and Limoux. They stop to visit the art lover Jean Girou and the writer Joseph Delteil (fig. 32), and then continue on to Collioure and Banyuls-sur-Mer on the coast, where they stop to see Maillol.

At the end of the year Chagall discovers the landscape of Savoy, first in Chamonix and then in the neighboring villages of Les Houches and Les Bossons, which inspires several artworks featuring churches and snow-filled landscapes that evoke the artist's memories of Russia.

1928–29

In the winter of 1928 Chagall creates more circus works, some of which are based on *The Vollard Circus*. He continues to work on the black-and-white engravings for the *Fables*, first with Louis Fort, who printed *Dead Souls;* later, after certain difficulties arise, the entire series is reprinted by Maurice Potin.

Chagall receives numerous letters from collectors wishing to acquire more of his work, and representatives of the press ask the artist for interviews. Galleries such as the Flechtheim in Berlin, run by Kurt Valentin, request the loan of additional paintings to supplement Chagall's already sizeable body of work in Germany. Letters from these and other dealers indicate the success of the artist's work in the market as well as the pressure he is under to grant the galleries exclusive contracts. Chagall is invited to take part in an exhibition of French art in Moscow. His illustrations for *Dead Souls* are shown during the presentation of André Salmon's monograph at the Galerie Le Portique in Paris.

In the summer Chagall goes on his own to Céret, in the Pyrenees. The poets Jules Supervielle, Paul Eluard, and René Schwob introduce him to the philosopher Jacques Maritain and his wife Raissa. Every Sunday for the next ten years a group of artists and writers that includes the Chagalls will meet at the Maritains' home. André Salmon is asked to translate *My Life;* Chagall finds his translation too "western," and Bella, together with Ludmilla Gaussel and Jean Paulhan, will go back over the text line by line.

The Galerie Époque in Brussels exhibits a series of Chagall's gouaches. In a letter dated January 23, 1929, Hermann Struck invites the Chagall family to visit him in Haifa, Palestine. In the fall Chagall returns to Céret, taking Bella with him this time. At the end of 1929 he buys a house: the family moves to the Villa Montmorency at 15, rue des Sycomores, near the Porte d'Auteuil (fig. 33).

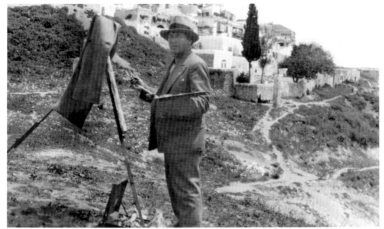

FIG. 35

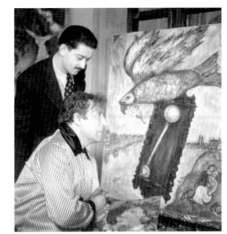

FIG. 36

The Chagalls spend part of the winter in the Savoy Alps, at the Hôtel Soleil d'Or in Mégève.

The 1929 stock market crash obliges Bernheim-Jeune to break the contract with Chagall. Only Chagall's work for Vollard will continue to provide him with a modest income.

1930

The preliminary gouaches for the *Fables* are shown at the Galerie Bernheim-Jeune in Paris, at the Galerie Le Centaure in Brussels, and at the Flechtheim Gallery in Berlin, where Chagall attends the opening. In late spring Chagall spends time with his family at Nesles-la-Vallée near L'Isle-Adam; on Delaunay's advice he buys some land there. He spends several weeks of the summer and fall on the Mediterranean coast and in Peira-Cava in the Maritime Alps, where the landscape inspires a number of gouaches featuring windows. As his biographer Lionello Venturi will later note, "Chagall does not go deep into a landscape; he looks at it from afar as if spellbound, dreaming of love with his eyes open."[4]

The key event of the year will be a commission from Vollard to illustrate the Bible, which has captivated Chagall since childhood with its spirituality and poetry ("I did not see the Bible, I dreamed it"). Now Chagall wants more than ever to visit the biblical land of Palestine.

The Demotte Gallery in New York shows a selection of oils, gouaches, and watercolors.

Meir Dizengoff, the mayor and founder of Tel Aviv, makes Chagall's acquaintance.

1931

Upon Dizengoff's invitation, from February to April Chagall travels with Bella and Ida to Haifa, Tel Aviv, and Jerusalem to celebrate Purim and attend the cornerstone ceremony for the Tel Aviv Museum of Art. On the way to Palestine, in the company of the poets Chaim Bialik and Edmond Fleg, they visit Alexandria, Cairo, and the Pyramids (fig. 34). Chagall is moved by the landscapes of Palestine; he works in Tel Aviv, paints the interiors of synagogues in Safed, and produces landscapes in Jerusalem (fig. 35). Upon his return to Paris, Chagall begins working on preliminary gouaches and etchings illustrating biblical scenes, a project that will occupy him for many years (at the time of Vollard's death in 1939, only 66 of the 105 plates envisaged will have been completed, and Chagall will not return to the series until 1952. The volume will ultimately be published by Tériade in 1956). The beautiful light

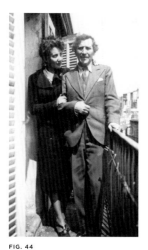

FIG. 44

FIG. 45

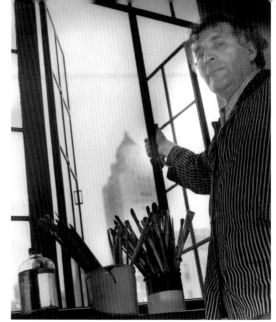

FIG. 46

FIG. 43

1939

Chagall returns to Villentroy but feels, mistakenly, that he is threatened; shortly before war is declared he moves to Saint-Dyé-sur-Loire, taking all the canvases from his Paris studio in a taxi with the help of his daughter Ida.

The Betrothed wins third prize at the Carnegie International.

1940

In January a number of paintings and gouaches, destined for an exhibition organized by Yvonne Zervos for the opening of the Galerie Mai, are brought back to Paris. One of them—the canvas *Revolution*, now known as *Composition*—is an expression of protest against the war. Chagall continues to work mainly in Saint-Dyé until the spring, when political events oblige him to move south of the Loire. On May 10, the day of the Nazi invasion, Chagall buys the building of an abandoned Catholic girls' school in Gordes (fig. 43) and allocates the biggest room as a studio. At the beginning of May the pieces that had stayed behind in Saint-Dyé are transported to Gordes by truck. The peaceful atmosphere of Gordes is reflected in the works of this period.

1941

During the winter the director of the Emergency Rescue Committee, Varian Fry, and the consul general of the United States in Marseille, Harry Bingham, deliver an invitation to Chagall from the Museum of Modern Art, New York—an invitation that has also been extended to Matisse, Picasso, Raoul Dufy, Rouault, André Masson, and Max Ernst. It is only after racial laws are promulgated in occupied France that the Chagalls finally decide to leave for Marseille and prepare for their departure from Europe. However, they want to obtain a French reentry visa to enable them to return at any moment to the country that has become their second home. In Marseille they take a room at the Hôtel Moderne, and a raid occurs during their stay; fortunately, thanks to the intervention of Fry and Bingham, Chagall is immediately released.

On May 7 the Chagalls leave Marseille; after stopping in Madrid, they arrive on May 11 in Lisbon, where they wait to sail for the United States. Crates and cases containing more than one thousand pounds of artwork, which were to be forwarded directly to Lisbon, are held up for five weeks in Spain. With the help of French, American, and Spanish friends, Ida manages to have the shipment released, and the artwork sails on the same ship as the artist. "A wall is raised between us / A mountain covered with grass and graves,"[5] Chagall writes in a poem. On June 23, the day

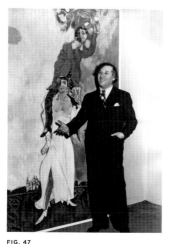

FIG. 47

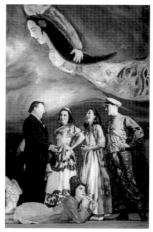

FIG. 48

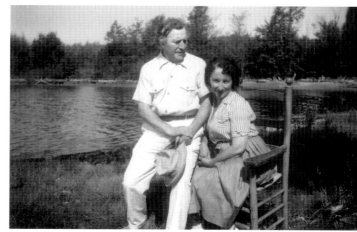

FIG. 49

the Nazis invade the Soviet Union, Chagall and Bella arrive in New York. The size and vitality of New York—he will refer to it as "Babylon"—impress the artist greatly.

Initially the family stays in hotels, first on 57th Street, then at the Hampton House, and finally at the Plaza, before spending a few weeks in New Preston, Connecticut, not far from the homes of André Masson and Alexander Calder. In September the Chagalls move into a small Manhattan apartment at 4 East 74th Street, where regular visitors include the Maritains, the art historian Lionello Venturi, and the poet Joseph Opatoshu. Chagall renews his acquaintance with Fernand Léger, Georges Bernanos, Piet Mondrian, and André Breton. A meeting with Pierre Matisse will be decisive for the artist: Matisse represents a vital link with France and French art, and he also becomes Chagall's dealer, displaying his works in his gallery from the moment Chagall arrives in New York. This first exhibition will be followed by others on a regular basis until the end of the artist's life.

1942

Chagall designs the sets and costumes for the ballet *Aleko* (music by Pyotr Ilich Tchaikovsky; libretto inspired by a poem by Aleksandr Pushkin), choreographed by Léonide Massine for the American Ballet Theatre. Although the premiere (fig. 48) will be held at the Palacio de Bellas Artes in Mexico City, all preparation takes place in New York; the sets are created in conjunction with the choreography. In order to oversee production of the four sets and the costumes, Chagall and Bella leave for Mexico City in August, a month before the premiere, and devote all their time to working on the ballet. Their discovery of the vibrant colors and cultures of Central America influences changes made to the original designs in the course of preparation for the premiere. *Aleko* opens on September 20 and is a triumphant success, as is its New York opening at the Metropolitan Opera House.

1943

News of the war, particularly from his native country, devastates Chagall and deeply affects his work. During the summer and fall the artist is able to renew his ties with Michoels and the poet Itzik Feffer thanks to a Soviet cultural mission to the United States. The snow-covered landscapes of Cranberry Lake, New York (fig. 49), where the Chagalls spend some time, remind the artist of his native country. The circus (women performing acrobatics on horseback, trapeze artists) once again becomes a prominent theme in the painter's work. At Stanley William Hayter's studio, where a good number of refugee artists in America are working, Chagall produces engravings

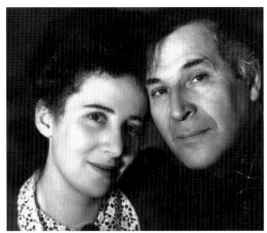

FIG. 50

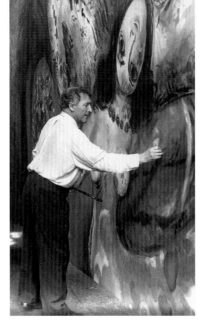

FIG. 51

FIG. 52

with circus themes, and for the first time he uses the imprint of string and cloth in his compositions.

1944

While at Cranberry Lake the Chagalls learn of the Normandy landings and, with great emotion, of the liberation of Paris. A few days before their return to France, scheduled for early September, Bella suddenly takes ill with a viral infection and a very high fever. She is rushed to the hospital, but for lack of treatment (reserved exclusively for returning American soldiers) she dies thirty-six hours later, on September 2, in New York. "Everything is darkness,"[6] Chagall will later write of this period. Stricken with grief and sorrow, he is unable to resume work for nine months, and all of his canvases are turned to face the wall of the studio.

1945

Chagall finds comfort and support in the company of his daughter Ida (fig. 50), who is living at 43 Riverside Drive in New York. At first they spend their time illustrating and working on the French translation of the first volume of Bella's memoirs, *Burning Lights.* In the summer Ida hires a young French-speaking Briton, Virginia McNeil, to look after her father.

At Krumville, in Ulster County, New York, and later at Sag Harbor on Long Island, Chagall works on designs for three sets, the stage curtain, and more than eighty costumes for Igor Stravinsky's *Firebird,* choreographed by Adolph Bolm, a former Diaghilev dancer, for the American Ballet Theatre. *Firebird* is a great success, and the American press reports that "Chagall's set design dominates the spectacle."[7]

1946

In the winter of 1945–46, Chagall buys a modest wooden house in High Falls in the Catskills, in northeastern New York. He moves there with Virginia, who will share his life for the next seven years; on June 22 she gives birth to David.

From time to time Chagall joins his daughter Ida, who, together with James Johnson Sweeney, is preparing a major retrospective of her father's work for the Museum of Modern Art, New York, and the Art Institute of Chicago. For the first time since the end of the war, Ida returns to Paris, where she collaborates with Jean Cassou, the director of the Musée d'art moderne, on an important tribute to Chagall for the museum's reopening.

Traveling with the collector Louis Stern, Chagall also goes to Paris, where he

FIGS.

50. Chagall and Ida, New York, ca. 1944

51. Chagall making corrections on the opening curtain for *Firebird,* New York, 1945

52. Chagall painting *Around Her,* New York, 1945

53. Chagall, Orgeval, ca. 1949

54. Chagall examining *Dead Souls,* Orgeval, ca. 1950

55. Chagall with Virginia McNeil, Jean, and David, Orgeval, ca. 1949

FIG. 53

FIG. 54

will stay for three months, renewing his ties with Europe and rediscovering the city's atmosphere and light. The visit also provides the opportunity to see literary and artist friends, particularly Paul Eluard, for whom he illustrates the poetry collection *The Difficult Desire to Endure*.

In the fall Chagall returns to High Falls but thinks constantly about returning to France. He concentrates on a series of important paintings, particularly some magnificent gouache studies for his first color lithographs, *A Thousand and One Nights*, commissioned by the publisher Kurt Wolff. A number of exhibitions of his work are held around the world.

1947

Chagall leaves High Falls to attend the opening of the retrospective organized by the Musée d'art moderne in Paris; other retrospectives follow at the Stedelijk Museum Amsterdam, London's Tate Gallery, the Kunsthaus Zurich, and the Kunsthalle Bern.

FIG. 55

1948

In August Chagall and Virginia, accompanied by the philosopher Jean Wahl, board the ocean liner *Le Grasse;* after a short crossing they land at Le Havre, France. The couple moves into a house with a big abandoned garden at Orgeval, near Saint-Germain-en-Laye, which quickly becomes a meeting place for people like Claude Bourdet (the editor-in-chief of *Combat*), Paul Eluard, Jean Paulhan, Jacques Maritain, Yvan Goll, Pierre Reverdy, the gallerists Louis Carré and Aimé Maeght (the latter will become Chagall's dealer in France), and the publisher Tériade, who acquires all of the artist's engravings for *Dead Souls,* the *Fables,* and the Bible from the Vollard Foundation.

In September Chagall goes to the Venice Biennale, where an entire room is devoted to his work; he is awarded the prize for engraving. As he visits museums, palaces, and churches, he is deeply impressed by the frescoes and paintings of the Italian masters.

Chagall begins work on murals for the foyer of the Watergate Theatre in London.

1949

In January Chagall interrupts his stay in Orgeval to go to Saint-Jean-Cap-Ferrat, where Tériade lives for part of the year on a magnificent estate with a sublime garden. The artist initially stays at the Pension Lou Mas de la Mer, which looks out over the

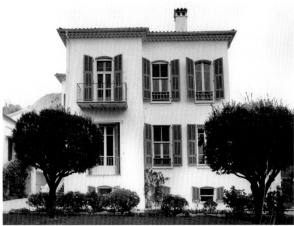

FIG. 57

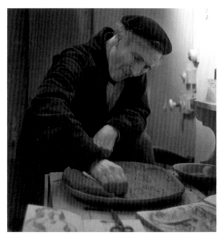

FIG. 58

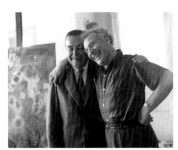

FIG. 56

fishing port. It is here that he produces his first ink and watercolor illustrations for Giovanni Boccaccio's *Decameron*, which will appear in 1950 in the art and literary review *Verve*, accompanied by a text by Jacques Prévert. Chagall and Tériade (fig. 56) have become close friends, and the latter gives the artist the idea to create illustrations for Longus's famous pastoral *Daphnis and Chloe*. Chagall rediscovers the enchantment of the light in the south of France that he had known in the 1920s.

In May, determined to fight against the reemergence of racism and anti-Semitism, Chagall attends a major rally at the Cirque d'Hiver.

The artist leaves again for the south of France in October, staying at the villa Les Chèvres in Saint-Jeannet, where the surrealist poet Georges Ribemont-Dessaignes lives. The following month Chagall rents Le Studio in Vence and creates his first ceramics in Madame Bonneau's workshop.

The Galerie Rosengart in Lucerne, Switzerland, organizes an exhibition of gouaches.

1950

At her father's request Ida returns to the United States to recover all of his works and bring them back to Europe. Chagall is so enchanted by the landscape of Vence that he decides to buy Les Collines (fig. 57), an estate located on the slopes of the Baou des Blancs, along the road between Vence and Saint-Jeannet. The estate consists of a house, garage, and studio surrounded by a magnificent garden with fruit trees, shrubbery, and flowers. He moves in during the spring.

In Vence Chagall finishes a number of works in progress and completes a series of village scenes infused with a magical Mediterranean light. He paints oils and gouaches celebrating lovers and begins monumental paintings inspired by the Bible (fig. 59).

The artist often goes to Paris, where he concentrates on engravings (fig. 60) and, together with other painters, sculptors, and writers, studies lithography at Fernand Mourlot's press. In Mourlot's studio he creates his first lithographed poster for an exhibition at the Galerie Maeght.

The French Riviera has become a thriving artistic center since the end of the war, and Chagall goes regularly to see Matisse in Cimiez and Picasso, who is also working on ceramics, in Vallauris. Chagall's ceramic work focuses initially on Provençal-style plates that he makes at Serge Ramel's in Vence and at the L'Hospied pottery in Golfe-Juan.

The Haus der Kunst in Munich organizes a Chagall retrospective.

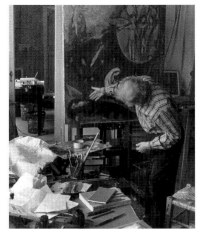

FIG. 59

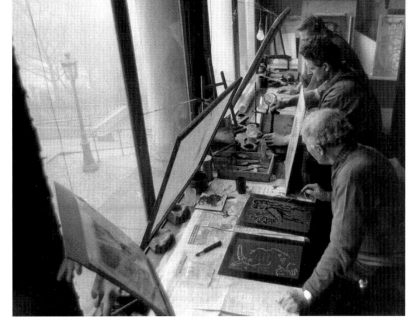

FIG. 60

The 1950s and 1960s will witness an increasing number of varied commissions that encourage Chagall to perfect his many techniques of artistic expression, including book illustration, monumental painting, ceramics, sculpture, stained glass, mosaics, and tapestry.

1951

Chagall travels to Jerusalem, Haifa, and Tel Aviv for the opening of an exhibition. In the summer he spends a few weeks in Gordes, where—together with Henri Langlois, the director of the Cinémathèque Française—he works on a film about his painting (the project is never completed). He enhances the *Fables* engravings with watercolor. After Gordes, Chagall spends a few weeks in Dramont, a little seaside village near Saint-Raphaël, which inspires him to create gouaches with a Mediterranean theme.

Virginia, with the two children, leaves Chagall to follow the photographer Charles Leirens to Brussels.

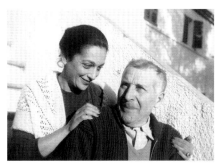

FIG. 61

1952

In the spring Chagall meets the Russian-born Valentine (Vava) Brodsky (fig. 61); they are married on July 12 in Clairefontaine, near Rambouillet.

Chagall immerses himself in creating ceramic murals, vases, pitchers, and plates, whose casting he alters by hand. He will continue his work in this medium until 1962 at Madoura, the Vallauris studio of Suzanne and Georges Ramié. He also produces marble and terra-cotta sculptures during this period.

In March and April a dozen or so of Chagall's ceramic murals are on display at the Galerie Maeght. With the consent of Father Marie-Alain Couturier, the artist begins working on the design of a monumental ceramic mural to be installed in the baptistery of Notre-Dame de Toute Grâce in Assy in 1957 (fig. 63).

In June Chagall visits Chartres Cathedral and studies the ancient technique of stained glass; he also begins work on a tribute to Paris (fig. 64).

His initial efforts on *Daphnis and Chloe* are interrupted by a trip to Greece—to Delphi, Athens, and the island of Poros—that influences a number of his works. Tériade publishes the *Fables* of La Fontaine. Chagall travels to Italy, visiting Rome, Naples, and Capri.

1953

Chagall goes to Turin for the opening of a retrospective of his work at the Palazzo Madama. He completes the first gouache studies for *Daphnis and Chloe.*

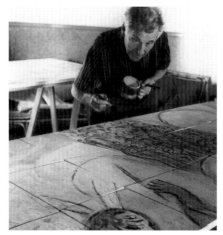

FIG. 63

FIG. 64

FIG. 65

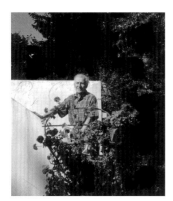

FIG. 62

1954

In the autumn Chagall and Vava return to Greece, first to Poros and then to Nafplion and Olympia. Chagall also travels to Venice and goes to see works by Titian and Tintoretto. He tries his hand at glassblowing at a Murano glassmaker and then visits Ravenna and Florence. Chagall paints two large murals for Tériade's house in Saint-Jean-Cap-Ferrat. The Galerie Maeght organizes a Paris exhibition.

1955

While scenes are being shot for a film at the Cirque d'Hiver, Chagall is once again so entranced by the circus atmosphere that he produces sketches for *The Big Circus*. He also begins work on a suite of large-scale paintings for the *Biblical Message* cycle. The Kestner-Gesellschaft in Hannover presents a retrospective.

1956

Chagall enters a period of intense production of lithographs and engravings. Tériade publishes an edition of the Bible containing Chagall's illustrations. Tributes are organized at the Kunsthalle Basel, the Kunsthalle Bern, and the Palais des Beaux-Arts in Brussels. Chagall devotes a painting to Gauguin, inspired by a work at the Courtauld Institute in London.

1957

Chagall travels for the third time to Palestine, now known as Israel. A retrospective of his engravings is held at the Bibliothèque Nationale in Paris. The printing of the *Daphnis and Chloe* lithograph cycle begins at Mourlot's studio. Chagall creates a cartoon (fig. 67) for his first mosaic mural, *The Rooster*, which will be fabricated by the Gruppo Mosaicisti in Ravenna in 1958. The ceramic mural *The Crossing of the Red Sea* is installed in the baptistery of the church at Assy.

Together with Jean Cassou, Chagall enters a period of intense debate over the possibility of enriching museum collections.[8] In Paris, the artist lives briefly at the Quai Bourbon before buying an apartment at 13, Quai d'Anjou on the Île Saint-Louis; it is here that he will concentrate exclusively on copper engraving and lithography, particularly after 1966.

1958–59

In February Chagall travels to Chicago to give a lecture—titled "Why Have We Become So Anxious?"—at the University of Chicago's Center for Human Understanding.[9]

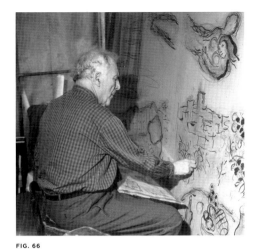
FIG. 66

FIG. 67

FIG. 68

Following publication of the *Daphnis and Chloe* lithographs, the Paris Opera commissions Chagall to design the sets and costumes for the ballet *Daphnis et Chloé* by Maurice Ravel and Michel Fokine, with choreography by Georges Skibine. The premiere is held at La Monnaie opera house in Brussels as part of the International Exhibition.

Chagall makes the acquaintance of Charles and Brigitte Marq (fig. 68), master glaziers and directors of the Atelier Simon in Reims. The Marqs—together with the Saint-Just Glassworks—are responsible for executing Chagall's designs as finished stained-glass windows. In 1959, working from the artist's sketches, they produce the windows for Metz Cathedral. The same year, Chagall's mural *Commedia dell'Arte* is unveiled in the foyer of the Frankfurt Theater. The artist continues to create circus works.

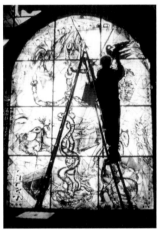
FIG. 69

In 1959 Chagall travels to Scotland to receive an honorary doctorate from Glasgow University. He is also elected an honorary member of the American Academy of Arts and Letters.

Retrospectives are organized by the Kunsthalle Hamburg, the Haus der Kunst in Munich, and the Musée des arts décoratifs in Paris. During this period Chagall corresponds with Gaston Bachelard, Jules Supervielle, Georges Charensol, and André Salmon.

1960

At the beginning of the year Chagall is in the snow-covered village of Sils-Maria in Switzerland, where he paints gouaches.

Brandeis University in Massachusetts confers an honorary doctorate on Chagall; in October, together with Oskar Kokoschka, he receives the Erasmus Prize from the European Cultural Foundation.

Chagall is engrossed with preliminary designs for twelve stained-glass windows for the synagogue of the Hadassah Medical Center in Jerusalem (fig. 69). The chief rabbi of France assists him with the information he needs for the work, which represents the twelve tribes of Israel.[10]

For the first time, Chagall exhibits stained glass and sculpture at the Musée des Beaux-Arts in Reims.

1961-62

Daphnis and Chloe is published by Éditions Tériade. The twelve stained-glass windows for Jerusalem are exhibited at the Musée des arts décoratifs in Paris and the Museum

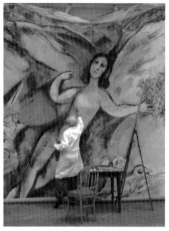

FIG. 70

FIG. 71

FIG. 72

of Modern Art, New York. In February 1962 Chagall is present at the installation of the windows in Israel. *Chagall et la Bible* (Chagall and the Bible) opens at the Musée Rath in Geneva. The artist continues his intense correspondence with Gaston Bachelard and Florent Fels.

1963–64

Museums in Tokyo and Kyoto organize Chagall's first Japanese retrospective.

André Malraux commissions a new ceiling for the Garnier opera house in Paris; Chagall creates multiple studies and drawings inspired by the themes of composers such as Debussy, Ravel, Mussorgsky, Tchaikovsky, and Mozart. The definitive model for the ceiling, which will be presented to Malraux and Charles de Gaulle, is made between January and June 1964 in a Gobelins Factory workshop (fig. 70). In September 1964 the new ceiling is inaugurated and proves a triumphant success (fig. 71).

Chagall and Vava travel to the United Nations headquarters in New York for the unveiling of the stained-glass window *Peace,* dedicated to the memory of Dag Hammarskjöld and his companions. During this visit Chagall meets Rudolf Bing, the general manager of the Metropolitan Opera, New York; Bing commissions two immense murals as well as sets and costumes for Mozart's *The Magic Flute.*

Chagall meets the master weaver Yvette Cauquil-Prince and is captivated by her work; she agrees to execute all of Chagall's future tapestries.

1965–67

Chagall receives an honorary doctorate from the University of Notre Dame in Indiana.

The Story of Exodus, with twenty-four original lithographs printed by the Imprimerie Mourlot, is published by Léon Amiel in New York in 1966.

Chagall and Vava leave Vence to settle in Saint Paul, a village featured in a number of his paintings. The house, La Colline (fig. 72), has been designed to facilitate the artist's work as much as possible. Chagall works on two murals for the Metropolitan Opera, *The Sources of Music* and *The Triumph of Music.*

The artist completes a group of nine stained-glass windows on the theme of the prophets for the Union Church in Pocantico Hills, New York; the project is commissioned by the Rockefeller family in memory of John D. and Michael C. Rockefeller. The Metropolitan Opera's production of *The Magic Flute,* with sets and costumes by Chagall, opens in February 1967 to unanimous critical acclaim. Two retrospective exhibitions are held in Zurich (fig. 73) and Cologne.

FIGS.

70. Chagall working on a panel for the ceiling of the Paris Opera at the Gobelins Factory, Paris, 1964

71. Chagall and Vava at the unveiling of the ceiling of the Paris Opera, 1964

72. La Colline, Saint Paul

73. Chagall surrounded by his daughter Ida and his grandchildren Piet, Meret, and Bella at the Kunsthaus Zurich, 1967

74. Chagall, Washington, D.C., November 1968

FIG. 73

FIG. 74

From June to October the Louvre exhibits the *Biblical Message* cycle, which the Chagalls donate to the French government on the condition that a permanent venue will be created in Nice to house the suite's seventeen large paintings and thirty-eight gouaches. The copper engravings and monotypes are printed by Jacques Frélaut on a press in his studio.

The Circus, featuring thirty-eight lithographs and a text by Chagall, is published by Verve in 1967.

At the request of Lady d'Avigdor-Goldsmid, Chagall undertakes the production, from 1967 to 1978, of twelve stained-glass windows for the church at Tudeley, a little village in Kent, England.

1968-70

Chagall and Vava visit Washington, D.C., and New York for the opening of an exhibition of his work at the Pierre Matisse Gallery. At the request of Louis Trotobas, the dean of the faculty of law at the University of Nice, Chagall paints the model for a major mosaic work, *The Message of Ulysses,* produced by the craftsman Melano. The windows for the triforium of the north transept of Metz Cathedral are completed. In 1969 the cornerstone is laid for the Musée National Message Biblique Marc Chagall in Nice.

Chagall travels to Israel for the inauguration of the Knesset, the new parliament building in Jerusalem, which features his mosaic *The Western Wall* along with three major tapestries, *The Prophesy of Isaiah, Exodus,* and *The Entrance to Jerusalem,* produced in the Gobelins workshops in Paris. *Letter to Marc Chagall,* with five original etchings and a text by Jersy Ficowski, is published by Éditions Adrien Maeght in 1969.

The Grand Palais in Paris organizes the retrospective *Hommage à Chagall* (Homage to Chagall), which presents 474 artworks. At the beginning of 1970, a retrospective of engraved work is held at the Bibliothèque Nationale in Paris. Chagall illustrates André Malraux's *Anti-Memoirs.*

In September 1970 a series of stained-glass windows produced by the Atelier Simon in Reims—*The Prophets Elijah, Jeremy, and Daniel; The Vision of the Prophet Isaiah; Jacob's Dream; The Tree of Jesse; The Crucifixion;* and *Celestial Jerusalem*—are unveiled in the choir of Fraumünster Church in Zurich.

1971-73

In the spring of 1971 Chagall returns to Zurich. He completes the model for *The Chariot of Elijah,* the mosaic intended for the facade of the Musée National Message

FIG. 75

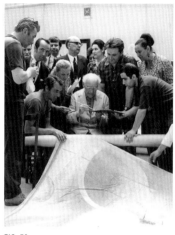

FIG. 76

FIG. 77

Biblique Marc Chagall. In 1972 he begins work on designs for the mosaic *The Four
Seasons*, commissioned by the First National Bank in Chicago.

The first retrospective of Chagall's work in the Eastern Bloc opens in Budapest
to enormous success.

Chagall works on lithographs for Camille Bourniquel's *Enchanting Kingdom*,
published in 1972, and Homer's *Odyssey*, published in 1974–75 by Éditions Mourlot.

At the invitation of Yekaterina Furtseva, the minister of culture of the Soviet
Union, Chagall travels with Vava to Moscow for the first time since his departure in
1922. At the State Tretiakov Gallery he signs the panels for the State Jewish Chamber
Theater, which the courageous curators have safeguarded for more than fifty years
(fig. 76). On the occasion of the artist's homecoming the museum also organizes a
Chagall exhibition. During his brief stay Chagall has a moving reunion with two of
his sisters (fig. 77).

July 1973 marks the opening of the Musée National Message Biblique Marc
Chagall (fig. 78), together with the unveiling of *The Creation of the World*, a suite of
three stained-glass windows designed for the museum's auditorium.

The Pierre Matisse Gallery in New York exhibits recent oils, gouaches, and
sculptures.

1974–77

On June 15, 1974 three stained-glass windows—*Abraham and Christ, The Tree of Jesse*,
and *The Kings of France*—are installed in the choir of Notre-Dame Cathedral in Reims.

The Musée National Message Biblique Marc Chagall organizes an exhibition on
the occasion of the artist's birthday; the presentation *Marc Chagall, l'oeuvre monumental*
(Marc Chagall, Monumental Work) opens in 1974.

Chagall goes to Chicago for the unveiling of the mosaic *The Four Seasons* in First
National Plaza and receives a triumphant welcome.

The artist corresponds with André Malraux about form and color.[11] Chagall
paints several large canvases devoted to spiritual and biblical themes, works marked
by a renewed vigor of technique and composition. Small formats and book illustra-
tions increasingly alternate with works of monumental scale. Éditions Gérald
Cramer in Geneva publishes a volume of Chagall's poems dating from 1930 to 1964,
illustrated with twenty-four woodcuts.

In 1976 Chagall completes the design for a stained-glass window (*Peace* or *The
Tree of Life*) for the Cordeliers Chapel in Sarrebourg; four more windows celebrating
the universal message of nature will be added by 1978.

FIG. 78

FIG. 79

The artist prepares five lithographs and two woodcuts to illustrate Robert Marteau's *Studios of Chagall*, published by Éditions Mourlot in 1976. He creates fifty black lithographs for Shakespeare's *The Tempest*, published by Éditions Sauret in 1976. The same year sees the unveiling of a mosaic for the Sainte-Roseline Chapel in Les Arcs in the Var region of southern France.

In September Chagall goes to Florence to attend the presentation ceremony of a self-portrait acquired by the Uffizi.

In 1976 a traveling exhibition of Chagall's painting opens in Japan. His engravings are exhibited at the Kupferstichkabinett in Berlin and at the Albertinum in Dresden.

Chagall completes twenty-four engravings to accompany a collection of poems by Louis Aragon titled *He Who Says Things with Nothing to Say* as well as fifteen etchings for André Malraux's *And on the Earth,* published by Adrien Maeght in 1977.

On January 1 Chagall is decorated with the Grand-Croix of the Legion of Honor by the president of the French Republic.

Two exhibitions of recent works open in France: *Marc Chagall, peintures bibliques récentes* (Marc Chagall, Recent Biblical Paintings) at the Musée National Message Biblique Marc Chagall and *Marc Chagall, peintures récentes* (Marc Chagall, Recent Paintings) at the Louvre in Paris.

Chagall is appointed an honorary member of the city of Jerusalem by the mayor, Teddy Kollek.

1978–80

In June 1978 Chagall attends the opening of an exhibition of recent paintings at the Palazzo Pitti in Florence. A stained-glass window (the first of an ensemble of nine created between 1979 and 1985) is installed at the church of Saint-Étienne in Mainz; another window is inaugurated at Chichester Cathedral in England.

In 1979 three stained-glass windows, commissioned for the American bicentennial and devoted to the arts, are unveiled at the Art Institute of Chicago. The Pierre Matisse Gallery in New York displays paintings dating from 1975 to 1978.

The Galerie Patrick Cramer in Geneva exhibits *The Psalms of David,* a series of thirty black etchings on an ocher background printed by Éditions Cramer in 1979. In 1980 the etchings are shown at the Musée National Message Biblique Marc Chagall.

In 1980 Chagall decorates the underside of the lid of a harpsichord offered to him by the American Friends of Chagall Biblical Message.

FIG. 80

1981–83

Chagall creates a number of large paintings and washes depicting biblical and mythical themes, village scenes, and the circus; all are made with a light and transparent touch.

Several exhibitions are held, one devoted to engravings at the Galerie Matignon in Paris, one to large-format lithographs at the Galerie Maeght in Paris, and one to recent paintings at the Galerie Maeght in Zurich.

The Tree of Life, an ensemble of stained-glass windows, is unveiled at the church of Saint-Étienne in Mainz. Chagall also completes six windows for the parish church at Saillant de Voutezac.

In 1982 retrospectives are held at the Moderna Museet in Stockholm and the Louisiana Museum in Humlebaek, Denmark. The Galerie Patrick Cramer in Geneva exhibits illustrated books, and the Pierre Matisse Gallery in New York introduces a series of recent paintings.

Chagall works mainly in a small format and on preliminary sketches for engravings and lithographs.

1984

The Musée national d'art moderne in Paris hosts *Oeuvres sur papier* (Works on Paper), an exhibition that travels to the Kestner Gesellschaft in Hannover, the Kunsthaus Zurich, and the Capitoline Museum in Rome. Chagall attends the opening of a retrospective of his paintings organized by the Maeght Foundation in Saint Paul and an exhibition devoted to his stained-glass windows and sculpture at the Musée National Message Biblique Marc Chagall.

1985

A major retrospective of paintings is being organized by the Royal Academy of Arts in London (due to travel to the Philadelphia Museum of Art) when Chagall's physical strength begins to decline.

Chagall dies peacefully on the evening of March 28 after a day spent working in his studio. The funeral services are held on April 1. The artist is buried in the cemetery at Saint Paul.

FIG.

80. The artist's hands, ca. 1977

NOTES

1. Édouard Roditi, "Entretiens avec Marc Chagall," *Preuves* 84 (February 1958): 27.

2. Chagall to the senior examining judge of the Civil Tribunal of the Seine, 1923, Marc Chagall Archives, Paris.

3. Florent Fels, *Propos d'artistes* (Paris: La Renaissance du livre, 1925), 33.

4. Lionello Venturi, *Étude biographique et critique* (Geneva: Skira, 1956).

5. Chagall, "Départ," in *Poèmes* (Geneva: Éditions Gérald Cramer, 1975), 109.

6. Chagall, preface to Bella Chagall, *Lumières allumées et Première rencontre*, trans. Ida Chagall (Paris: Gallimard, 1973). Bella's memoirs are available in English as *Burning Lights*, trans. Norbert Guterman (New York: Schocken Books, 1962).

7. John Martin, *New York Times*, quoted in *Dance Index* 4, no. 11 (November 1945): 188.

8. Jean Cassou to Chagall, 1950s, Marc Chagall Archives, Paris.

9. Chagall, "Why Have We Become So Anxious?", in John Nef, ed., *Bridges of Human Understanding* (New York: University Publishers, 1964), 115–20.

10. The chief rabbi of France to Chagall, 20 September 1959, Marc Chagall Archives, Paris.

11. Correspondence between André Malraux and Chagall, 1975–76, Marc Chagall Archives, Paris.

PLATES

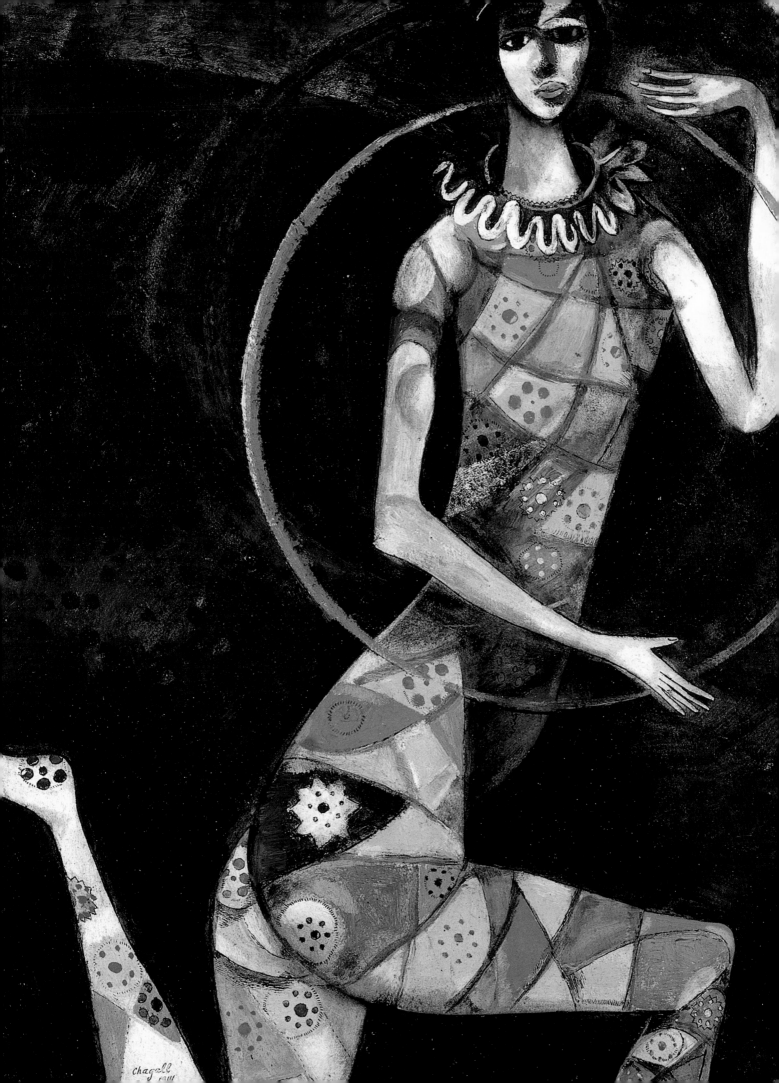

RUSSIA FRANCE RUSSIA

In 1907 Chagall was twenty years old and, despite his rudimentary knowledge of art, had already begun painting. The chronology in this volume describes how Chagall's familial and religious envirous would have hardly predisposed him to any study of art. In fact, the Jewish culture in which Chagall grew up was devoid of images; the prohibition on representation inscribed in Jewish law, which forbids the representation or worship of anything created by God, was still widely observed in the Jewish communities of Russia and Eastern Europe during Chagall's childhood. It was, therefore, outside of his familial and social circles that Chagall would become acquainted with painting and would begin to engage actively with visual culture. This helps to explain why, upon his arrival in Paris in 1911, the young Jewish artist—whose earliest paintings were self-portraits, portraits of his family, and views of his native Vitebsk—devoted his first significant work, *Calvary* (1912; pl. 1), to the quintessentially Christian theme of the Crucifixion. Although Chagall had completed a few other paintings with Christian themes (the Procession, the Madonna and Child, the Holy Family) while still in Russia, the monumental *Calvary* marked the start of a long series of works based on Christian subjects that would continue throughout the artist's career. This volume contains several other examples of works addressing Christian themes, including *The Apparition* (1917–18; pl. 3), *The Fall of the Angel* (1923–47; pl. 92), and *White Crucifixion* (1938; pl. 98).

It was only in Paris—far from his boyhood shtetl and its iconoclastic mores—that Chagall would be able to broach Jewish topics in his large compositions. *Temptation (Adam and Eve)* (1912; pl. 2) depicts a traditional Old Testament subject but employs a cubist technique reminiscent of Fernand Léger. The painting communicates Chagall's effort to articulate his Russian-Jewish background with a newly discovered modernism. It seems that Chagall's unique marriage of these two disparate strands, which gave his work power but also a certain strangeness, is what so pleased the Parisian audiences of his time. Indeed, *Temptation (Adam and Eve)* demonstrates the singularity of Chagall's vision: no other artist in the Parisian avant-garde of the early twentieth century explicitly depicted scenes from the Torah or Genesis vis-à-vis the cubist formal principles of fragmentation and deconstruction. To put it another way, at the precise moment when the avant-garde was moving away from figuration, narrative compositions, and genre painting in favor of formalism and abstraction, Chagall reintroduced traditional themes and religious subject matter. This decision, though defining for Chagall, represented the beginning of a deep rift between the artist and the avant-garde.

Much as Chagall took liberties with the predominant styles of the period—adapting modernist techniques to his own interests—he also demonstrated little regard for the ordinary rules and basic visual logic that structure traditional compositions. He employed contradictory elements quite liberally, provoking accidents and irrational affinities within his pictures. This compositional eclecticism, although somewhat evident in drawings from as early as 1909, developed during Chagall's stay in Paris: his exposure to the art at the Louvre and, more importantly, his association with a circle of avant-garde figures that included Robert Delaunay, Guillaume Apollinaire, and Blaise Cendrars certainly influenced Chagall's thinking as a painter. To be sure, Chagall's relationship with these artists helps to account for the cubist tendency—or, more precisely, the rendering of "Chagallian subjects" in a vaguely cubist manner—in artworks made during his stay in Paris. It is clear that the formal study undertaken by the "real" Cubists, those who had a philosophical investment in the movement, was entirely foreign to Chagall and had no place within his own practice; he did not completely understand, nor was he interested in joining, their endeavor.

Yet, despite this categorical distinction, Chagall maintained a unique affinity with the Cubists. Indeed, his strongest works from this period are those that adopt their strategy of fragmenting the figure. When, in 1912, the Cubists introduced foreign elements into their work by way of collage, Chagall began to disrupt the coherence of his own work in similar but distinct ways: the artist upset certain visual codes, rendering some figures with their heads backward or with animal features; transformed single canvases into multiscene compositions; abandoned the rules of perspective; and introduced metaphoric, even symbolic, meaning. This singular approach earned Chagall the admiration of some of the period's most important critics, notably Apollinaire, who described the artist's painting as "supernatural," anticipating the high regard that the Surrealists would have for Chagall in the next decade.

Upon his return to Russia in 1914, Chagall found himself back in Vitebsk, a town to which he was profoundly attached, but also one that was utterly removed from the artistic activity of Paris. Chagall had intended only a brief sojourn in Russia, but the outbreak of World War I prevented him from returning to France. Chagall's forced stay in his native land prompted the first stylistic rupture in the artist's work: his subjects (family members, neighbors, various local characters, and a few regional landscapes) became more naturalistic. Indeed, he himself termed the fifty or sixty paintings he produced between 1914 and 1915 "documents," as if to acknowledge a difference between these and his Parisian works.

Chagall returned to a more experimental kind of painting in 1917. Having married Bella Rosenfeld two years earlier, he embarked on a number of canvases evocative of married life (such as *Promenade* [1917–18; pl. 25]) that allowed him to reintroduce fantastic imagery to his work. He also produced several landscapes (such as *The Cemetery* [1917; pl. 15]) that reveal a continued dialogue with Cubism. Chagall was in Moscow during autumn 1917, and the political events surrounding the Russian Revolution doubtlessly had an influence on his working method and professional life. Chagall was awarded full Russian citizenship and was named commissar of fine arts for Vitebsk, charged with creating a fine arts academy and museum and with organizing exhibitions. As the director of the academy, Chagall worked with a number of other professors, namely Jean Pougny, El Lissitzky, and, above all, Kazimir Malevich, a Suprematist known for his severe geometric abstractions.

The rivalry created by this convergence of artists in Vitebsk pushed Chagall to experiment, and the few abstract works he is known to have made all date from this period. But Chagall and Malevich soon had a falling out; to all appearances their animosity was personal, but it also, and more fundamentally, resulted from their disagreement over aesthetic concerns. Unlike Malevich, Chagall was simply not able to renounce figuration. For him, abstract art was the product of a world without God. The religious aspect of Chagall's inspiration is captured in his painting *The Apparition,* which also marks the conclusion of this phase of Chagall's artistic life. The painting, like others, is arrived at by "abduction," in this case, from the Annunciation. However, in giving the angel Gabriel Bella's features and in replacing the Virgin Mary with a self-portrait, Chagall adds a profane sense to a scene in which religious meaning resolutely survives.

CALVARY The grand scale of this canvas and the multiple preparatory sketches made by the artist in planning for its execution strongly suggest that *Calvary* was a pivotal work for Chagall. The painting was first exhibited in Berlin in 1914 with the title *Dedicated to Christ*. In representing the Crucifixion, Chagall devoted himself to one of Western painting's most canonical subjects and, accordingly, could not avoid conceding somewhat to tradition. The work's deliberate, monumental quality attests to the artist's awareness of this capitulation. However, choosing to portray this quintessential Christian scene was hardly a conventional or popular decision for the artist. Indeed, Chagall's decision to paint the Crucifixion placed him at once in a double breach, simultaneously transgressing the cultural boundaries of Judaism, which clearly did not endorse any depiction of Jesus, and breaking ranks with the avant-garde of 1912, which was not particularly interested in reviving the tradition of religious painting.

This breach constitutes the first of numerous occasions in which Chagall would swim against the tide, refusing to adhere to the dominant artistic movements of his milieu. However, despite the many traditional elements of this work—its title, its format, its academic preparation through preliminary studies—Chagall was by no means entirely removed from avant-garde practice. To the contrary, this canvas responds to the formal preoccupations of Cubism as practiced by Chagall's friend Robert Delaunay. The painting, much like *The Fall of the Angel* (1923–47; pl. 92) or Chagall's 1920 decorations for the State Jewish Chamber Theater in Moscow (pls. 33–39), should be seen as a sort of manifesto. That is, the tendencies that made Chagall unique when he arrived on the Parisian art scene in 1911—an articulation of his native culture, a dialogue with the visual languages of modernism, and an interest in subjects and genres not popular with the avant-garde—are acutely evoked in this artwork. Chagall demonstrated, with a certain naïveté but also with great force, that it was possible to unite his Jewish and Russian heritage with the formal vocabulary of modern art—that it was possible to reconcile grand historical art (such as the many Crucifixions that Chagall saw in the Louvre) with a modern artistic sensibility. A few years later, the artist's decorative work for the Jewish Theater would affirm his belief that it was possible to create art derived from Jewish folklore. But in 1912, the year *Calvary* was made, Chagall succeeded—insofar as his artist friends and dealers were concerned—in marrying the lessons of Cubism, his personal history, and aspects of his own religious faith within the context of his painting.

Overall, *Calvary* evokes the deconstructive strategy introduced by the Cubists. But whereas the Cubists tended to be self-referential, or at least sought out relatively neutral cultural references, Chagall uses cubist technique here to render Christian iconography. Although this cubist treatment departs from traditional representations of the Crucifixion, the fragmentation does not overtake the narrative, nor is it dominant enough to be considered the work's primary organizing element. Indeed, Chagall has retained a somewhat conventional sense of depth and perspective, having rendered discrete figures in the foreground, the background, and on the periphery. *Calvary*'s title and its relationship to canonical painting would suggest that the work's true subject is the Crucifixion; given the circumstances under which it was made, however, it is equally possible that the painting's theme is the hybridization of disparate artistic concerns and practices. Even so, the depiction of the Crucifixion necessarily infuses the picture with religious significance—an effect that Chagall would not have renounced.

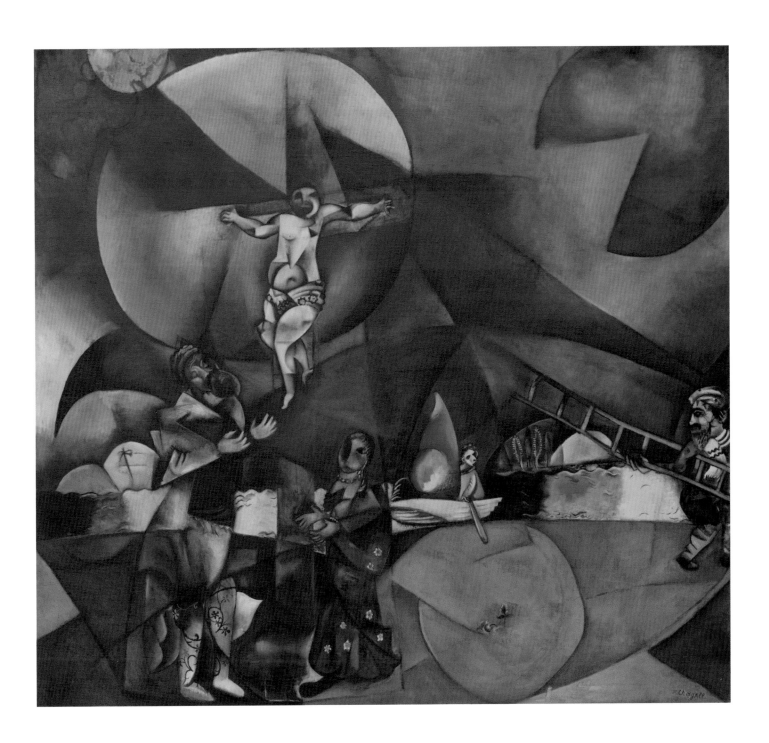

1

CALVARY 1912
oil on canvas
68 ¾ x 75 ¾ in. (174.6 x 192.4 cm)
The Museum of Modern Art, New York, acquired through the
Lillie P. Bliss Bequest, 1949

TEMPTATION (ADAM AND EVE) In 1912 Chagall's relationship to Cubism was decidedly ambiguous. Presented at the Salon des indépendants in 1913, this large canvas seems to bear out the sympathetic side of this relationship: the painting adheres to period styles of Cubism and Futurism, recalling Fernand Léger's practice in particular, and evidences Chagall's participation in formal experiments that were common among the avant-garde. The exercise was largely successful in the eyes of his contemporaries; in the March 25, 1913, issue of *L'Intransigeant*, Guillaume Apollinaire remarked that the painting was "a large decorative composition [that] reveals an impressive sense of color, a daring talent, and a curious and tormented soul." It is true that the complex rendering of Adam and Eve, arrived at through the layered development of colored planes, and the way in which the figures are entwined with the tree trunk lend a forceful presence to this painting and make it a fascinating work. Yet incongruous elements disrupt what would otherwise be merely a formal exercise: the leaves and fruit of the tree, like the animals at the painting's margins, are treated in a more naturalistic fashion. These elements usher in a kind of fantasy, even an explicit humor, that opposes the seriousness of the image's cubist deconstruction.

Chagall did not believe in Cubism. The decorative abundance of the painted leaves and fruit proclaims this doubt. But he made use of Cubism as one might make use of any period style—he employed it without entirely adopting it. In addition to this stylistic ambivalence, Chagall revealed his ultimate rejection of Cubism by way of his subject matter; given the cultural and historical charge of biblical themes such as Adam and Eve, they did not easily lend themselves to pure formalism and were not part of the cubist repertoire in 1912. Chagall produced other works with biblical subjects during this period: a 1911 gouache that illustrates the primordial couple's creation in Genesis preceded another on the theme of Cain and Abel. This canvas, then, may be viewed as part of a series of works about the human condition (starting from Chagall's individual experiences and evolving into a commentary on the role of the artist) that begins with *Calvary* (1912; pl. 1) and will continue with *The Apparition* (1917–18; pl. 3).

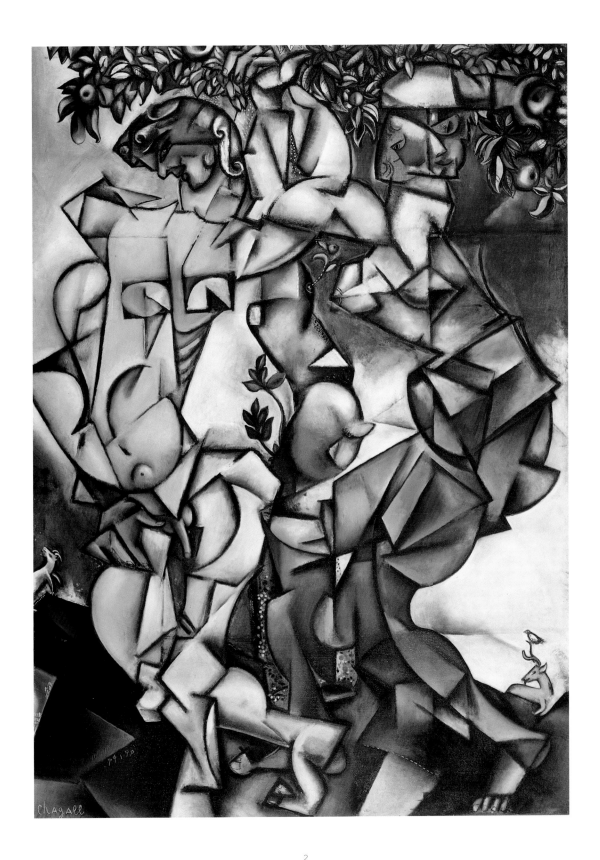

TEMPTATION (ADAM AND EVE) 2
1912
oil on canvas
65 ½ x 46 ¾ in. (166.4 x 118.7 cm)
The Saint Louis Art Museum, gift of Morton D. May

THE APPARITION This painting is the first in a series of representations of a painter as an angel or of a painter being inspired by an angel, themes that the artist would revisit over the next sixty years of his career. The depicted painter is obviously Chagall himself, and some of these works may be thought of as self-portraits. In proffering *The Apparition,* Chagall declares that the work of art is divine in origin; that the artist's inspiration is a gift from heaven; and that, ultimately, God guides the hand of the painter. Chagall is hardly the first artist to evoke the notion of divine inspiration. Renaissance and Baroque art includes many examples of paintings in which the artist's hand is guided by an angel. Other representations from these periods deliberately omit the painter's palette so that his brush seems to produce images out of thin air, as if to suggest that the work of art does not come from matter but from God's own will.

This work, alternatively titled *Inspiration,* also incorporates the iconography of the Annunciation, even as its palette, severe diagonal divisions, and overall geometric fragmentation are reminiscent of work by the Futurists and artists such as Fernand Léger and Robert Delaunay. As in many paintings of the Annunciation, the angel is visually cordoned off from the recipient of his news, but Chagall has transposed the characters: the Virgin Mary has been replaced with a self-portrait and the angel Gabriel seems to be Chagall's wife, Bella. Chagall had no blasphemous intent in altering this canonical scene. Rather, his amendments resulted from a number of layered influences. There is a declaration of sentimental romance for Bella, portrayed as Chagall's muse. There is evidence of what Chagall learned from Léger and Delaunay in Paris. There is an emulation of his Russian colleagues, the Cubo-Futurists, but also a sense of dissent—while they used Cubism and Futurism to describe a fast-paced modern world, Chagall exploits their techniques to represent himself and to affirm the existence of divine artistic inspiration.

In the end, there is a kind of double appropriation at work here. Chagall has repurposed and secularized a Christian motif while adapting the aesthetics of the Russian painters Pavel Filonov and Natan Al'tman and of the Parisian artists Léger and Delaunay to his own liking.

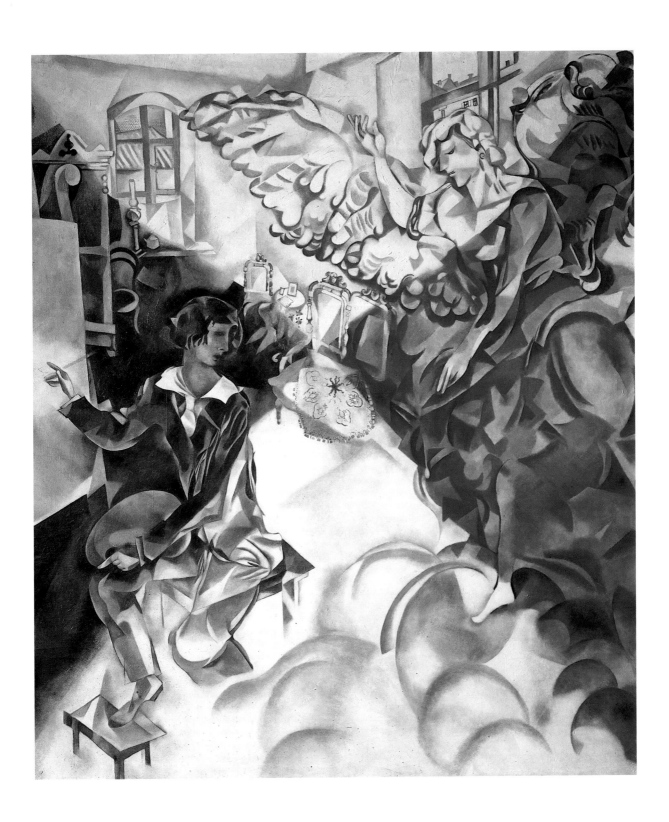

3

THE APPARITION 1917–18
oil on canvas
61 ⅞ x 55 ⅛ in. (157 x 140 cm)
Private collection, Saint Petersburg

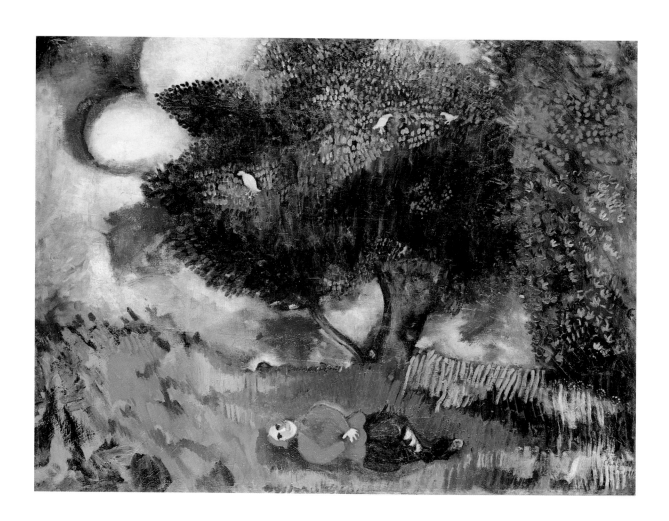

4

THE POET WITH BIRDS 1911

oil on canvas

28 ½ x 39 in. (72.4 x 99 cm)

The Minneapolis Institute of Arts, bequest of Putnam Dana McMillan

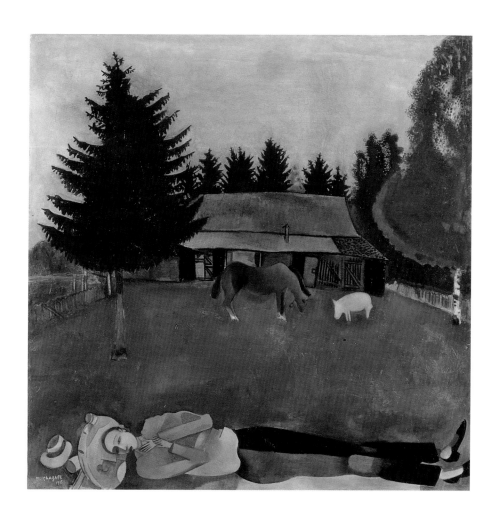

5

THE POET RECLINING 1915
oil on board
30 ⅜ x 30 ½ in. (77 x 77.5 cm)
Tate, London, purchased 1942

THE MIRROR Throughout the history of Western art, mirrors have been used to evoke the representational power of painting. Between the fifteenth and seventeenth centuries, virtually every art theoretician, from Leon Battista Alberti to Leonardo da Vinci, related the act of painting to the mirror's reflection of reality. In classical painting, mirrors often play a symbolic role, and beginning in the fifteenth century, mirrors were used to reveal evidence of a painting's creation—they often "reflected" the artist or a scene that was beyond the scope of the primary composition. A number of seventeenth-century Dutch still lifes contain mirrors that reflect objects visible elsewhere in the picture.

Chagall's painting draws upon this tradition of mirrors in art, but also takes it a step further: the object in the mirror is only knowable by its reflection—the object itself is not rendered within the frame. By denying the viewer the reflection's source, the mirror in this work functions more like a window or a painting within the painting. The preposterously small sleeping figure at the lower left corner of the composition accentuates the sense that Chagall is deliberately playing with pictorial logic.

THE MIRROR 6
1917
oil on board
39 ³⁄₈ x 31 ⁷⁄₈ in. (100 x 81 cm)
The State Russian Museum, Saint Petersburg

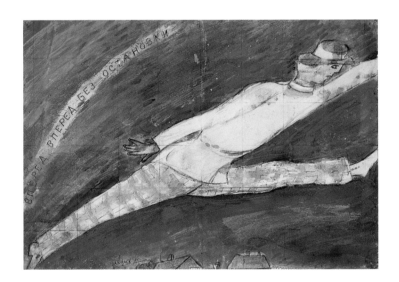

7
1912–13
gouache on paper
9 ¼ x 6 ½ in. (23.5 x 16.5 cm)
Archiv Baumeister, Stuttgart

8
1918
pencil and gouache on vellum
9 ⅛ x 13 ¼ in. (23.4 x 33.7 cm)
Centre Georges Pompidou, Paris, Musée national d'art moderne/
Centre de création industrielle, dation 1988

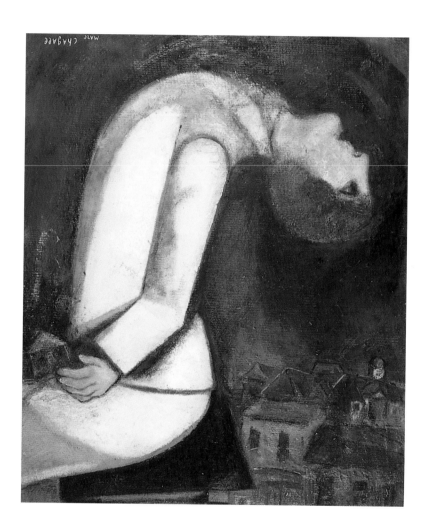

9

MAN WITH HIS HEAD THROWN BACK 1919
oil on board
22 ⅜ x 18 ½ in. (57 x 47 cm)
Private collection, Paris

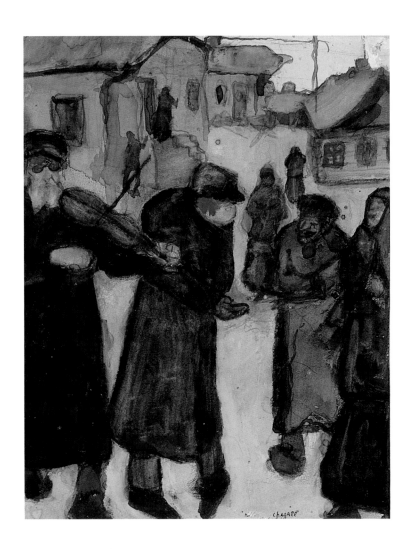

10

STREET MUSICIANS 1907

gouache and india ink on paper

11 ⁵⁄₈ x 9 ¹⁄₈ in. (29.7 x 23 cm)

Private collection, Paris

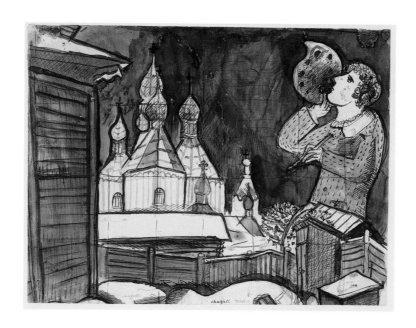

11

VITEBSK 1911
pencil, ink, and gouache on paper
6 ¾ x 9 ⅛ in. (17.1 x 23.1 cm)
Centre Georges Pompidou, Paris, Musée national d'art moderne/
Centre de création industrielle, dation 1988

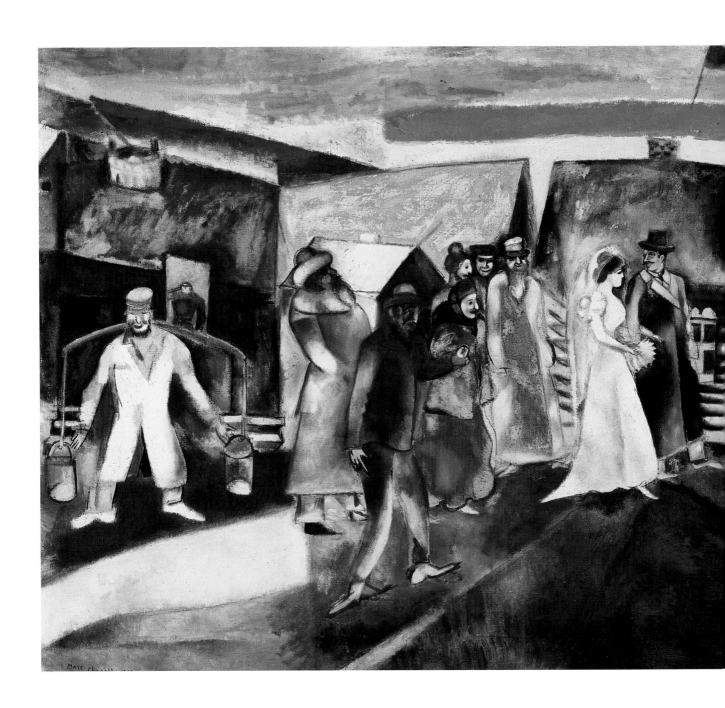

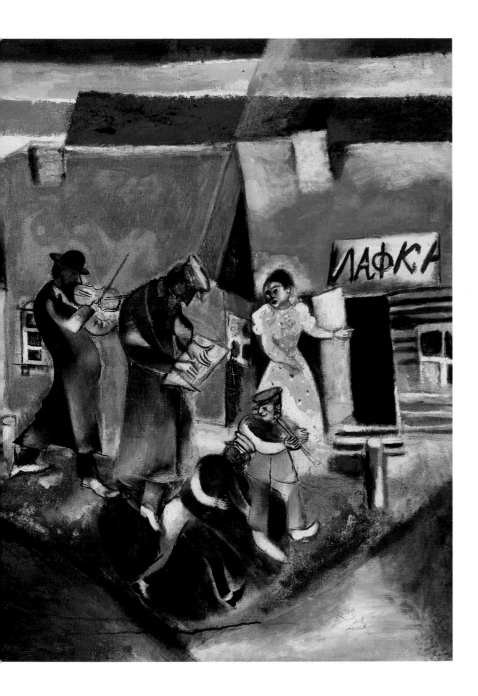

12

THE WEDDING 1910

oil on linen

39 ⅛ x 74 ⅛ in. (99.5 x 188.5 cm)

Centre Georges Pompidou, Paris, Musée national d'art moderne/

Centre de création industrielle, dation 1988

THE CEMETERY Chagall completed several landscapes during his stay in Vitebsk in the fall of 1917. Unlike the more realistic paintings of Vitebsk the artist made upon his return to Russia in 1914, these later works distort the scene, evoking a sense of nostalgia and emotional memory. The town's cemetery was one of the places that brought back a flood of emotions for the artist. In his autobiography, *My Life*, Chagall remarks: "Green leaves rustling. Your stones. Your graves. Hedgerows, muddy river, prayers made. All that is before me. No words. It all lies deep within me, writhes and soars like my memory of you."

Chagall had come to terms with death and its inescapable role in life's cycle, yet the cemetery in this painting is hardly solemn or peaceful. The artist has massed the tombstones in sprawling clusters interspersed with dense vegetation. Certain tombs appear to be ruined, adding to the disorder. The sky, consisting of geometric forms that echo those in the cemetery, enhances the animated, chaotic aspect of the work. Indeed, the ascending movement of the tombstones suggests that the sky is inhaling the scene below, drawing up the earthly structures. Chagall invites the possibility that all of the composition's elements will eventually coalesce. This notion of unification relates both to Chagall's pictorial conception of the universe—in which human beings, animals, the heavens, and the earth form a united whole—and to the Jewish belief in an eternal afterlife.

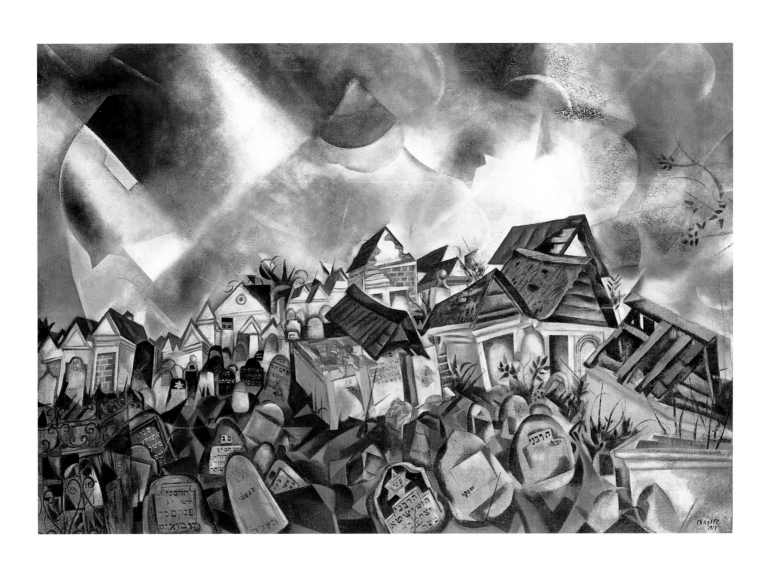

15

THE CEMETERY 1917
oil on canvas
27 ⅜ x 39 ⅜ in. (69.3 x 100 cm)
Centre Georges Pompidou, Paris, Musée national d'art moderne/
Centre de création industrielle, dation 1988

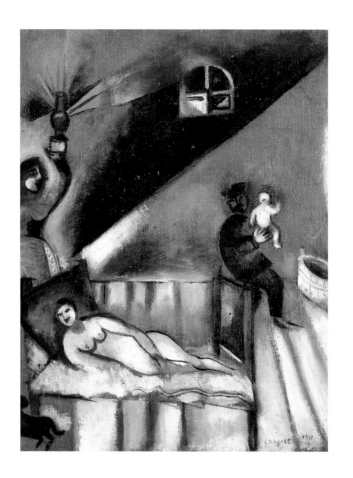

16

THE BIRTH 1911
oil on canvas
18 ⅛ x 14 ⅛ in. (46 x 36 cm)
Private collection, Paris

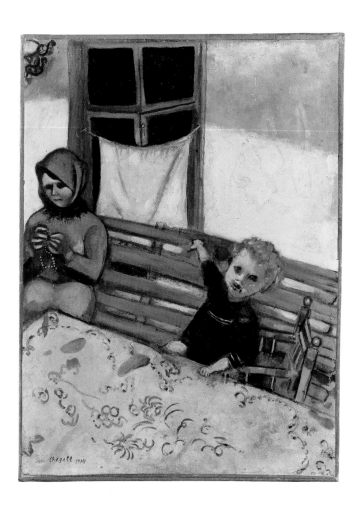

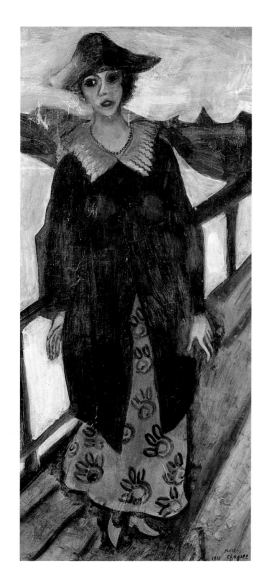

17

SERVANT AND CHILD 1914
oil on board
20 ⅛ x 14 ⅞ in. (51 x 38 cm)
Collection of David McNeil

18

BELLA ON THE BRIDGE 1915
oil, colored pencil, and ink on paper mounted on canvas
25 ⅛ x 11 ⅝ in. (64 x 29.5 cm)
Private collection, Paris

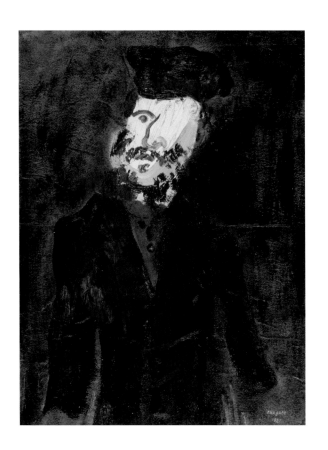

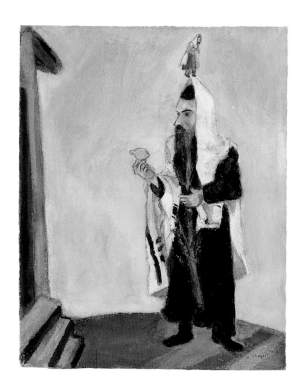

19

THE FATHER 1921
oil on board
26 ⅜ x 19 ⅞ in. (67 x 50.5 cm)
Private collection, Paris

20

SKETCH FOR FEAST DAY (RABBI WITH LEMON) 1914
gouache and watercolor on paper
16 ⅞ x 13 ⅝ in. (42.7 x 34.4 cm)
Private collection, Paris

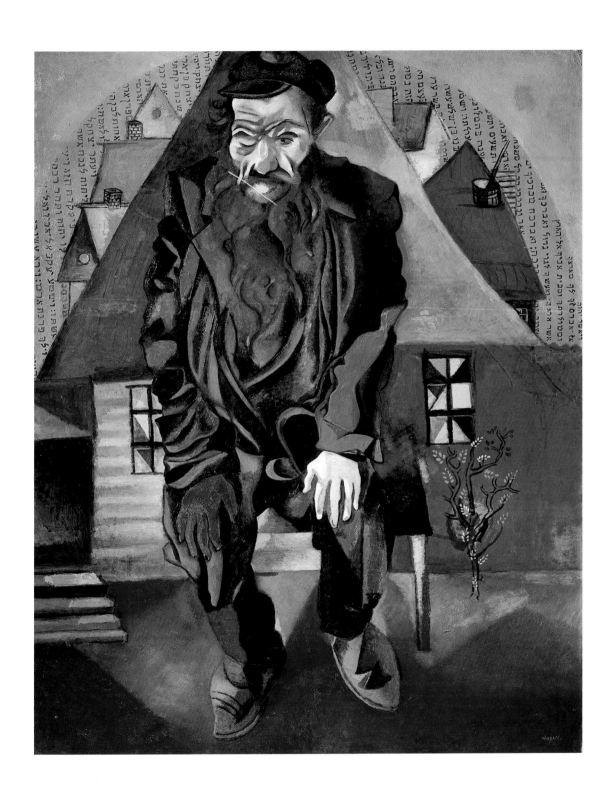

THE JEW IN RED 1915
oil on board
39 ⅜ x 31 ⅝ in. (100 x 80.5 cm)
The State Russian Museum, Saint Petersburg

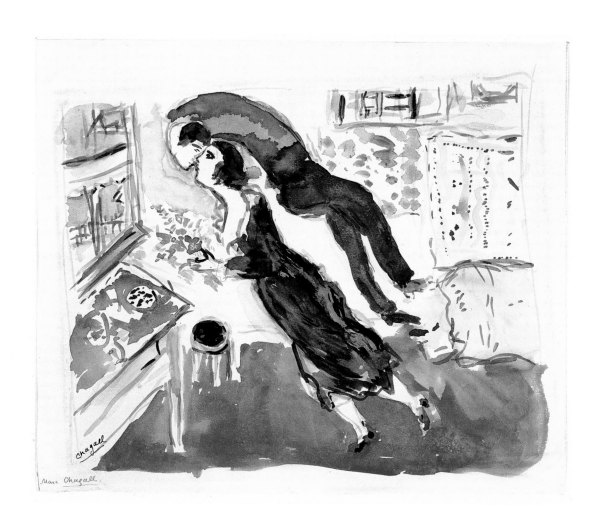

22

THE BIRTHDAY　1915
pencil and watercolor on paper
8 ⅝ x 10 ½ in. (22 x 26.6 cm)
Centre Georges Pompidou, Paris, Musée national d'art moderne/
Centre de création industrielle, dation 1988

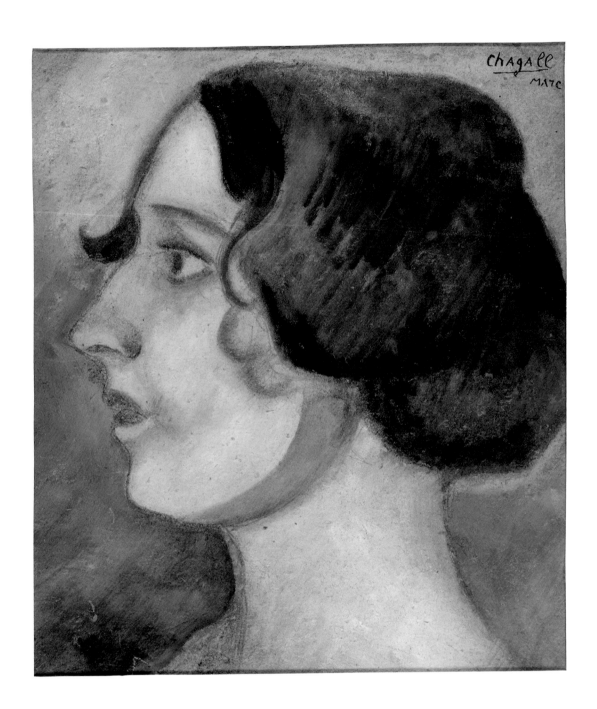

23

BELLA IN PROFILE 1916
oil and gouache on board
12 x 10 ⅝ in. (30.5 x 27 cm)
Private collection, Paris

BELLA WITH WHITE COLLAR Chagall married Bella Rosenfeld during the summer of 1915. Although this painting of the artist's wife is fairly modest in size, it conveys a rare impression of monumentality. Its unusual format, rigorous composition, and idiosyncratic use of scale are not the only things that encourage this perception. While the work makes obvious reference to traditional representations of the Assumption of the Virgin, closer examination reveals a decidedly non-Catholic absence of ecstasy and a sense of distant coldness, physical power, and disturbing severity on the part of this overwhelming woman. Emerging from a leafy wood with her gaze focused on the ground rather than toward the heavens, the figure suggests the influence of other, more pagan, sources. Germanic folklore, for example, tells of woodland deities rising from the deep primordial forest, dangerous feminine forces that relegate men to the edges of their domain. Such legends may illuminate the tiny image of Chagall and his daughter Ida that the artist has consigned to the painting's immediate foreground.

The disquieting central figure, a heraldic sign in black and white that rends the fabric of the sky, corresponds to none of the stereotypical images of Jewish women. In spite of its ostentatious character, this majestic composition may be counted among a group of intimate works documenting Chagall's relationship with his wife. Contemporaneous with several double portraits as well as paintings such as *Above the Town* (1914–18; pl. 26) and *Promenade* (1917–18; pl. 25), with their aerial flights of amorous transport, *Bella with White Collar* suggests that Chagall cherished a private vision of his wife as the divine protector of his art, even beyond death.

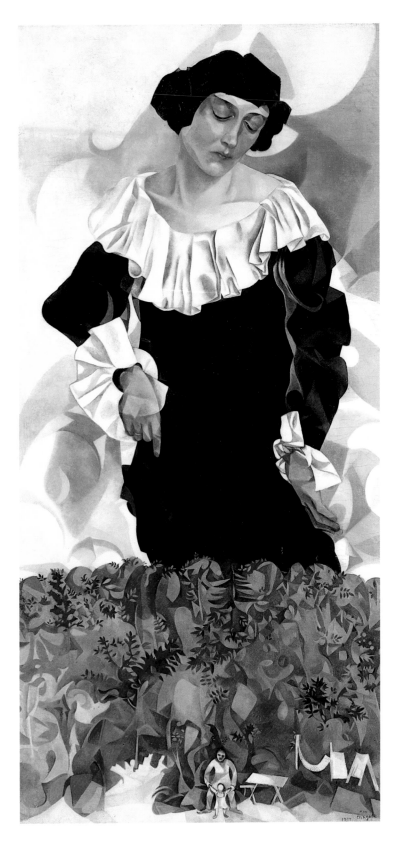

24

BELLA WITH WHITE COLLAR 1917
oil on linen
58 ⅝ x 28 ⅜ in. (149 x 72 cm)
Centre Georges Pompidou, Paris, Musée national d'art moderne/
Centre de création industrielle, dation 1988

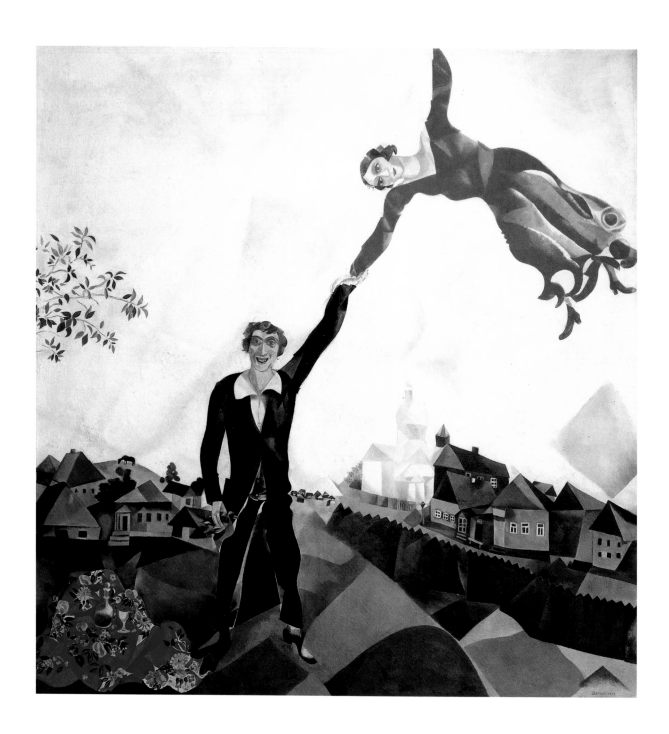

25

PROMENADE 1917–18
oil on canvas
66 ⅞ x 64 ⅜ in. (170 x 163.5 cm)
The State Russian Museum, Saint Petersburg

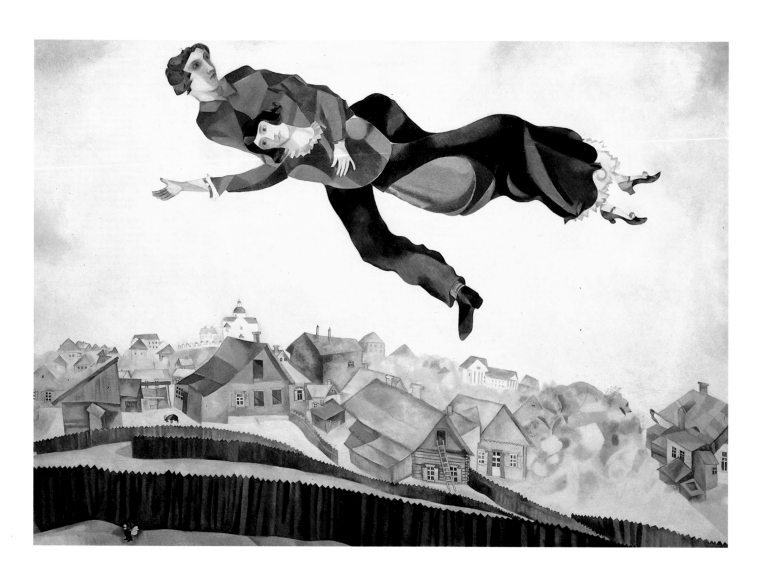

26

ABOVE THE TOWN 1914–18
oil on canvas
54 ¾ x 77 ⅝ in. (139 x 197 cm)
The State Tretiakov Gallery, Moscow

27

NUDE IN THE GARDEN 1911
oil on canvas
13 x 15 ⁷⁄₈ in. (33 x 40.5 cm)
Private collection, Paris

28

RED NUDE 1909
oil on canvas
33 ⅛ x 45 ⅝ in. (84 x 116 cm)
Private collection, Paris

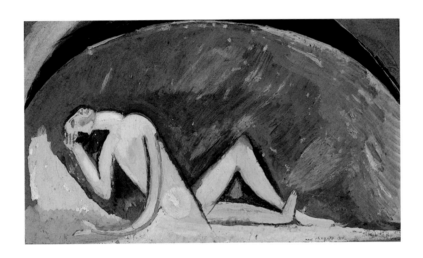

29

FIGURE IN FRONT OF BLUE VAULT 1910

gouache on paper

10 ⅝ x 15 ¾ in. (27 x 40 cm)

Private collection, Paris

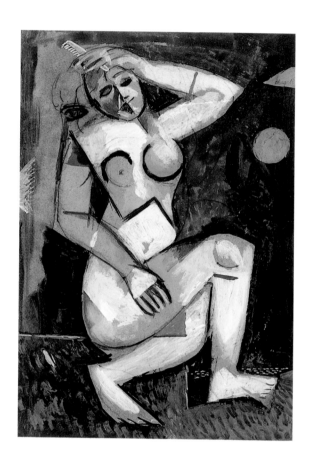

30

NUDE WITH COMB 1911–12
ink and gouache on paper
13 ⅛ x 9 ¼ in. (33.5 x 23.5 cm)
Private collection, Paris

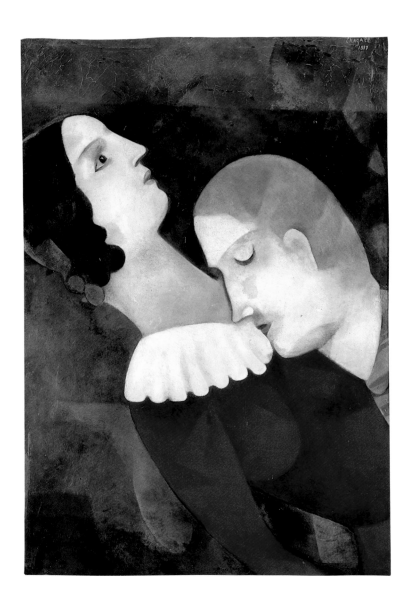

31

LOVERS IN GREEN 1916–17
oil on paper mounted on canvas
27 ⅜ x 19 ½ in. (69.7 x 49.5 cm)
Centre Georges Pompidou, Paris, Musée national d'art moderne/
Centre de création industrielle, dation 1988

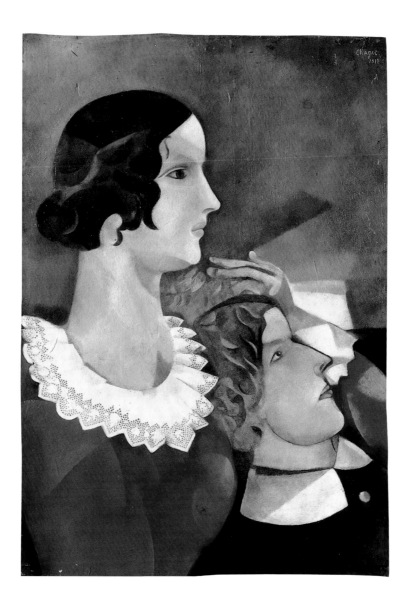

32

LOVERS IN GRAY 1916–17
oil on paper mounted on canvas
27 ⅛ x 19 ⅜ in. (69 x 49 cm)
Centre Georges Pompidou, Paris, Musée national d'art moderne/
Centre de création industrielle, gift of Ida Chagall, 1984

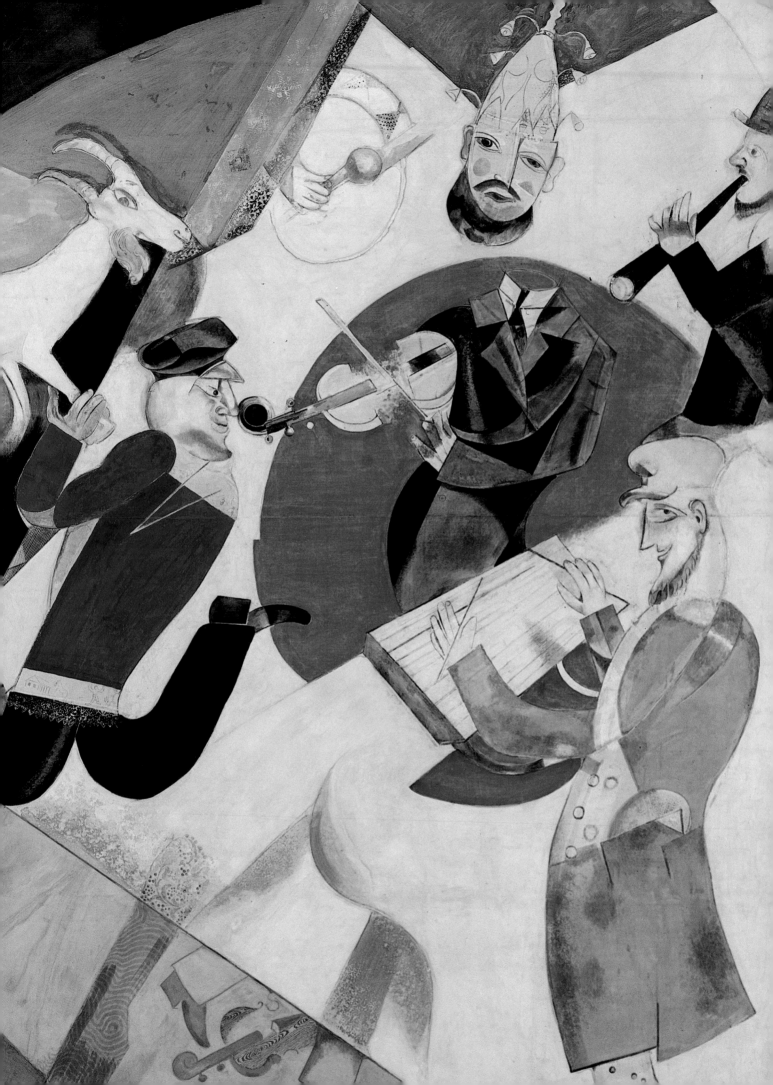

THE JEWISH THEATER IN MOSCOW

In 1918, in his capacity as the commissar of fine arts for the Vitebsk region, Chagall announced the creation of the People's School of Art, whose faculty included Kazimir Malevich, El Lissitzky, and Jean Pougny. Malevich quickly imposed the teaching of Suprematism and sought to establish abstraction as the school's sole doctrine. Chagall, who clearly did not uphold the tenets of Suprematism, eventually clashed with Malevich and left the school, moving to Moscow in the spring of 1920. Chagall's opposition to Malevich was a power struggle for the direction of the academy, but it was also a larger conflict, bound up with greater aesthetic and philosophical concerns. Quite simply, Chagall did not believe in abstraction—for him, the desire to remove recognizable aspects of humanity from painting was a desire to make a world without God. However, it was not until he was commissioned to create a large decorative cycle for the State Jewish Chamber Theater in Moscow in late 1920 that he was able to reconcile this conviction with his work. The project gave Chagall the opportunity to declare his distaste for pure abstraction and his enduring belief in figuration. According to witnesses, he set to work with a true creative frenzy, producing a series of mural-like paintings that should be considered nothing less than an aesthetic manifesto.

The significance of Chagall's work for the Jewish Theater is multifaceted. On one level, the decorative scenes are deliberate responses to Chagall's recent falling out with Malevich, whose work is abundantly—if somewhat antagonistically—quoted, as is that of Aleksandr Rodchenko. But more generally, this series of works seems to index all of the artistic concerns that Chagall had been confronting in the previous decade, from his Paris sojourn through his return to Vitebsk. The panels reference Robert Delaunay's Orphic style; Albert Gleizes and Jean Metzinger's principles concerning the opposition of zones of activity and rest on a painting's surface; orthodox Cubism; Jewish folklore; and portraiture and self-portraiture, including images of Chagall's wife Bella and their daughter Ida. This broad mixture of genres and styles suggests that Chagall used this commission to offer a response to everything that had stimulated him in art. As in 1912 with *Calvary* (pl. 1), Chagall attempted to combine what appear to be completely paradoxical elements: the modernist formalism of Suprematism and the lyrical rhetoric of Jewish folklore. He wanted to show that Jewish folklore— as much as Christian iconography, Cubism, or Suprematism—could provide an aesthetic framework. This innovative assertion allowed Chagall to embody the archetype of the modern artist: a figure who critiques and contradicts prevailing beliefs, who is capable of envisioning new approaches and forging a singular identity.

Before the Russian Revolution, Chagall had worked within the theater community of Saint Petersburg, where he had produced several decorative projects, specifically for plays by Nikolay Gogol. Chagall's work for the Jewish Theater in Moscow, however, was unique in that, in addition to creating murals and designing costumes, the artist also determined the style of the sets and therefore aspects of the performances themselves. For three of Sholem Aleichem's short plays, *Agents, It's a Lie*, and *Mazel Tov*, Chagall created surreal scenery and costumes that inspired a kind of performance that departed from what was commonly staged at the time; the playfulness of his set designs moved Aleichem's subtle, delicate humor toward farce and pantomime. The element of fantasy Chagall brought to these productions had a lasting influence on set design at the Jewish Theater, which would come to influence Western theater decades later.

Painted over the course of forty days in 1920, the surviving elements of Chagall's decorative cycle for the Jewish Theater comprise panels of the allegorical figures Dance, Music, Literature,

and Drama (pls. 35–38); a long, narrow frieze portraying a wedding banquet (pl. 39); *Introduction to the Jewish Theater* (pl. 34), the central panel, in which Chagall, carried by the theater's artistic director Abram Efros, is presented to the work's patron, Alexander Granovsky, and holds out his palette, gesturing to a cadre of musicians and peasants; and a frieze titled *Love on the Stage* (pl. 33). The overall mood of the program is decidedly festive—with all of the dancing and flying, one easily gets the impression that Chagall's figures are in the midst of a celebration.

What, then, is Chagall declaring in this manifesto-like decorative cycle? Above all, his work for the Jewish Theater reveals an interest in visually interweaving spirituality, Jewish cultural life and folklore, and a dialogue with avant-garde art movements. In the *Introduction*, for instance, Chagall makes a broad range of references: the central acrobat holds a list of great Yiddish authors between his legs; the clarinetist's trousers are mockingly adorned with horizontal and vertical motifs that may refer to Suprematism; and the man with the pistol alludes to Uriel da Costa, a progressive seventeenth-century theologian who was regarded as a hero by secular Jews. Similarly, the four allegorical panels, originally situated opposite the *Introduction*, replace the traditional iconography for Dance, Music, Literature, and Drama with everyday figures from Jewish life, whom Chagall described, respectively, as a female dancer, a klezmer musician, a Torah scribe, and a wedding jester. Although allegorical figures had long been used in theater decoration, Chagall's are hardly traditional: they are vivacious, whimsical, and anything but academic. This choice suggests that the artist viewed the characters of Jewish folklore, including Yiddish theater, as carrying a symbolic resonance on a par with canonical figures from classical art.

Designed as part of a total environment, Chagall's decor for the Jewish Theater, which originally included a ceiling panel and an illustrated curtain (now lost), was doubtlessly intended to represent the theatricality of the stage itself, but it also seems that Chagall was interested in portraying realistic aspects of Yiddish culture in Russia as well as elements of Jewish theology and religious tradition. For example, the narrow *Wedding Table* frieze alludes to the marriage scenes in Aleichem's play *Mazel Tov*, but may, more generally, refer to the cultural significance of wedding traditions and ritual meals in Jewish culture. When planning the overall program for the Jewish Theater, Chagall may even have had Hasidic celebrations in mind. Hasidism, the Jewish sect in which Chagall was raised, considers dance to be one of the highest forms of religious fervor. For the Hasidim, the movement of the body mirrors the movement of the soul and offers a means of communing with God. With this in mind, it is conceivable that the decorative panels for the Jewish Theater represent a Hasidic celebration, thereby intermingling the spheres of theater and ceremony, the profane and the sacred.

Despite these affinities with Jewish spiritual life, it is inaccurate to conceive of the panels solely as literal illustrations. They are, in fact, much more metaphorical and comprise a nuanced compendium of the artist's experiences as a child, in Paris, and at the Vitebsk art academy. They also reference his aesthetic experiences: Cubism, Suprematism, and other forms of abstraction are present throughout the ensemble. All of these components are caught up in sprawling movement, particularly in the *Introduction*, which is led by an orchestra conductor. There is also a sense that figures from the past encounter figures from the present: at times the overlapping of various characters indicates spatial depth, but at other moments it seems to suggest a collapsing of space and time, the visual evocation of memory.

It is conceivable that this interest in the present meeting up with the past has roots in

Chagall's messianic beliefs, in which a fundamental tenet of Jewish faith was bound up in a personal vision of art's capacity to reflect upon biblical texts and other aspects of religious import. The work should also be viewed against the larger context of Russia in 1920, a time of severe political, economic, and ideological turmoil that renders the murals' interweaving of humor, celebration, and redemption even more poignant.

Chagall's decorative cycle for the Jewish Theater, then, positions the artist as the bearer of an intricately composed message. Indeed, in the *Introduction,* the figure of the painter is ushered in as a sort of prophet, a man who comes to announce a new world. To use a term familiar to the Hasidim, Chagall succeeds in evoking "divine sparks" while seamlessly, if indirectly, attesting to his faith in God. Many years after these decorations were made, Chagall would remark: "I have always considered clowns, acrobats, and actors as tragically human; to me they resemble the characters of certain religious paintings. And even today, when I paint a Crucifixion or another religious painting, I feel almost the same emotions that I experience while painting circus people. Nevertheless, there is nothing literary in these paintings, and it is extremely difficult to explain why I find a [psychological or formal] resemblance between these two kinds of composition." Given the complex ways in which the artist incorporated spirituality into his work—even in pieces that ostensibly do not have religious subjects—it is clear that outright abstraction, for Chagall, signified the absence of God.

33

JEWISH THEATER, LOVE ON THE STAGE 1920

tempera and gouache on canvas

111 ⅜ x 97 ⅝ in. (283 x 248 cm)

The State Tretiakov Gallery, Moscow

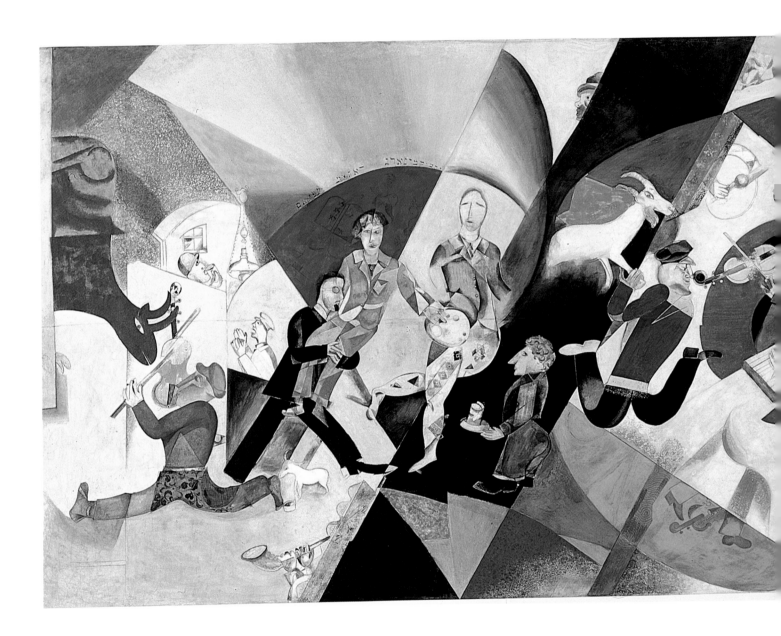

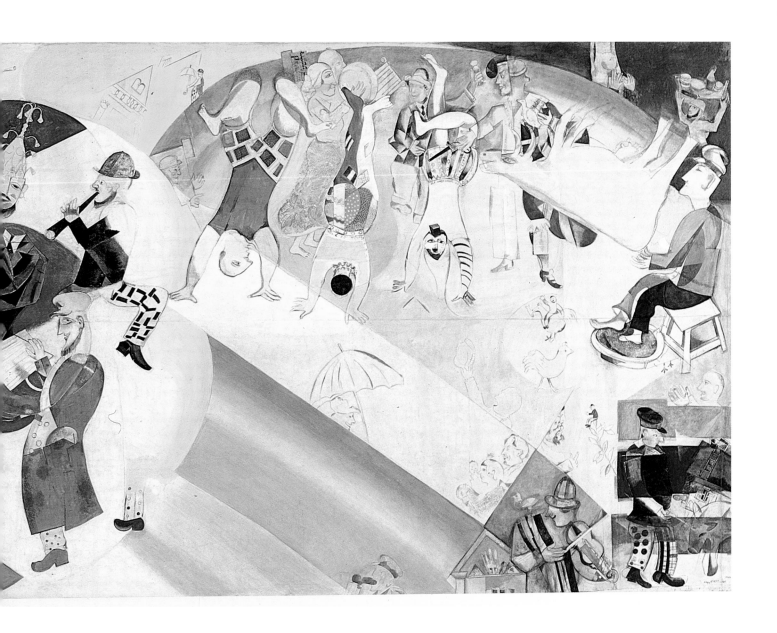

INTRODUCTION TO THE JEWISH THEATER 1920
tempera, gouache, and clay on canvas
111 ⅞ x 309 ⅞ in. (284 x 787 cm)
The State Tretiakov Gallery, Moscow

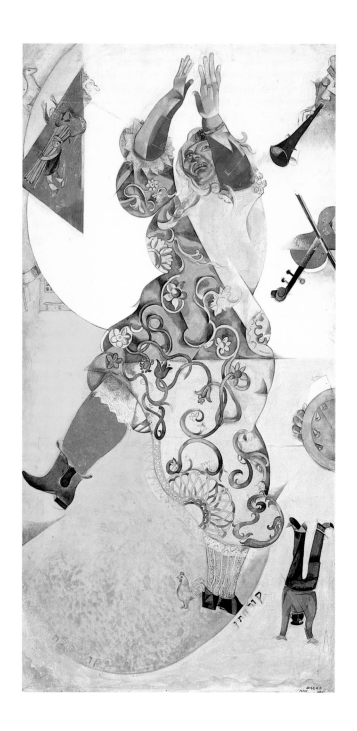

35

JEWISH THEATER, DANCE 1920
tempera and gouache on canvas
84 ¼ x 42 ⅝ in. (214 x 108.5 cm)
The State Tretiakov Gallery, Moscow

36

JEWISH THEATER, MUSIC 1920

tempera and gouache on canvas

83 ⅝ x 40 ⅝ in. (212.5 x 103.2 cm)

The State Tretiakov Gallery, Moscow

39

JEWISH THEATER, THE WEDDING TABLE 1920
tempera and gouache on canvas
25 ⅛ x 314 ⅝ in. (64 x 799 cm)
The State Tretiakov Gallery, Moscow

40

THE DANCER, SKETCH FOR DANCE 1918
pencil on paper
9 ¾ x 5 ¼ in. (24.8 x 13.4 cm)
Private collection, Paris

41

THE DANCER, SKETCH FOR DANCE 1919
pencil and gouache on paper
9 ½ x 5 in. (24.1 x 12.7 cm)
Private collection, Paris

42

THE DANCER, SKETCH FOR DANCE 1920
watercolor and pencil on paper
9 ⅞ x 6 ⅛ in. (25 x 15.5 cm)
Private collection, Paris

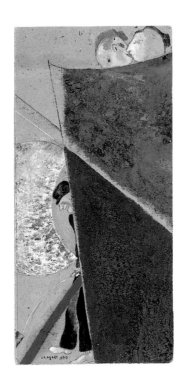

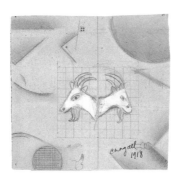

43

STUDY FOR INTRODUCTION TO THE
JEWISH THEATER (MAN URINATING) 1920 (signed and dated 1917)
watercolor and gouache on paper
14 x 6 ⅞ in. (35.5 x 17.4 cm)
Private collection, Paris

44

CURTAIN DESIGN FOR THE JEWISH THEATER 1920 (signed and dated 1918)
pencil, gouache, and ink on paper
5 ½ x 19 ⅝ in. (14 x 49.9 cm)
Private collection, Paris

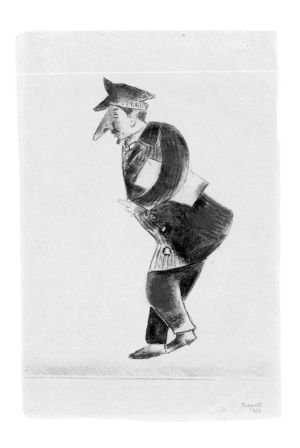

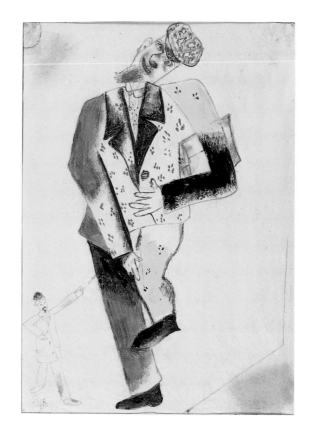

53

THE MAN WITH THE LONG NOSE (COSTUME DESIGN) 1920
pencil and gouache on paper
10 ⅜ x 7 ⅛ in. (26.5 x 18 cm)
Private collection, Paris

54

COSTUME DESIGN 1919
watercolor and pencil on paper
10 ⅝ x 8 ⅛ in. (27.2 x 20.5 cm)
Private collection, Paris

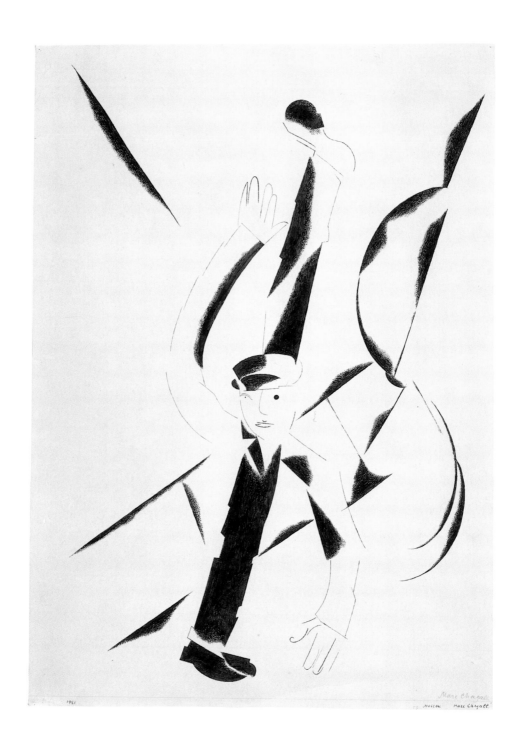

55

MOVEMENT 1921

ink on paper

18 ⅜ x 13 ⅜ in. (46.9 x 34 cm)

Centre Georges Pompidou, Paris, Musée national d'art moderne/

Centre de création industrielle, dation 1988

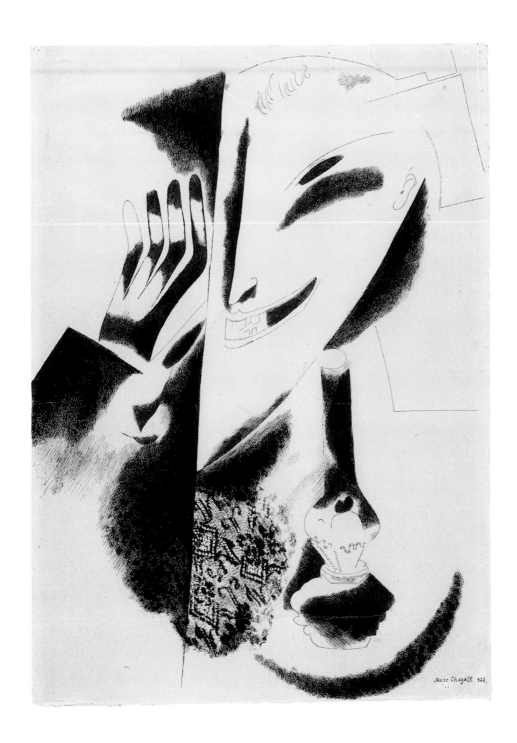

56

MAN WITH LAMP 1921

ink on paper

18 ⅛ x 13 in. (46 x 33 cm)

Centre Georges Pompidou, Paris, Musée national d'art moderne/

Centre de création industrielle, dation 1988

COLLAGE Although Chagall was acutely engaged with abstract art, he usually incorporated abstraction in a manner that modified, questioned, or even undermined its significance. Especially after his falling out with Kazimir Malevich, Chagall's regular insistence on figuration and narrative signified dissent from Suprematism. This ambivalence is especially notable in *Love on the Stage* (1920; pl. 33), one of the decorative panels executed for the State Jewish Chamber Theater. The composition borrows from Suprematism and, to a lesser extent, from Cubism, revealing Chagall's aptitude for using formal conventions being developed in Russia at the time. However, the artist superimposes a dancing couple in the otherwise abstract field, proclaiming, yet again, his inability to renounce figuration.

A similar dynamic is evident in this collage, made one year after the Jewish Theater panels. At first glance, this work seems to be a purely abstract undertaking, reminiscent of work by the Constructivist Aleksandr Rodchenko. Compared with Chagall's other work from this period, the collage appears to be a rather formal exercise. However, it is clearly charged with symbolic meaning: the fragment of printed paper is from an invitation to a 1921 exhibition of the artist's work (Chagall must have misdated the work to 1920), and the Hebrew inscription *TSEDEK* in the triangle at the top, which recalls a Jewish tombstone, means "justice." The work has proven to be something of an enigma; its precise meaning is unknown, but there is little doubt that Chagall was referring to a particular situation. In all, this collage is an elegant example of one of Chagall's rare "abstract" pieces.

57

COLLAGE 1921 (signed and dated 1920)
paper collage with ink
13 ⅜ x 11 in. (34.2 x 27.9 cm)
Centre Georges Pompidou, Paris, Musée national d'art moderne/
Centre de création industrielle, dation 1988

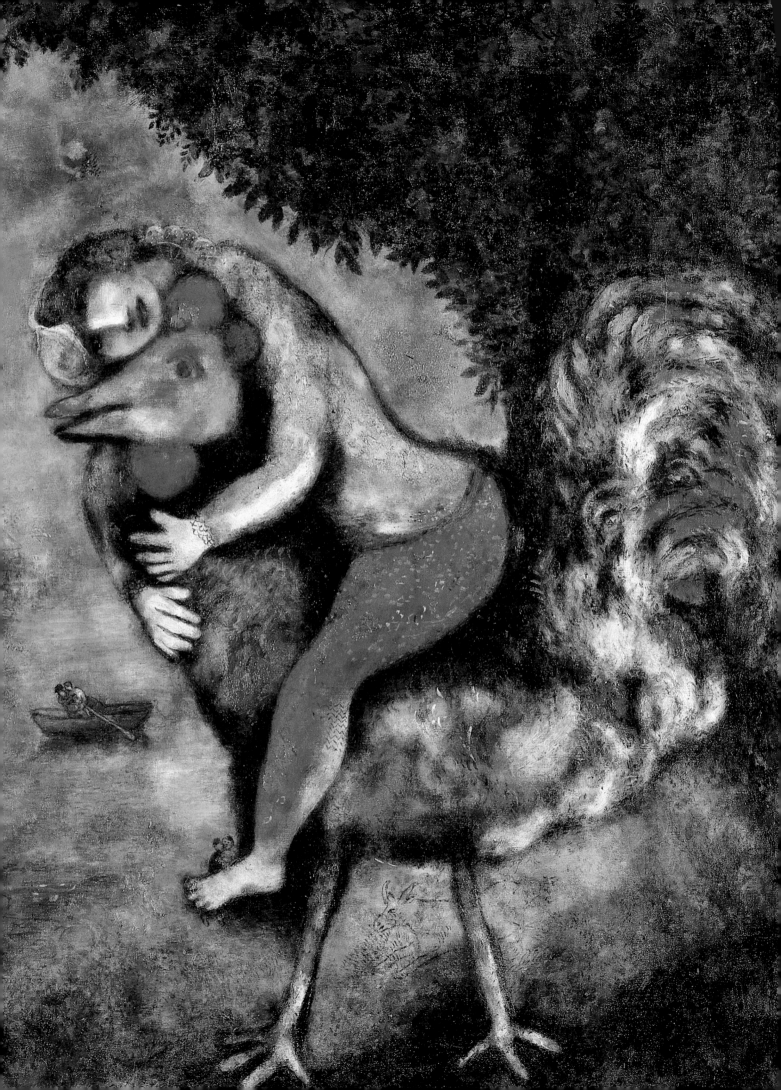

FRANCE
AMERICA
FRANCE

In 1922 Chagall decided to leave the Soviet Union. Unless they enjoyed the favors of power, artists living there faced a discouraging set of circumstances, and in the preceding two or three years Chagall's personal standing had been considerably reduced. In 1920, when he had executed his work for the State Jewish Chamber Theater in Moscow, Chagall thought he might have had some influence on the future of Soviet art. By 1922, however, he had no such illusions—Chagall was isolated, and his aesthetic message was not understood. Neither the avant-garde artists who were pioneering abstraction nor those establishing the official style of Socialist Realism could relate to his artistic concepts. Chagall's sales and commissions in his native land had become fewer and fewer.

On the other hand, Chagall was quite well known in Berlin. The paintings left in Germany before World War I helped to make his reputation, and the magazine *Der Sturm* regularly published reproductions of Chagall's works (more than twenty-five between 1917 and 1922) and even devoted a special issue to the artist. The local artistic community was also interested in Chagall: Kurt Schwitters dedicated a poem to him, Max Ernst professed his profound admiration in the pages of *Der Sturm*, and several artists had begun to imitate his style. So in the summer of 1922 the artist left for a year's stay in Berlin, where he devoted himself to producing engravings for his autobiography, *My Life*, before settling in Paris in September 1923.

From this point there is a marked change in Chagall's art. The artist's stylistic break with his past work was so pronounced that many critics and curators came to favor the output of his "Russian years." This preference tended to imply that Chagall's move to France brought about a decline in his art, which by 1924 would become "academic." It is true that the artist's work changed upon his arrival in France—it seems to become softer, to lose its wild side. The frequency of subjects such as flowers, loving couples, and tranquil landscapes reinforced the impression that his painting was becoming dull. Yet flowers, lovers, and landscapes had appeared in Chagall's work even during the Russian years; his choice of subjects is thus not so much a diminishment of taste as a redistribution of priorities. Upon moving to France, Chagall set out to learn about his adopted country, its land, and its culture by executing numerous landscapes, illustrating the *Fables* of La Fontaine, and painting floral scenes, thus inserting himself into a rich artistic tradition that included practitioners such as Auguste Renoir, Pierre Bonnard, and Edouard Vuillard. This turn in Chagall's work was nothing less than an attempt at cultural assimilation through the act of painting. Over the course of several years, this strategy would lead him to prioritize subjects that, in the eyes of his contemporaries, seemed academic or reactionary. It was not Chagall's work that had changed, but rather the regard in which it was held by his fellow artists.

Chagall stood at the margins of the art world for at least two reasons: as an immigrant painter, he sought to be surrounded by a French milieu that was more bourgeois than revolutionary and, with pride and independence of spirit, he wished to develop his oeuvre alone and influence others with his aesthetic ideas. The latter is the most important point in assessing the evolution of his work. Three times Chagall would refuse to adhere to an avant-garde movement: in 1912 he did not become a Cubist; in 1919, though close to Kazimir Malevich and El Lissitzky, he did not become a Suprematist or a proponent of abstraction; and in 1924, when Max Ernst and Paul Eluard proposed that he join the Surrealists, he declined to do so. Compared to what was considered modern in twentieth-century art, Chagall's aesthetic deviations were considerable. Yet they did not spring from his ignorance of artistic developments, but from his will to affirm his own identity and autonomy.

To survive the art world of the 1920s and 1930s, he chose a strategy of partial identification rather than total allegiance to a given movement. Thus he established a paradoxical relationship—one might say a negative dialectic—with the artistic orthodoxy of his time, creating works that seemed to agree with its tenets while evidencing unconventional elements. Such an attitude can be understood as intrinsic to Chagall's Jewishness. His response to the pressure of stylistic conformity was an individual one. In his art it may be seen as an affirmation of his identity, but its context is social, linked to his experience as a Jew in a Christian society. The question of identity—the anxiety with regard to the subject—is common to both Jewish life and modernity. Indeed, according to the critic Harold Rosenberg, it is the "most serious theme of Jewish life" and the "metaphysical theme" of modern art.[1]

If Chagall was unique, it was precisely because he refused to abandon the broad spheres of experience that modern art had renounced, and because he put the figure of the artist at the center of his visual explorations. Modernity had freed artists from the constraints of socially imposed themes, positing individual subjectivity as art's only true motivation. Chagall used this freedom to produce allegorical or narrative paintings, genres considered reactionary in his day. He created illustrations for unfashionable texts such as the *Fables* of La Fontaine and the Bible, even though they were rarely read anymore, and he executed floral still lifes at a time when nobody dared to paint them. Regardless of subject, at the heart of all of his work is the figure of the artist—the painter whose palette is the picture's origin. Between his affirmation of the artist's messianic role and his appropriation of multiple fields of experience, by 1924 Chagall had begun to construct an original pictorial universe almost entirely at odds with the art of his time.

NOTE

1 Harold Rosenberg, "Is There a Jewish Art?" in *Discovering the Present: Three Decades in Art, Culture, and Politics* (Chicago: University of Chicago Press, 1973), 230.

58

MEMORY 1925
watercolor and gouache on paper
18 ¾ x 24 ¾ in. (47.7 x 62.8 cm)
Courtesy Galerie Boulakia, Paris

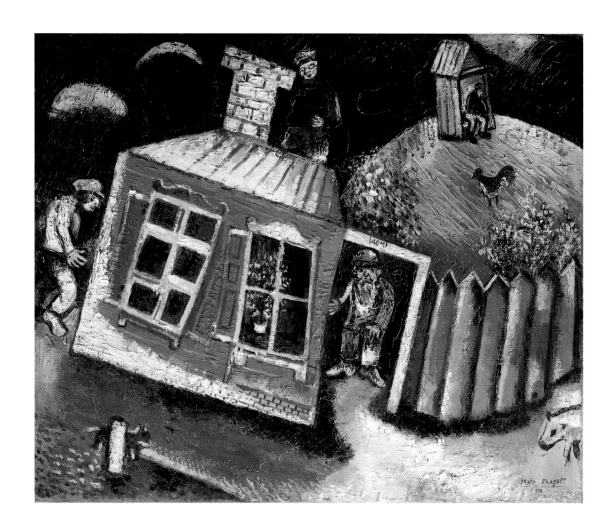

THE LITTLE RED HOUSES 1922
oil on canvas
31 ½ x 35 ⅜ in. (80 x 90 cm)
Private collection, courtesy Libby Howie, London

MONTCHAUVET 1925
oil and gouache on paper mounted on canvas
19 7/8 x 19 3/8 in. (50.5 x 49 cm)
Private collection, France

L'ISLE-ADAM LANDSCAPE 1925
oil on canvas
39 ⅝ x 28 ¾ in. (100.7 x 73 cm)
Private collection, Paris

62

THE PAINTING ANGEL 1927–28
watercolor, gouache, and pencil on paper
26 ⅛ x 20 ⅜ in. (66.3 x 51.6 cm)
Musée National Message Biblique Marc Chagall, Nice

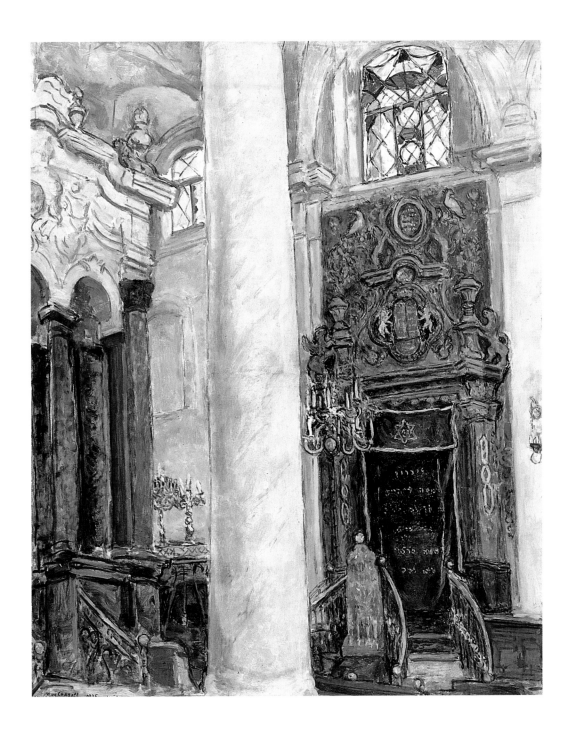

63

IN THE VILNA SYNAGOGUE 1935
oil on canvas
32 ⅝ x 25 ⅞ in. (83 x 65.5 cm)
Private collection, Paris

THE FABLES OF LA FONTAINE Chagall's first stay in Paris, in 1911, was for the purpose of study. Just as Rome had been a pilgrimage site for his artistic predecessors, Paris had become a mandatory destination for his contemporaries. His second stay, in 1923, had nothing to do with his education as an artist: it was an immigration. Installed in Paris with the intention of staying there, Chagall found himself in the position of needing to assimilate to a new culture. He therefore set about getting to know France, something he hadn't done during his first visit. He went about this in two ways: by looking at the French countryside and interpreting what he saw through his painting, and by illustrating the work of Jean de La Fontaine, a classic author of the French literary canon.

In many ways the *Fables* were merely a starting point for Chagall: the gouaches are not literal illustrations of the stories. The artist sought out aspects of French culture that appealed to him personally. La Fontaine made animals speak, and Chagall liked to paint them—they simply had to come together. The gouaches for the *Fables* are part of an extensive body of work—spanning 1911 to 1985—that addresses the subject of animals. Chagall would be the only major painter of the twentieth century to explore the relationship between human beings and animals in such a persistent (and humorous) way.

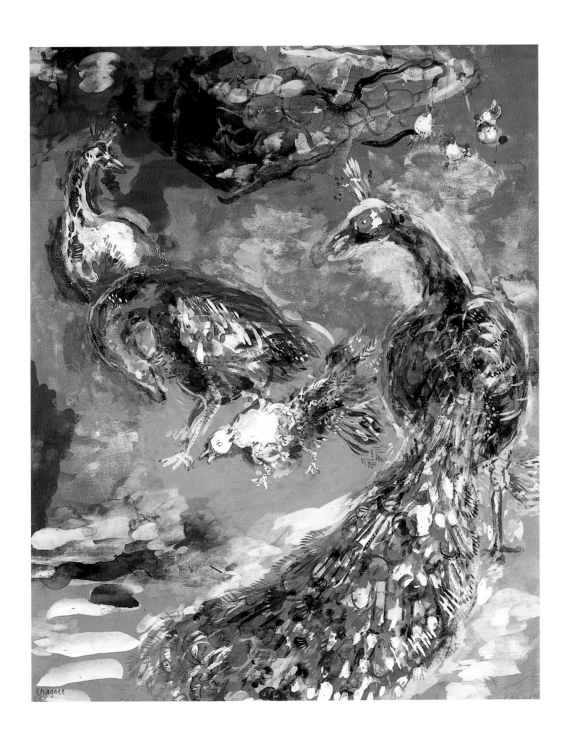

THE JAY ADORNED IN PEACOCK'S FEATHERS

64

1927

watercolor and gouache on paper

20 ⅛ x 16 ⅛ in. (51 x 41 cm)

Collection of Larock-Granoff, Paris

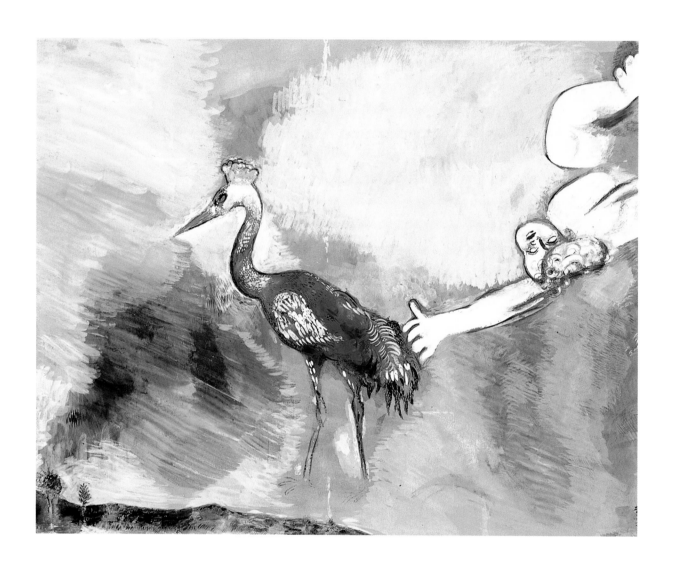

65

THE FROGS WHO ASK FOR A KING 1929
gouache on paper
16 ⅜ x 20 ¼ in. (41.5 x 51.5 cm)
Private collection, Paris

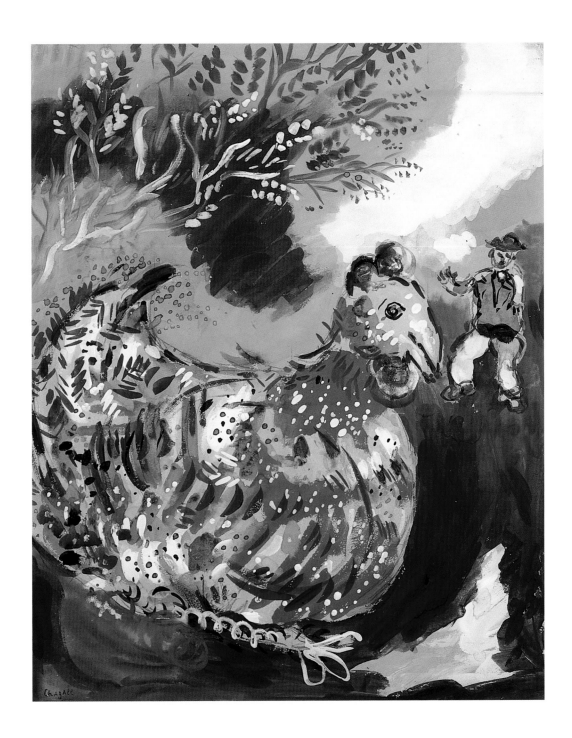

66

THE HEN WITH THE GOLDEN EGGS 1927
gouache and pencil on paper
20 ⅛ x 16 ⅜ in. (51.1 x 41.5 cm)
Private collection—Charles-Henri Sabet

67

THE FOX AND THE GRAPES 1926

watercolor and gouache on paper

19 ⅝ x 15 ¾ in. (50 x 40 cm)

Collection of Larock-Granoff, Paris

68

THE CAT AND THE TWO SPARROWS 1925–26

watercolor and gouache on paper

20 ⅛ x 16 ⅛ in. (51 x 41 cm)

Collection of Larock-Granoff, Paris

69

THE FOX WHO LOST HIS TAIL 1927
watercolor and gouache on paper
19 ⅜ x 16 ⅜ in. (49 x 41.5 cm)
Collection of Larock-Granoff, Paris

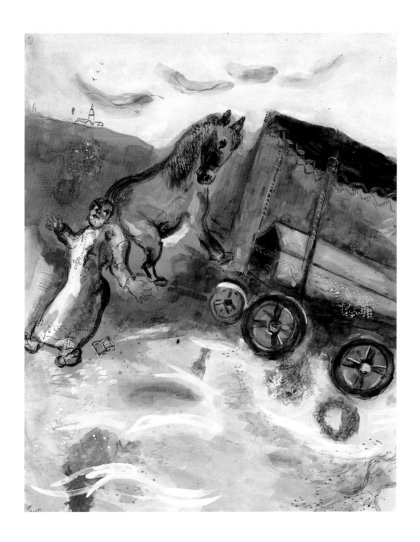

70

THE PRIEST AND THE DEAD MAN ca. 1926

gouache on paper

19 ⅝ x 15 ¾ in. (50 x 40 cm)

Musée d'art moderne de la Ville de Paris

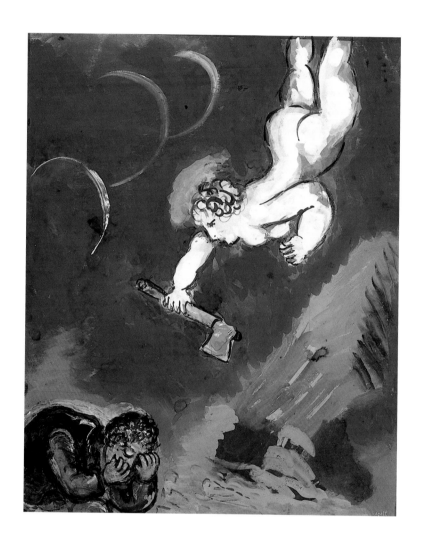

71

THE WOODCUTTER AND MERCURY 1926

gouache on paper

20 ¼ x 16 ¼ in. (51.4 x 41.2 cm)

Private collection, Paris

CLOWN WITH DONKEY Before Chagall finished his *Fables* cycle, the publisher and art dealer Ambroise Vollard asked him to create illustrations for a circus that never actually came into being. Between 1927 and 1928 the artist painted nineteen gouaches, titled *The Vollard Circus* to distinguish them from later circus-themed works.

Vollard had a box at the Cirque d'Hiver Bouglione that he generously shared with the artists who worked for him, including Fernand Léger, Pablo Picasso, and Chagall. Chagall's experiences there inspired memories of his childhood fascination with traveling acrobatic troupes. Hasidism, the faith in which he was raised, preaches joy and considers dance and music to be forms of prayer. For Chagall, the acrobat and the violinist—characters present in his work throughout his career—were thus inseparable from the ceremonies and family gatherings of Jewish life. For instance, in *Introduction to the Jewish Theater* (1920; pl. 34), his monumental panel for the State Jewish Chamber Theater, acrobats and musicians perform a spectacle that fuses theater and ritual.

Chagall gave his imagination free rein in his circus gouaches, even more so than in his illustrations for the *Fables*. Departing from the descriptive character of his French landscapes or Russian scenes, the artist infused the circus images with a novel surreal quality. In one example, Chagall's beloved Eiffel Tower—complete with legs—rides upon a donkey's back. *Clown with Donkey* turns the tables even more dramatically: it's the donkey that rides the clown. Although Chagall never shared the Surrealists' predilection for automatism, the circus gouaches enabled him to record his crazy ideas, the funny or fantastic notions that simply popped into his head.

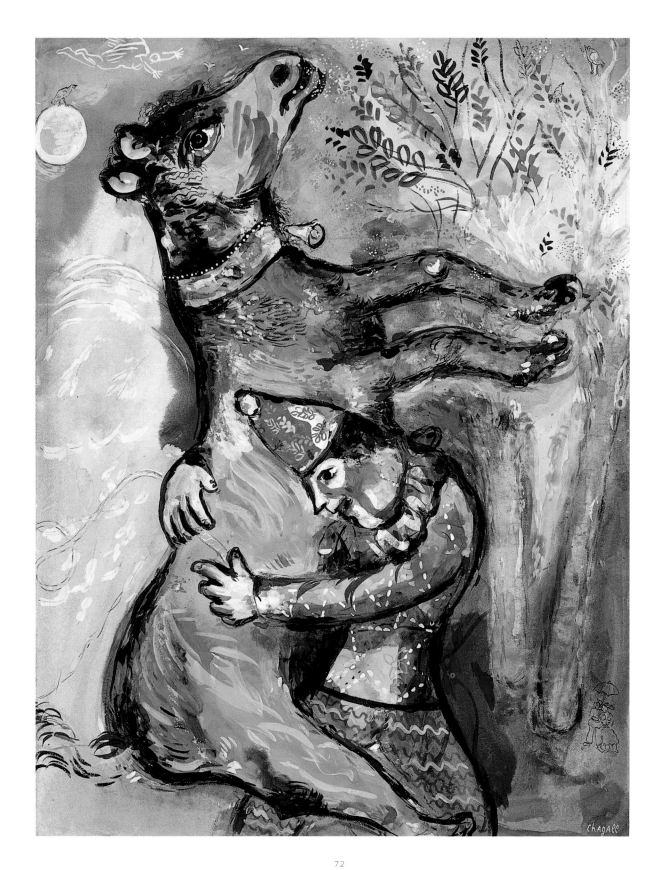

72

CLOWN WITH DONKEY 1927
gouache on paper
24 ⅝ x 19 ⅛ in. (62.5 x 48.5 cm)
Private collection

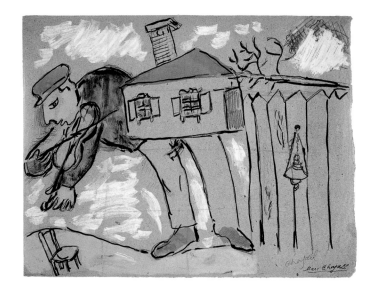

73

CHARLIE CHAPLIN 1925
india ink and ink on paper
10 ¼ x 7 ¾ in. (26 x 19.7 cm)
Private collection, Paris

74

THE VIOLINIST 1926–27
ink, gouache, and pencil on parcel paper
10 ⅞ x 14 ⅜ in. (27.8 x 36.6 cm)
Centre Georges Pompidou, Paris, Musée national d'art moderne/
Centre de création industrielle, dation 1988

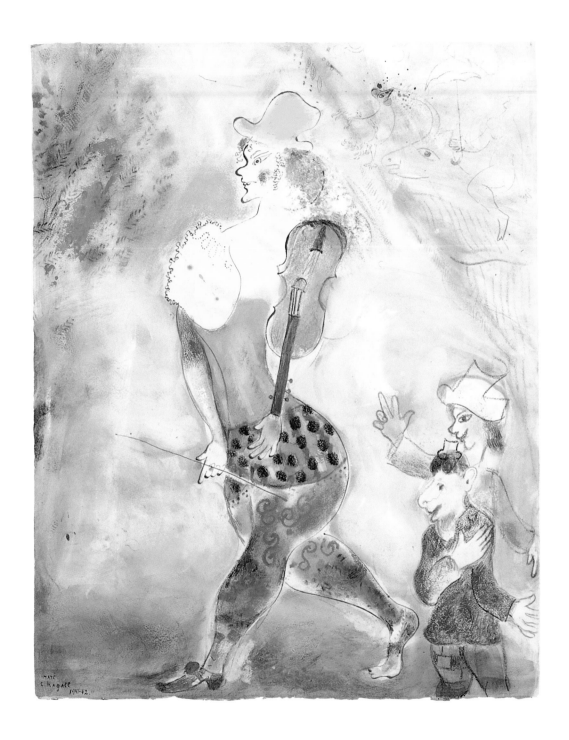

75

CLOWN PLAYING THE VIOLIN 1941–42
watercolor, pastel, and pencil on paper
24 ⅜ x 19 ⅜ in. (61.9 x 49 cm)
Private collection, Paris

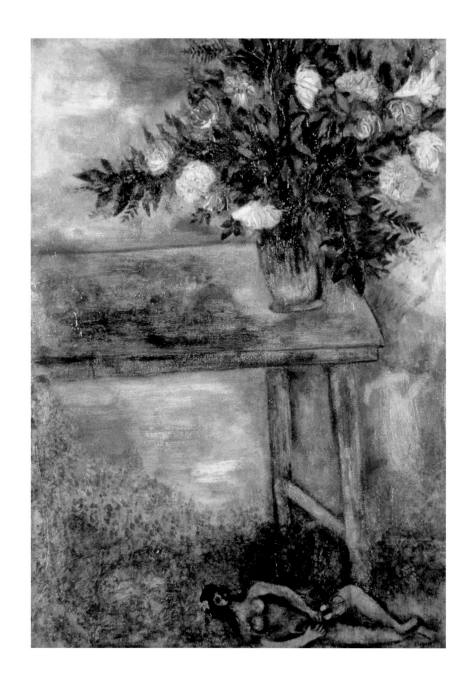

NUDE UNDER THE TABLE 1927–28
oil on canvas
33 ⅜ x 22 ⅞ in. (85 x 58 cm)
Collection of Larock-Granoff, Paris

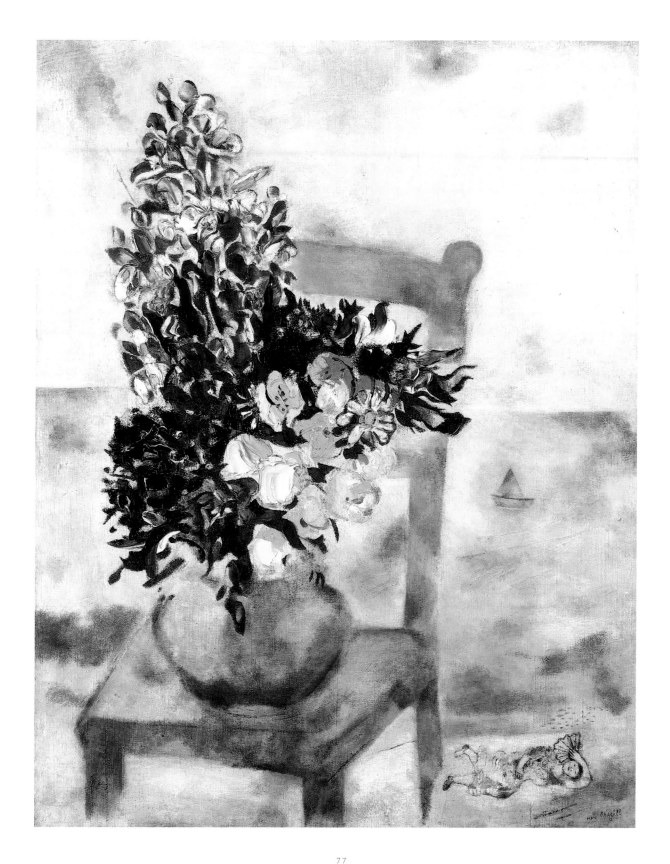

77

FLOWERS ON A CHAIR, MOURILLON 1926
oil on canvas
36 x 28 ¾ in. (91.5 x 73 cm)
Collection of Richard Nathanson, London

BELLA WITH CARNATION This portrait's immediately perceptible classicism makes it characteristic of Chagall's work from the 1920s. The traditional composition—reinforced by the austerity of Bella's voluminous black costume and large white collar—is reminiscent of an earlier Chagall canvas titled *Self-Portrait with Paintbrushes* (1910). At the time the artist painted the self-portrait, Bella—to whom Chagall had just become engaged—was introducing him to classical painting, and in particular the art of the Renaissance. Both works suggest the extent of his interest in historical forms: the figures' busts dominate the foreground, treated almost as pedestals for the heads. However, the early self-portrait's naive style, which clearly denotes the work of a novice painter, has here been replaced by a clear sense of the artist's mastery of the medium. Although Bella's solemn expression contributes to the canvas's overall severity, the richly nuanced red background gives it a more contemporary edge, while the discreet echo of red at the heart of the carnation helps to balance the composition.

Chagall's quotation of Renaissance sources reflects a larger cultural tendency in Europe during the 1920s. During World War I, artists and intellectuals violently rejected the idea of a civilization capable of producing the horrors of modern trench warfare, a rejection that found its apogee in the Dada movement. But very quickly, like a kind of pendulum, art began to revisit traditional genres, as exemplified by Pablo Picasso and André Derain's explorations of classical style. This "return to order" was characterized, as it is in Chagall's portrait of Bella, by symmetrical compositions, the renewed primacy of drawing, and a uniform and naturalistic style of execution.

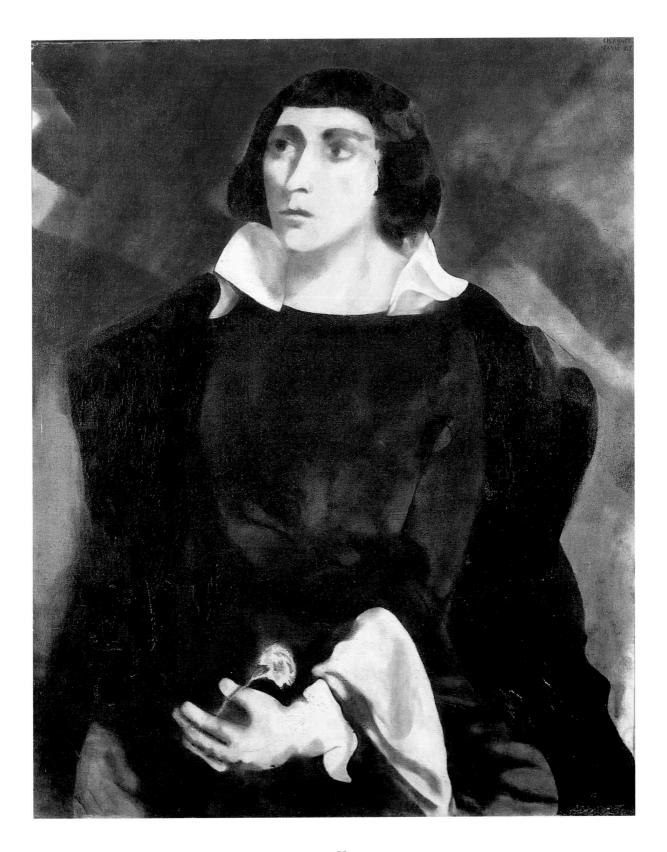

78

BELLA WITH CARNATION 1925
oil on canvas
39 ⅜ x 31 ½ in. (100 x 80 cm)
Private collection, Paris

NUDE ABOVE VITEBSK From his earliest work Chagall composed paintings by assembling collagelike
groups of assorted figures. Several compositions from the 1920s feature men and women floating in the
sky above Vitebsk, a formal motif—undoubtedly inspired by Russian popular imagery, particularly signboards—
that the artist revisited throughout his career. In this canvas, the nude above the city is treated in a manner
that owes much to French neoclassicism of the early 1920s. Had Chagall not placed the figure arbitrarily on the
horizon, the smooth handling of the paint and the quality of the modeling would have suggested an academic
exercise in rendering the female nude.

 The composition's arbitrariness is merely illusory, however, and the work's surrealistic aspect (one
cannot help but think of Man Ray's 1934 painting *Observatory Time—The Lovers*) is superficial and incidental.
Once again, Chagall employs the strategy of an avant-garde movement not to endorse that movement, but rather
to speak about himself. He portrays the village of Vitebsk and his wife's nude body with total equality: each
takes up half of the composition. Vitebsk, on the bottom, implies the artist's past; Bella, on the top, represents the
present. The vase of flowers isolated in the lower left corner of the painting, its colors blazing against the
gray background, may be read as a symbol for Chagall—a sort of signature. Indeed, in other paintings dating from
his first years in France, Chagall uses floral arrangements almost as substitute self-portraits. In *Flowers on a
Chair, Mourillon* (1926; pl. 77), for instance, the flowers stand in for the artist himself, just as elsewhere Chagall
uses clowns, acrobats, or musicians in a self-reflexive manner. The artist's tendency to undermine traditional
representation via discrepancies in scale or incongruous juxtapositions does not spring, therefore, from a desire
to deconstruct the work or to liberate the imagination or unconscious; instead it denotes an emotional logic
that plays with perspective, likeness, and reason. With Chagall, sentiment invents its own codes of representation.

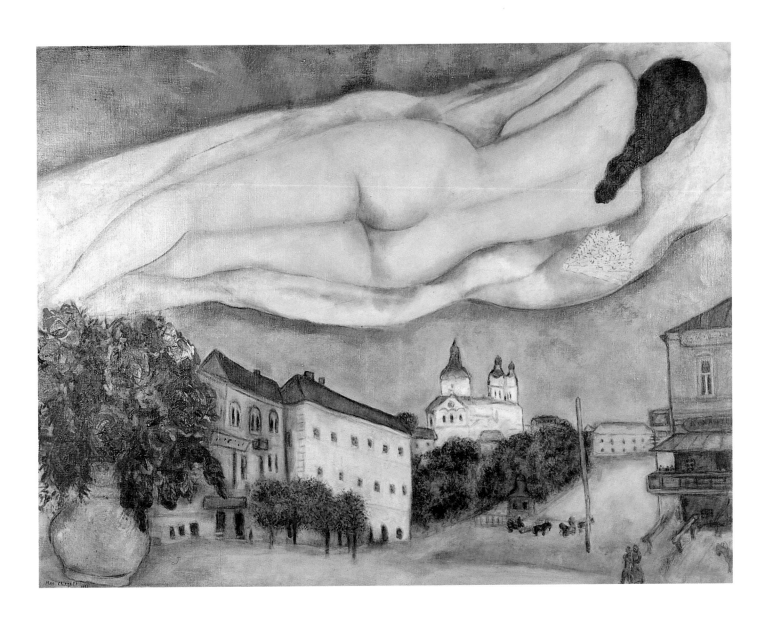

79

NUDE ABOVE VITEBSK 1933
oil on canvas
34 ¼ x 44 ½ in. (87 x 113 cm)
Private collection, Paris

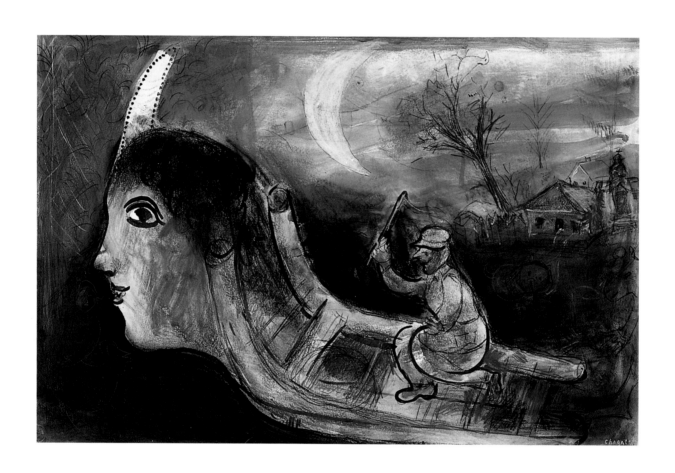

80

THE SLEIGH 1943
gouache on paper
20 ⅛ x 30 ⅝ in. (51 x 78 cm)
Private collection

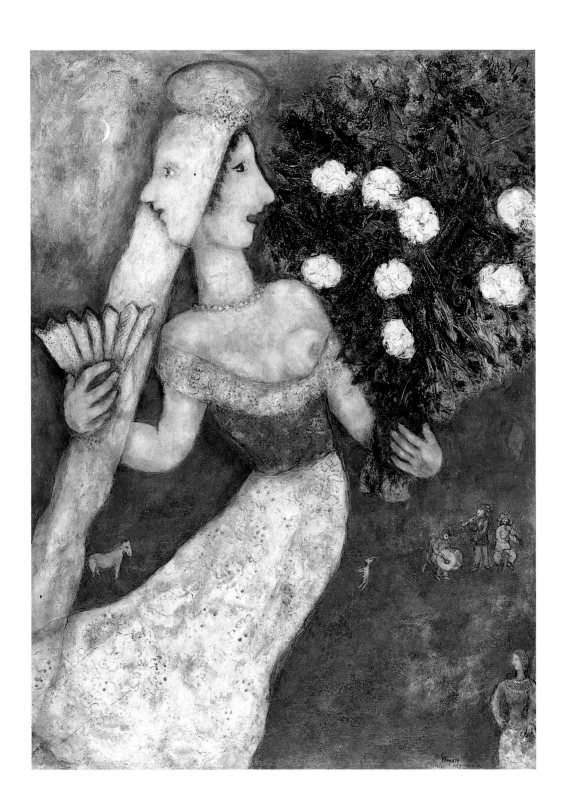

THE BRIDE WITH THE DOUBLE FACE 1927
oil on canvas
39 x 28 ⅜ in. (99 x 72 cm)
Private collection, Paris

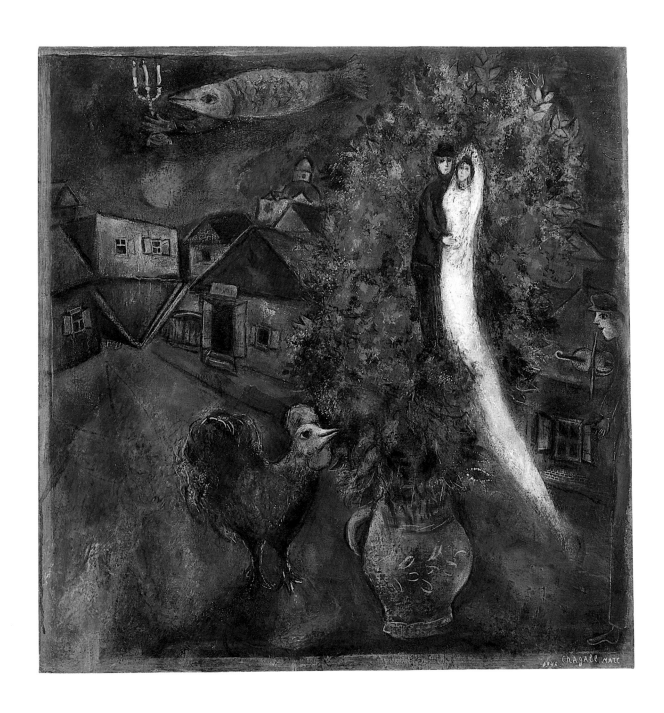

THE FLYING FISH 1948
oil on canvas
26 x 25 ½ in. (66 x 64.8 cm)
Albright-Knox Art Gallery, Buffalo, New York, Room of Contemporary
Art Fund, 1949

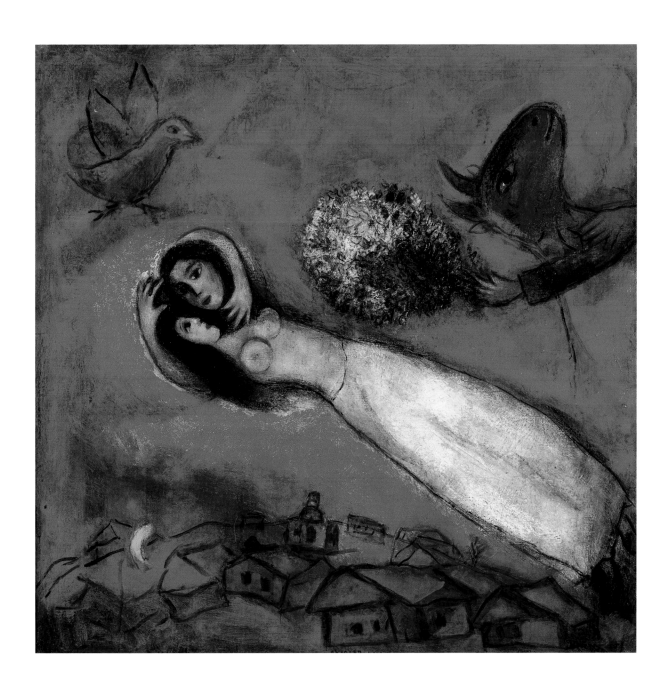

83

LOVERS IN THE RED SKY 1950
oil on canvas
25 ⅝ x 26 ⅛ in. (65.1 x 66.4 cm)
San Francisco Museum of Modern Art, gift of Wilbur D. May

MIDSUMMER NIGHT'S DREAM Begun in 1930, this painting was not completed until 1939. Chagall borrowed the title from Shakespeare, and the work may depict two of the play's lovers, Titania and Bottom. Shakespeare's exploration of the irrational side of human nature was clearly appealing to Chagall; it allowed him, once again, to portray a hybrid creature, much as he had done in his earlier circus works and his illustrations for the *Fables* of La Fontaine.

With this canvas, Chagall revisits the archetypal theme of Beauty and the Beast, a subject he first investigated in 1911 with *Dedicated to My Fiancée.* Dominated by three strong verticals—the two figures and the flowering tree (perhaps the tree of life)—the composition is peculiarly static; the lovers, with their abstract gaze, seem to express a strange absence in their relationship. Even the colors of the paint, despite their great richness, fade upon contact with one another. The little red angel (or is it an imp?), the only dynamic component in the piece, is undoubtedly meant to invoke the idea of temptation, which contrasts strongly with the implied chastity of the bride in white. The painting's overall sense of distortion and absurdity is reminiscent of a number of works from the 1930s that brought Chagall closer to Surrealism.

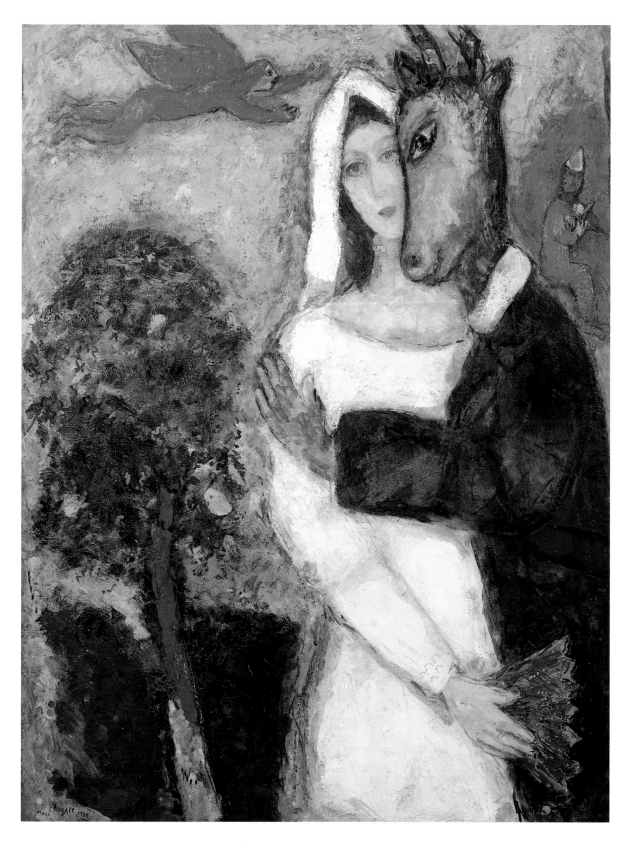

84

MIDSUMMER NIGHT'S DREAM 1939
oil on canvas
45 ⅞ x 35 ⅛ in. (116.5 x 89 cm)
Musée de Grenoble, gift of the artist, 1951

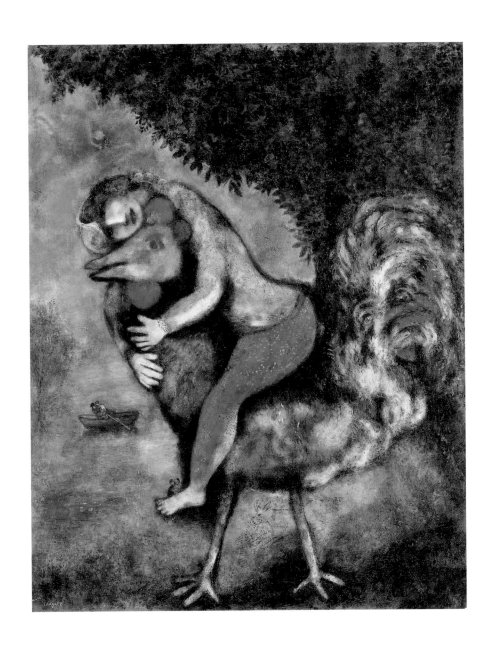

85

THE ROOSTER 1929
oil on canvas
31 ⅞ x 25 ⅞ in. (81 x 63 cm)
Museo Thyssen-Bornemisza, Madrid

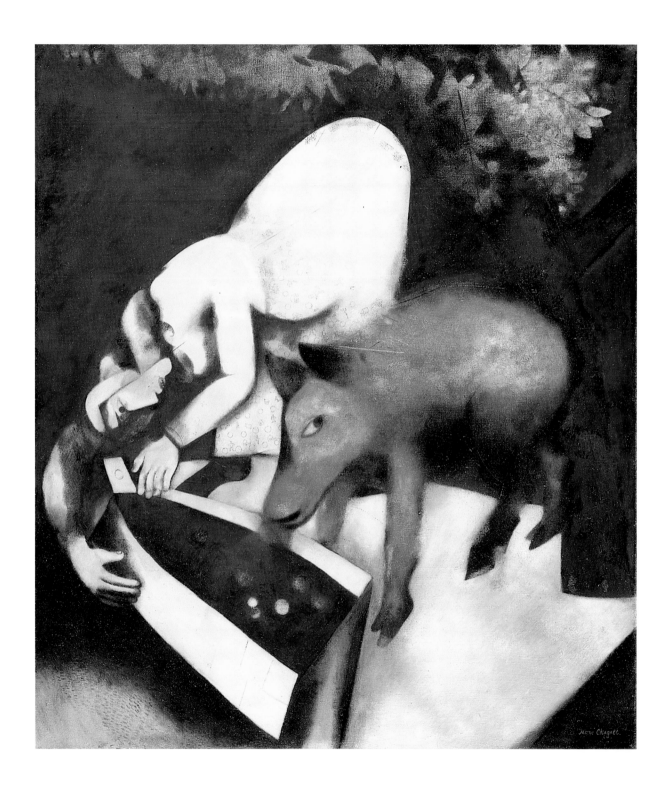

86

THE WATERING TROUGH ca. 1925

oil on canvas

39 ¼ x 34 ⅝ in. (99.7 x 88.1 cm)

Philadelphia Museum of Art, The Louis E. Stern Collection, 1963

TIME IS A RIVER WITHOUT BANKS This is perhaps the most surrealistic of Chagall's paintings. With its flying clock, winged fish, and enigmatic title, the piece is reminiscent of the work of René Magritte. However, the canvas's apparent disorder is in fact a form of organized chaos. Although the composition overturns the laws of perspective, abolishes all semblance of gravity, and disturbs natural order with the impossible appearance of a fish with wings, each element relates, in one way or another, to the artist's personal history.

If the protagonists of the painting seem familiar, it is because they appear in other Chagall works. The grandfather clock, which turned up for the first time in a 1914 painting, recurs throughout his oeuvre (see, for example, *The Fall of the Angel* [1923–47; pl. 92] and *The Black Glove* [1923–48; pl. 100]). *Time Is a River without Banks* marks one of the first manifestations of the fish, but the motif will return in *The Flying Fish* (1948; pl. 82), among other works. The landscape is obviously that of the omnipresent Vitebsk, which suggests that the artist used the fish and the clock as vehicles for recording memories of his youth.

The painting's charm, however, comes from the impression that it is not just an accumulation of childhood symbols. Juxtaposition and displacement, operating in the same way as in dreams, seem the true organizing principles behind this confluence of images. It is as if Chagall composed the work in a kind of trance, which allowed him to materialize his dreams through his painting.

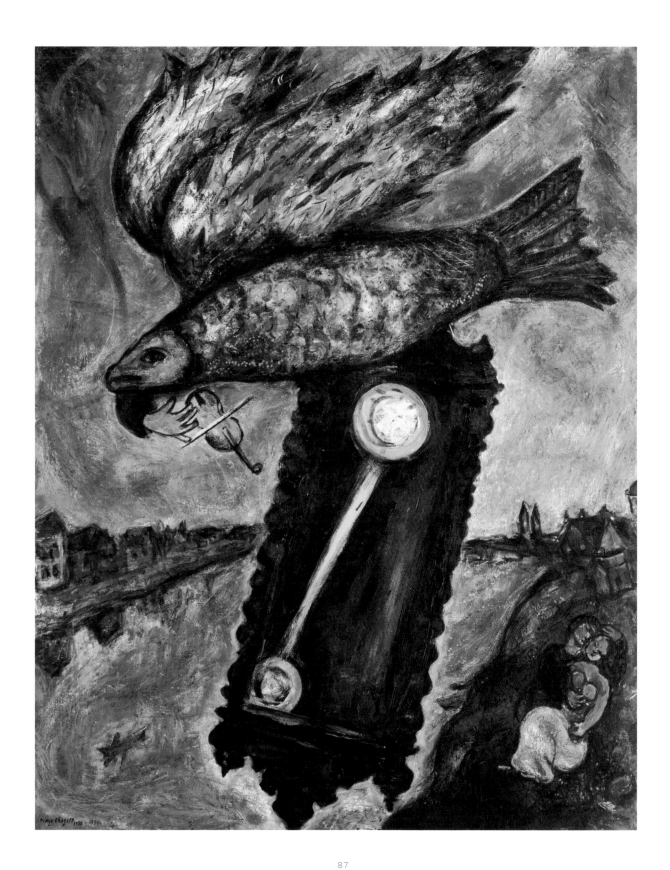

87

TIME IS A RIVER WITHOUT BANKS 1930–39
oil on canvas
39 ⅜ x 32 in. (100 x 81.3 cm)
The Museum of Modern Art, New York, given anonymously, 1943

88

THE GREEN EYE 1944
oil on canvas
22 ⅞ x 20 ⅛ in. (58 x 51 cm)
Private collection, Paris

89

THE ESCAPE: ROOSTER AND GOAT ABOVE THE VILLAGE 1962
gouache and ink on paper
29 x 22 ⅛ in. (73.7 x 56.2 cm)
Private collection, Paris

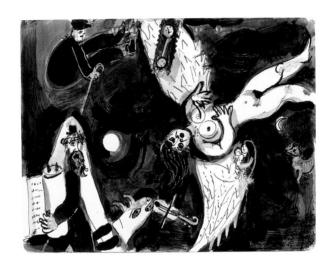

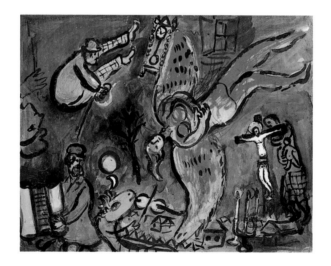

90

STUDY FOR THE FALL OF THE ANGEL 1934
india ink and gouache on paper
9 ⅝ x 12 ⅝ in. (24.5 x 31.9 cm)
Private collection, Paris

91

STUDY FOR THE FALL OF THE ANGEL 1934
oil and india ink on board
19 ½ x 24 ⅜ in. (49.5 x 63 cm)
Private collection, Paris

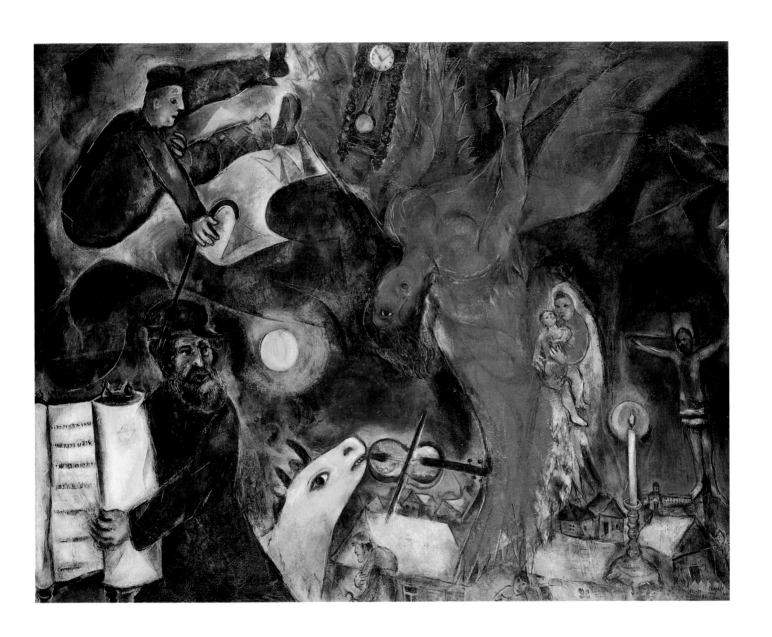

92

THE FALL OF THE ANGEL 1923–47

oil on canvas

58 ¼ x 65 ⅜ in. (148 x 166 cm)

Private collection, permanent loan to the Öffentliche Kunstsammlung Basel

RESISTANCE, RESURRECTION, LIBERATION The source of these three paintings was a single large-scale work titled *Revolution,* which Chagall began in 1937 and divided into a triptych in 1943, during his American exile. The artist had originally conceived the work, which was oriented horizontally, in anticipation of the twentieth anniversary of the Russian Revolution. In the finished triptych, the homage to the Revolution is quite ambiguous, tempered by the artist's increasing concerns about anti-Semitism, which peaked during his 1935 trip to Poland. Chagall's earlier experiences of communism also bore associations with anti-Semitism. In the 1920s—especially in 1921, the year in which Lenin introduced the New Economic Policy, an emergency fiscal program that temporarily restored the capitalist market system; and in 1922, when the artist decided to leave the Soviet Union—he had witnessed both the resurgence of anti-Semitism and the transformation of art in the service of political objectives.

In 1943, under the pressure of the Nazi occupation, Chagall left France to take refuge in New York. The anguish of World War II and its repercussions on Jews who remained in Europe—particularly those in the area of Vitebsk, who were hard hit by Germany's aggression toward Russia—instigated a dramatic change in his work. The artist's palette, subjects, and compositions took on an overtly tragic tone. Jesus, as a sacrificed Jew and a symbol of humanity's suffering, became a virtual obsession for Chagall; his portrayal enabled the artist to bear witness to the persecution of the Jews and to express his compassion.

The blood-red background of *Resistance* (1937–48; pl. 93) emphasizes the calamity of war. A violent fire devastates a Russian village, plunging the town into darkness. Near the bottom of the canvas floats a grandfather clock, a symbol of the family hearth. A distraught crowd flees in disarray, making a desperate escape. Echoing the crimson sky of *Resistance, Resurrection* (1937–48; pl. 94) expresses bitter disappointment in the aftermath of revolution. While a figure in the upper left corner raises a light above the crowd, celebrating the onset of freedom, the foreground tells a more tragic tale. Beside the cross, on a pale background of snow, a man clutches the Torah while a woman, fleeing with her child, extends her arm toward Jesus. The work suggests that the persecution of the Jewish people will continue, and that the only hope lies in divine and human love. The luminous figure of Jesus dominates both paintings, and the stylized, rounded form of his belly prefigures the central compositional motif of the final canvas, *Liberation* (1937–53; pl. 95). This work captures the flavor of life in Chagall's native Vitebsk: recollections of the family home, Sabbath and wedding celebrations, clowns, and a violinist revolve gently around a radiant yellow target with a vivid red heart. Throughout the triptych, the flame represents humanity's aspiration to freedom and divine love; in the final work, this takes the form of the menorah of Jewish festivals.

The paintings' large geometrical forms, intensified by Chagall's color choices, are indisputable references to the formal language of Suprematism. In the first two works, the compositions' dynamic obliques emphasize a sense of violence, while the conspicuous yellow circle punctuates the serenity of *Liberation.* Chagall carried certain forms, colors, and themes from one canvas to the next, demonstrating his determination to make the paintings function as a single work.

Chagall, palette in hand, makes appearances in all three paintings. In *Resistance* he lies prostrate in the foreground, as if struck by an apocalyptic vision. In *Resurrection* he hangs upside down beside Jesus' legs, as if crucified by the suffering he perceives. In *Liberation* he is shown at the easel, re-creating a vanished world. Through his presence in this monumental triptych, which blends historic events with personal history, he declares the triumph of painting over death.

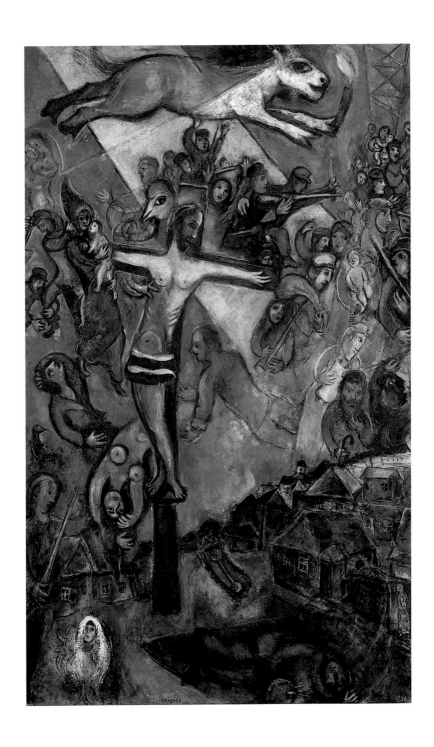

93

RESISTANCE 1937–48
oil on canvas
66 ⅛ x 40 ⅝ in. (168 x 103 cm)
Centre Georges Pompidou, Paris, Musée national d'art moderne/
Centre de création industrielle, dation 1988, on loan to the Musée
National Message Biblique Marc Chagall, Nice

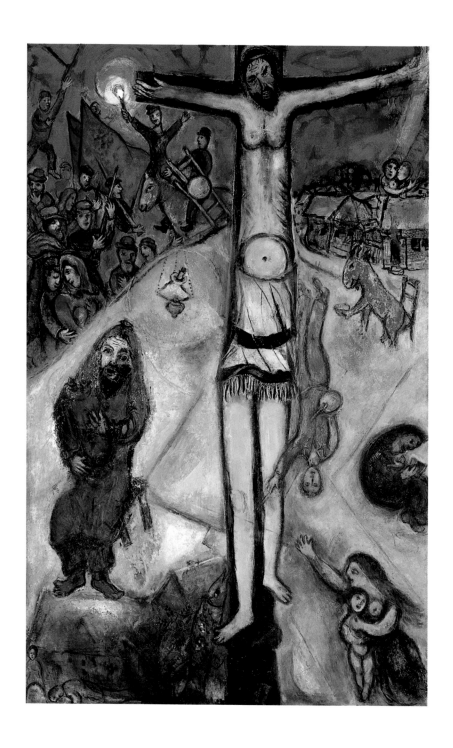

94

RESURRECTION 1937–48
oil on canvas
66 ¼ x 42 ⅜ in. (168.3 x 107.7 cm)
Centre Georges Pompidou, Paris, Musée national d'art moderne/
Centre de création industrielle, dation 1988, on loan to the Musée
National Message Biblique Marc Chagall, Nice

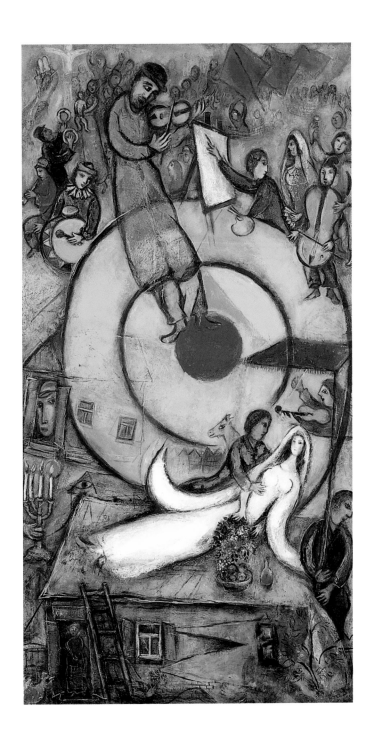

95

LIBERATION 1937–53
oil on canvas
66 ⅛ x 34 ⅝ in. (168 x 88 cm)
Centre Georges Pompidou, Paris, Musée national d'art moderne/
Centre de création industrielle, dation 1988, on loan to the Musée
National Message Biblique Marc Chagall, Nice

96

MEXICAN CRUCIFIXION 1945
pastel and gouache on paper
22 ³⁄₈ x 20 ⁵⁄₈ in. (57 x 52.4 cm)
Private collection

97

AROUND HER 1945
oil on canvas
51 ⅝ x 43 ⅛ in. (131 x 109.5 cm)
Centre Georges Pompidou, Paris, Musée national d'art moderne/
Centre de création industrielle, gift of the artist, 1953

WHITE CRUCIFIXION Chagall approached the theme of the Crucifixion for the first time in 1912 with *Calvary* (pl. 1), and for many years the painting remained an exception within his oeuvre. He returned to the subject in 1938 with *White Crucifixion,* a monumental composition in which numerous scenes are arranged around the central figure of Jesus on the cross. As in *Calvary,* Chagall refers to tradition and then gives it a new direction. While the composition borrows its central motif from traditional Christian iconography, it is hardly a Christian work. The episodes that surround the Crucifixion, though organized in a manner resembling Catholic ex-votos, relate to events from Jewish history: the destruction of the temple, the burning of the scrolls, the lamentation of the elders. Likewise, Chagall identifies the figures populating the work as Jewish, from the man at the lower left who wears a ritual garment known as the *arba kanfot* to the central figure of Jesus. As in Christian crucifixions, the Latin inscription *INRI* (an acronym meaning "Jesus of Nazareth, King of the Jews") appears above Jesus' head, but a Jewish prayer shawl takes the place of his loincloth and a menorah burns at the foot of the cross. In fact, the work is intended as a commentary upon Jewish reality in the late 1930s, when anti-Semitic fervor was sweeping across Europe.

As the art historian Franz Meyer has pointed out, what distinguishes this painting from traditional renderings of the Crucifixion is that Jesus is not the only one suffering. The work lacks any suggestion of redemption, a concept that lies at the heart of Catholic representations. For Chagall, notes Meyer, "suffering remains man's lasting fate.... It is not his divine but his human nature that Christ's suffering preserves." Other works in which Chagall explored the theme of the Crucifixion include *Mexican Crucifixion* (1945; pl. 96) and the triptych *Resistance, Resurrection, Liberation* (1937–53; pls. 93–95).

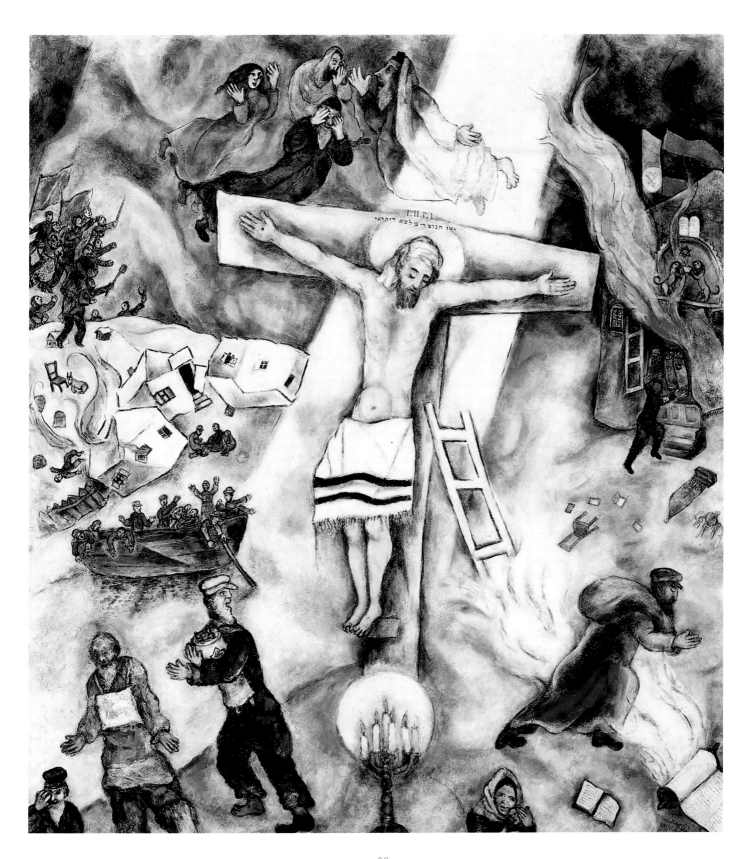

WHITE CRUCIFIXION 1938
oil on canvas
60 ¾ x 55 in. (154.3 x 139.7 cm)
The Art Institute of Chicago, gift of Alfred S. Alschuler

THE FLAYED OX

In [grandfather's] stable there is a cow with a large belly; she is standing up and staring stubbornly.

Grandfather goes up to her and talks to her as follows:

"Eh, listen here! Give me your legs. I'll have to tie you up. We need the goods, meat, you understand?"

She falls down with a sigh.

I stretch out my arms to caress her muzzle, to whisper a few words to her, that she mustn't worry, I'm not going to eat the meat; what more could I do?…

But the butcher, in white and black, knife in hand, is rolling up his sleeves. Scarcely does one hear the prayer when, pushing back her head, he plunges the steel into her throat.

Streams of blood.

Unmoved, dogs and chickens wait for a drop of blood, a bit of meat that may fall to the ground.

All one hears is their clucking, their rustling, and grandfather's sighs amid floods of fat and blood.

And you, little cow, naked and crucified, in heaven, you are dreaming. The glittering knife has borne you aloft.

Silence.

The intestines uncoil and pieces fall apart. The skin falls.

Pink pieces of flesh, reddened with blood, pour out. The steam rises.

What a profession in his hands!

—Marc Chagall, *My Life*

Chagall waited more than fifty years to record this childhood memory in his painting. By the 1930s the artist had made multiple works illustrating anecdotes from his autobiography, but he would produce only one iconic canvas on this particular theme. As the philosopher Élisabeth de Fontenay has noted of Chagall's artistic predecessors, "When Rembrandt and Soutine portray a flayed cow or a side of beef, they practice a form of humanism; through their painting they express piety toward those killed so that men might be nourished." Chagall's treatment of animal sacrifice, both in his memoirs and his painting, reveals a similar sentiment.

The religious dimension in Chagall's work abolishes any tendency to interpret *The Flayed Ox* as a still life. The *shochet,* the ritual slaughterer—who appears in the upper right corner wearing a *kippot,* slicing the air with his knife—is in fact a symbol of redemption. Chagall depicts him as a messianic figure emerging from the dark night, releasing childhood terrors that are inextricably linked with the devastating experiences of European Jews during the 1930s.

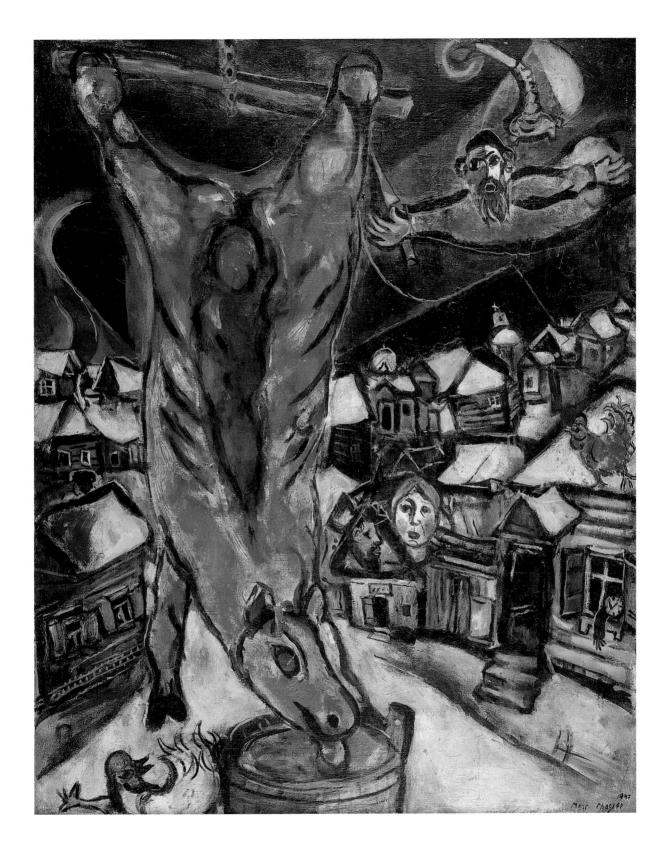

99

THE FLAYED OX 1947
oil on canvas
39 ⅜ x 31 ⅞ in. (100 x 81 cm)
Centre Georges Pompidou, Paris, Musée national d'art moderne/
Centre de création industrielle, dation 1997

100

THE BLACK GLOVE 1923–48
oil on canvas
43 ⅝ x 32 ⅛ in. (111 x 81.5 cm)
Private collection, Paris

101

BETWEEN DOG AND WOLF 1938–43
oil on canvas
39 ⅜ x 28 ¾ in. (100 x 73 cm)
Private collection, Paris

ANGEL WITH PALETTE Chagall's self-portraits offer an excellent indication of his aesthetic position. Indeed, he almost always portrayed himself with his palette in hand. From *Self-Portrait with Seven Fingers* (1912–13; fig. 1) to *Introduction to the Jewish Theater* (1920; pl. 34) and beyond, numerous artworks show him posing with the instruments of his trade. That the artist has a central presence in so many of his works attests that Chagall presented his oeuvre as a kind of autobiography.

Yet Chagall is also present—sometimes in the margins, sometimes in a more central way—in compositions where self-portraits are rather unexpected. In a painting with a biblical theme, for example, the artist's presence, however modest, serves to remind viewers that the work is intended to address artistic rather than religious concerns. Conversely, when he portrays an angel with a palette and gives the figure his own features, Chagall endows art with a new religious implication. In traditional Christian iconography, an angel might guide the hand of Saint Luke as he paints the Virgin, but the angel rarely takes up the brush. Asserting the artist's status as an envoy and divine messenger, even as a kind of prophet, this amendment testifies to the significance of art for Chagall: it is entertainment, a source of visual pleasure, but it can also have a spiritual function in society.

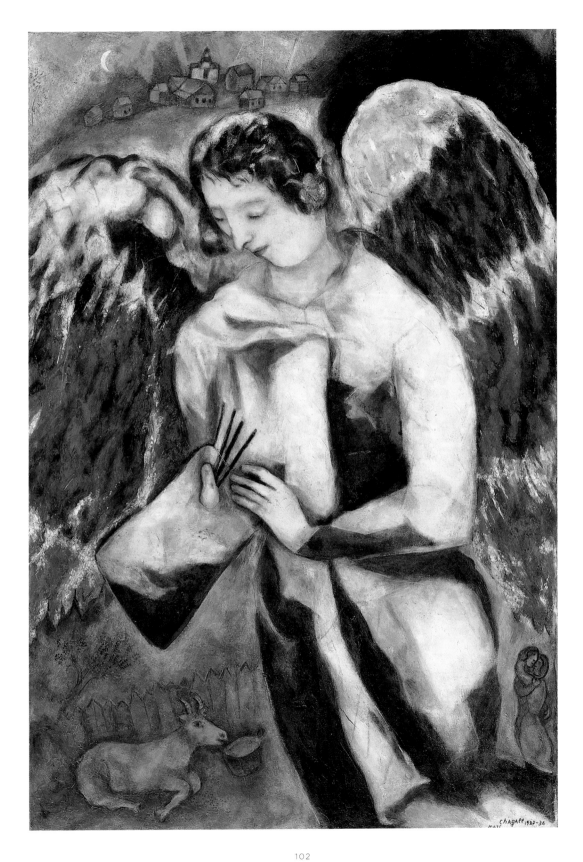

102

ANGEL WITH PALETTE 1927–36
oil on canvas
51 ¾ x 35 ⅜ in. (131.5 x 89.7 cm)
Centre Georges Pompidou, Paris, Musée national d'art moderne/
Centre de création industrielle, dation 1988

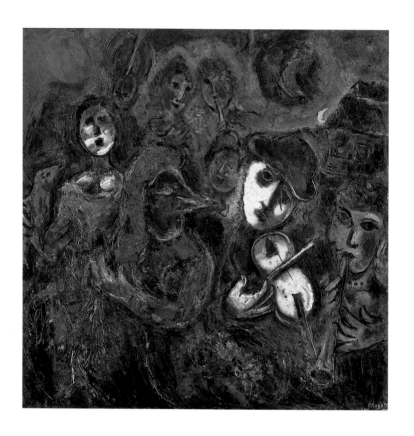

103

ACROBATS IN THE NIGHT 1957
oil on canvas
37 ³⁄₈ x 37 ³⁄₈ in. (95 x 95 cm)
Centre Georges Pompidou, Paris, Musée national d'art moderne/
Centre de création industrielle, dation 1988, on loan to the Musée
d'art moderne de Saint-Etienne

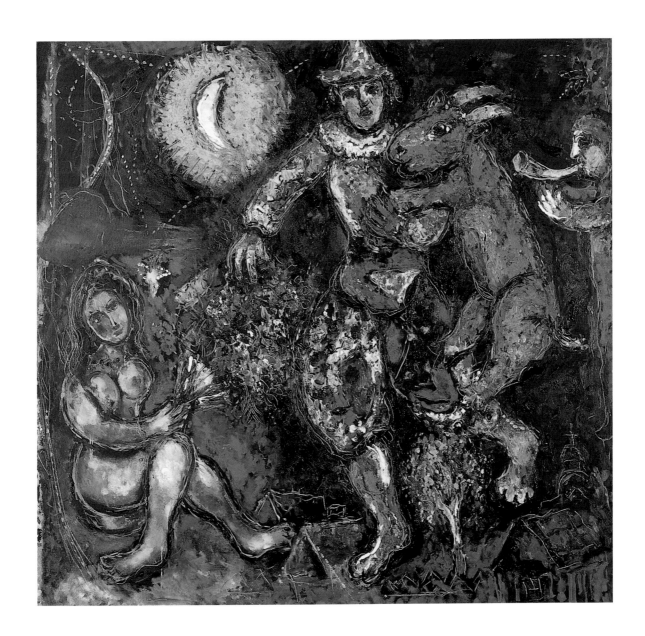

104

MAUVE NUDE 1967
oil on canvas
55 ⅛ x 58 ¼ in. (140 x 148 cm)
Private collection, Paris

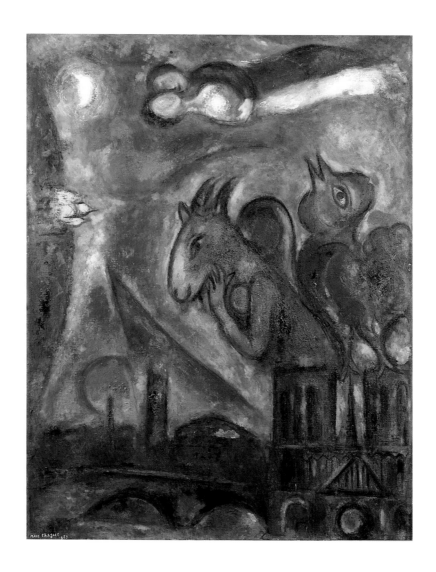

105

THE MONSTER OF NOTRE-DAME 1953

oil on canvas

41 ¾ x 33 ¼ in. (106 x 84.5 cm)

Private collection, Paris

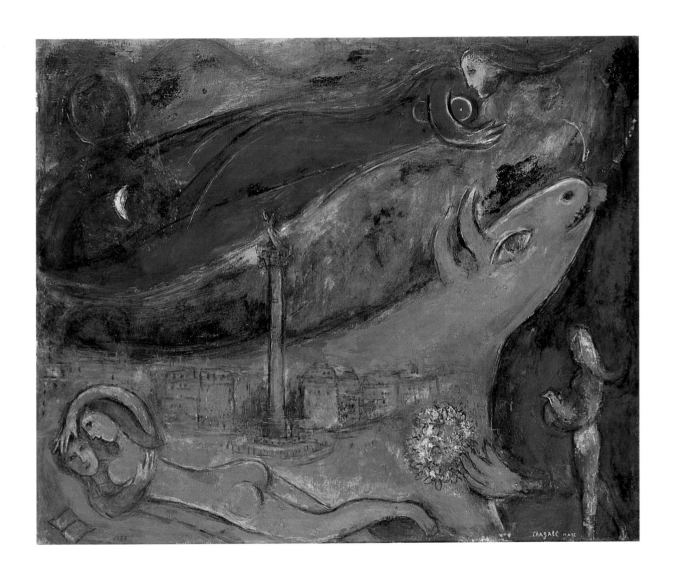

106

THE BASTILLE 1953
oil on canvas
31 ⅞ x 39 ⅜ in. (81 x 100 cm)
Private collection, Paris

COUPLE IN BLUE LANDSCAPE 1969–71
oil on canvas
44 ⅛ x 42 ½ in. (112 x 108 cm)
Private collection, Paris

THE RAINBOW 1967

oil on canvas

63 x 66 ⅞ in. (160 x 170 cm)

Centre Georges Pompidou, Paris, Musée national d'art moderne/
Centre de création industrielle, dation 1988, on loan to the Musée
d'art moderne et contemporain de Strasbourg

109

EASTER 1968
oil on canvas
63 x 63 in. (160 x 160 cm)
Centre Georges Pompidou, Paris, Musée national d'art moderne/
Centre de création industrielle, dation 1988, on loan to the Musée
National Message Biblique Marc Chagall, Nice

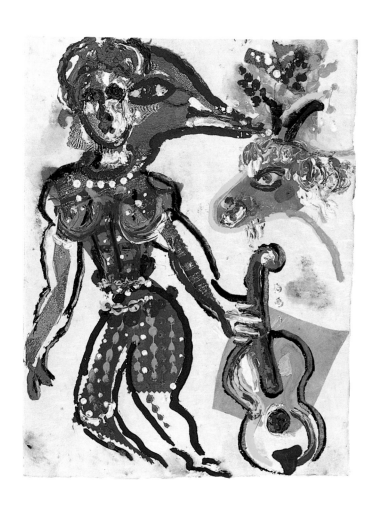

119

SKETCH FOR THE PLAYERS 1968

fabric collage with gouache on paper

13 x 10 in. (33 x 25.4 cm)

Private collection, Paris

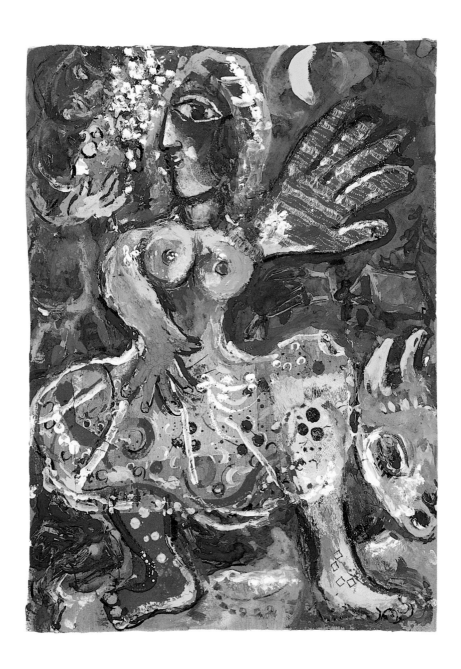

120

WOMAN WITH RED AND GREEN HANDS 1970
fabric and paper collage with gouache and india ink
14 ¾ x 10 ⅝ in. (37.4 x 26.9 cm)
Private collection, Paris

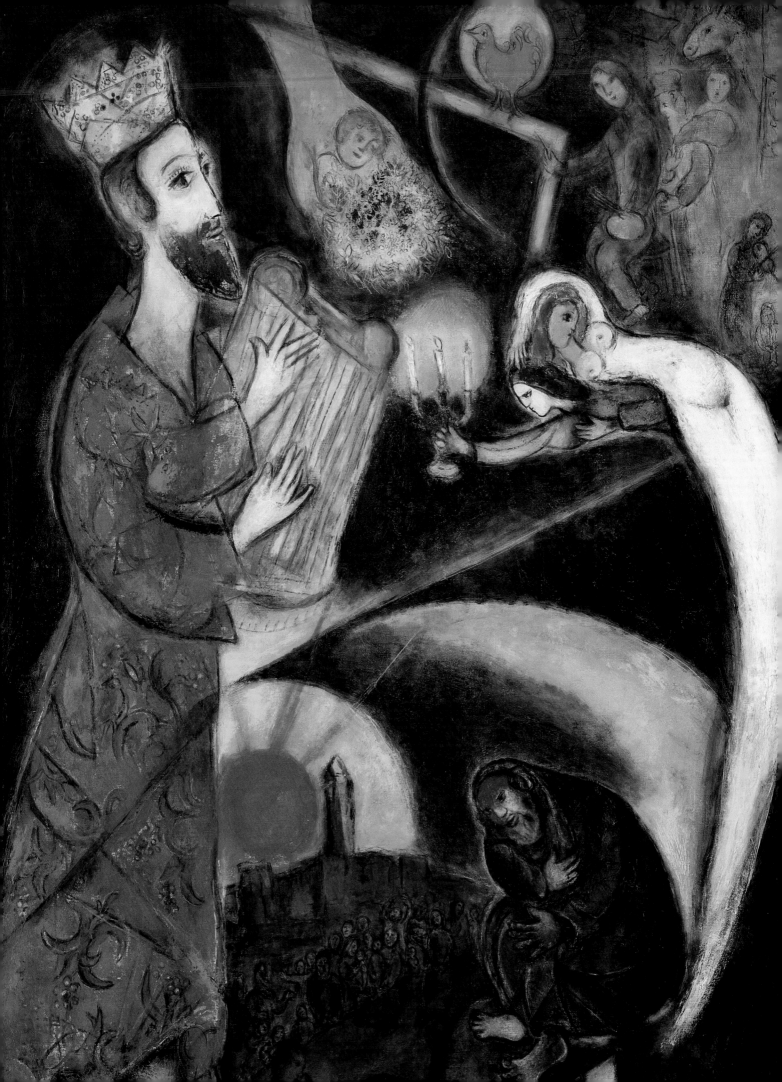

THE
BIBLE

Chagall had a deep and sincere love for the Bible. He often remarked that he loved to read it, for he found it "the greatest source of poetry." Chagall's fondness for the Bible was not a deliberate, self-conscious means of disassociating himself from his contemporaries, but a true predilection whose origin can be found in the artist's religious upbringing. In 1930, the publisher and art dealer Ambroise Vollard suggested to Chagall that he illustrate the Bible, and the artist accepted with decided enthusiasm. Not only were the stories of the patriarchs, the prophets, and the kings dear to Chagall, they were capable of generating a rich world of imagery.

Chagall was also drawn to the Bible because of his conception of the artist as messenger. The roots of this philosophy can be seen in *The Apparition* (1917–18; pl. 3), which reinterprets the traditional subject of the Annunciation. Alluding to the iconography of the angel Gabriel, a heavenly muse appears before the artist and offers him divine inspiration. The angel is a messenger, and the painter who receives the angel's revelation becomes a messenger in turn, communicating through his canvas.

Chagall's representation of the artist—and thereby his representation of himself—as the interpreter of a message persisted throughout his career. The concept is evident in *Introduction to the Jewish Theater* (1920; pl. 34), all of the self-portraits in which the painter has an angel's wings (such as *Angel with Palette* [1927–36; pl. 102]), and, more generally, all of Chagall's works that portray episodes from the Bible. Apostles and prophets are the interpreters or bearers of important messages; they announce a future time, a world to come, and a messiah. They deliver revelatory truths. Chagall associated these ideas with his own artistic practice: as an artist, he conceived of himself as a divine agent. This view, held since at least 1917 and perhaps as early as 1912 with *Calvary* (pl. 1), obviously predisposed Chagall toward painting scenes from the Bible. Although biblical motifs entered his work long before 1930, it is in that year that Chagall began to illustrate biblical scenes per se, a project he would return to in the 1950s with the *Biblical Message* cycle, a collection of works that depict episodes from the Old Testament.

It is important to understand that Chagall's representation of the artist as prophet has dual significance. In one sense, this concept, central to religious art of the Renaissance, posits the artist as the bearer of a message that he does not originate. In this scenario, paintings become vessels, complex and monumental pictograms of that which has been bestowed upon the artist. However, for Chagall, the notion of the painter as messenger was also a metaphor for his own practice, one that allowed him to claim some authority as the creator of his paintings. Although his works take inspiration from the Bible, they remain what they are: products of the painter's palette. Ultimately, they are not about religion; they are manifestos concerning the inherently subjective nature of artistic practice.

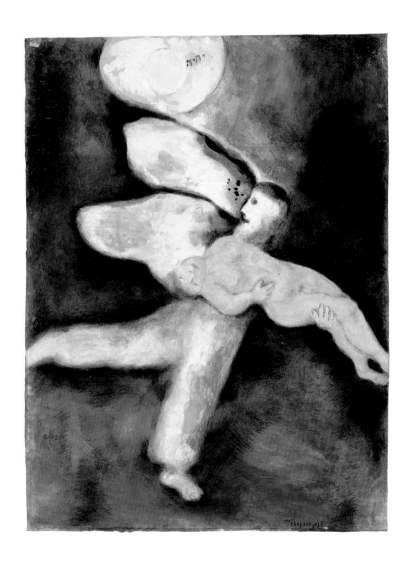

GOD CREATED MAN (GENESIS 1:26, 2:7)

121
1930
gouache on paper
25 ⅛ x 18 ⅞ in. (64 x 48 cm)
Musée National Message Biblique Marc Chagall, Nice

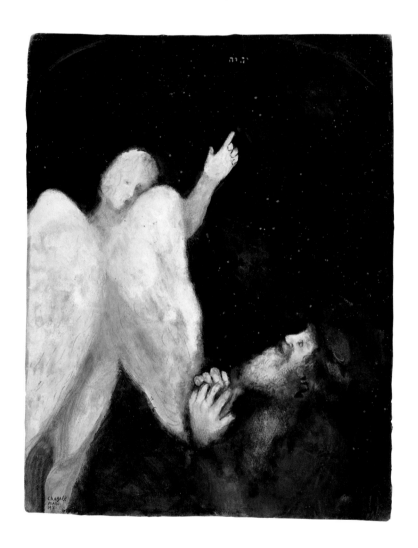

122

NOAH RECEIVES THE ORDER TO BUILD
THE ARK (GENESIS 6:13–14) 1931
gouache on paper
22 ⅞ x 16 ¾ in. (58 x 42.5 cm)
Musée National Message Biblique Marc Chagall, Nice

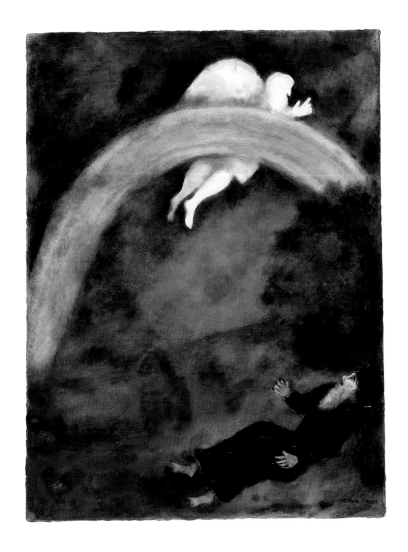

123

THE RAINBOW, SIGN OF THE COVENANT BETWEEN
GOD AND THE EARTH (GENESIS 9:9–17) 1931
gouache on paper
25 x 18 ⅝ in. (63.5 x 47.5 cm)
Musée National Message Biblique Marc Chagall, Nice

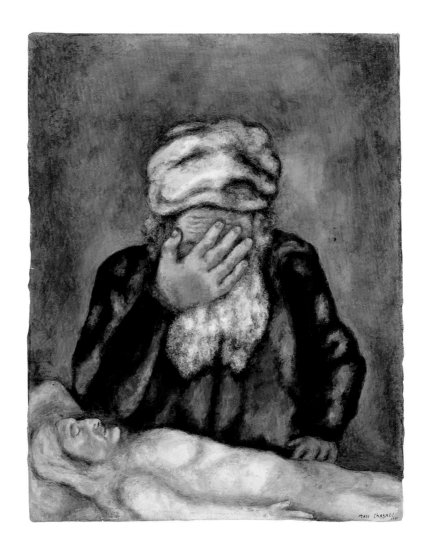

ABRAHAM MOURNING SARAH (GENESIS 23:2)

124
1931
gouache on paper
24 ⅝ x 19 ½ in. (62.5 x 49.5 cm)
Musée National Message Biblique Marc Chagall, Nice

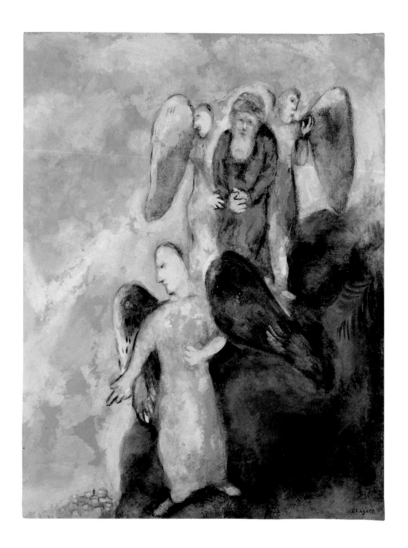

ABRAHAM AND THE ANGELS: DESCENT
TOWARD SODOM (GENESIS 18:16) 1931
gouache on paper
24 ⅝ x 19 ⅜ in. (62.7 x 49.1 cm)
Musée National Message Biblique Marc Chagall, Nice

THE FIRST BIBLICAL WORKS At the suggestion of the publisher Ambroise Vollard, Chagall set out
to illustrate the Bible in 1930. The artist first made a number of gouaches before engraving the plates from which
the series would ultimately be printed. Depicting particular biblical passages, the works demonstrate Chagall's
fondness for literal interpretation. Taken as a whole, Chagall's illustrations of the Bible are incomparable to any
other biblical illustrations in the history of art. Certain Old Testament scenes can be found in Rembrandt's
oeuvre, but no other artist proceeded as systematically as Chagall, nor has anyone else produced a series of bibli-
cal works so totally independent of conventional iconography. Chagall's choice of subjects simultaneously
evidences an immense knowledge of the biblical texts and an enormous freedom with regard to tradition.

 Even in the twentieth century, this endeavor is unique: modern artists were largely uninterested in
the Bible. But it is not originality alone that makes this series notable. Its quality stems from its deliberately non-
canonical style: Chagall's interpretation does not reference established conventions within the history of art.
Instead he simply borrowed from his memories, those of Vitebsk and more recent recollections from a 1931 trip
to Palestine, to compose these pictures. What lends such force to Chagall's enterprise is the union of the Bible's
narrative complexity and rich cultural resonance with the naked simplicity of his imagery.

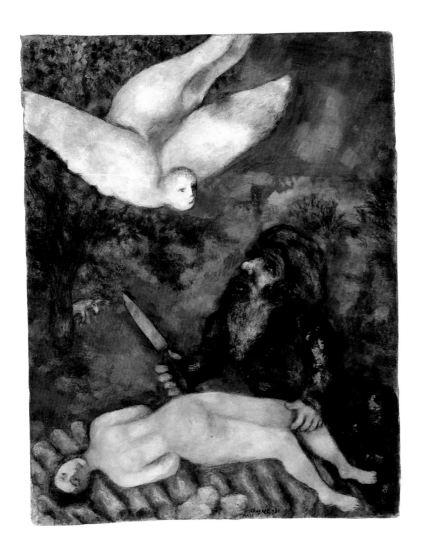

126

ABRAHAM READY TO SACRIFICE
HIS SON (GENESIS 22:9–12) 1931
gouache on paper
24 ³⁄₈ x 19 ¹⁄₈ in. (62 x 48.5 cm)
Musée National Message Biblique Marc Chagall, Nice

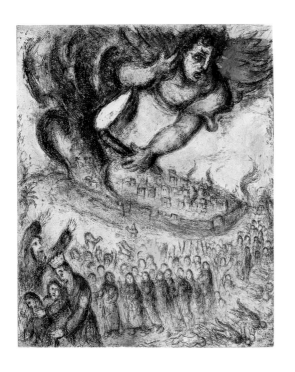

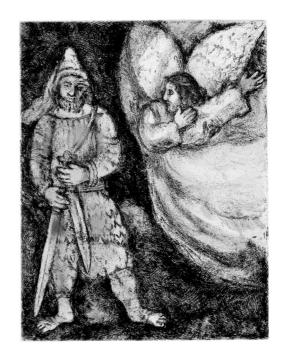

THE CAPTURE OF JERUSALEM BY NEBUCHADNEZZAR
ACCORDING TO JEREMIAH'S PROPHECY (JEREMIAH 21:4–7) 1952–56
etching with watercolor
12 ⅜ x 10 ¼ in. (31.5 x 26 cm)
Private collection, Paris

JOSHUA, SUCCESSOR TO MOSES AS THE LEADER
OF ISRAEL, PREPARES TO CROSS THE JORDAN ON THE
ORDER OF THE ETERNAL (JOSHUA 1:1–6) 1952–56
etching with watercolor
13 x 9 in. (33 x 22.8 cm)
Private collection, Paris

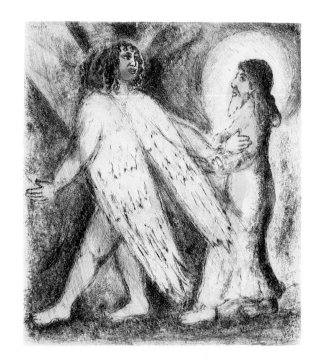

ELIJAH ON MOUNT CARMEL, ANNOUNCING THE NEXT
RAINFALL BEFORE A SINGLE CLOUD APPEARED
IN THE SKY (1 KINGS 18:41–46) 1952–56
etching with watercolor
12 ⅞ x 10 ¼ in. (32.9 x 26 cm)
Private collection, Paris

MAN GUIDED BY THE ETERNAL ON THE PATH
OF RIGHTEOUSNESS (ISAIAH 58:8–11) 1952–56
etching with watercolor
11 ¼ x 10 ⅛ in. (28.6 x 25.5 cm)
Private collection, Paris

THE CROSSING OF THE RED SEA During the 1950s, the same period in which he was embarking on a number of architectural projects that included stained glass and mosaics, Chagall returned to the use of monumental dimensions for his secular and biblical paintings. The latter once again became the focus of Chagall's production during these years, a period in which the artist executed a major biblical cycle that consisted of this work, *Moses Receiving the Tablets of the Law* (1950–52; pl. 134), *King David* (1951; pl. 135), and the three other Moses paintings. In undertaking a cohesive biblical series, Chagall made a distinction between his secular works, each of which speaks with its own voice, and his religious works, which are intended to be understood as an ensemble.

Chagall admired the biblical works of the sixteenth-century painter El Greco, and it is possible that he had these paintings in mind when working on the Moses cycle. Chagall had begun to use eccentric, irrational colors to render human figures before the 1950s, but here this stylistic choice seems to have been drawn directly from the art of El Greco. In fact, Bertrand Jestaz, writing in the 1984 volume *L'Art de la Renaissance* (The Art of the Renaissance), describes El Greco's work in terms that could easily apply to Chagall's painting: "The fundamentally unreal quality of the colors (also inherited from icons) is purposefully strident (lemon yellow, brilliant red, and above all emerald green). From Titian, [El Greco] had registered the technique of divided strokes and the allusive power of this handling. From Tintoretto, especially, he had inherited the taste for figures at oblique angles or in flight, foreshortening, muscular silhouettes with sinuous contours, shadowy settings, and dramatic lighting. . . . He added . . . an expressionistic boldness that pushed him toward the implausible elongation of figures made fashionable by Mannerism."

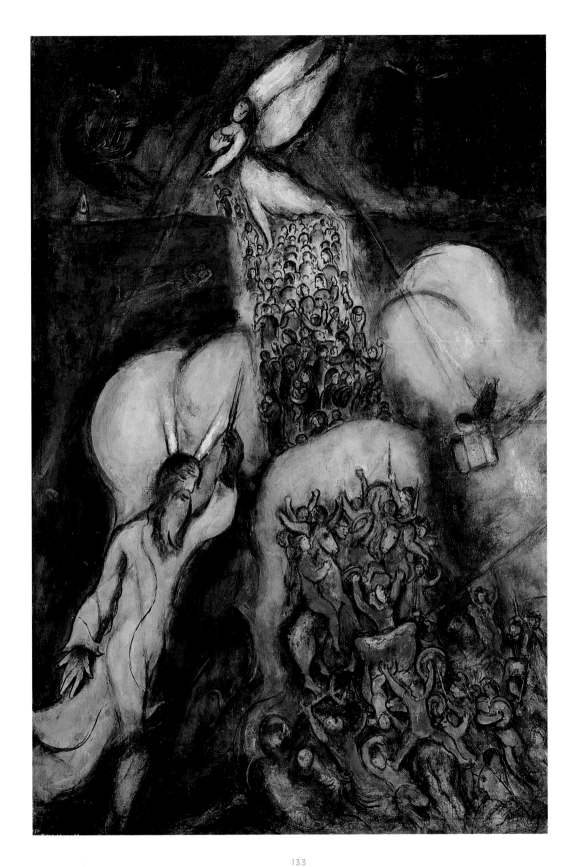

133

THE CROSSING OF THE RED SEA　1955
oil on linen
85 ¼ x 57 ½ in. (216.5 x 146 cm)
Centre Georges Pompidou, Paris, Musée national d'art moderne/
Centre de création industrielle, dation 1988, on loan to the Musée
National Message Marc Chagall, Nice

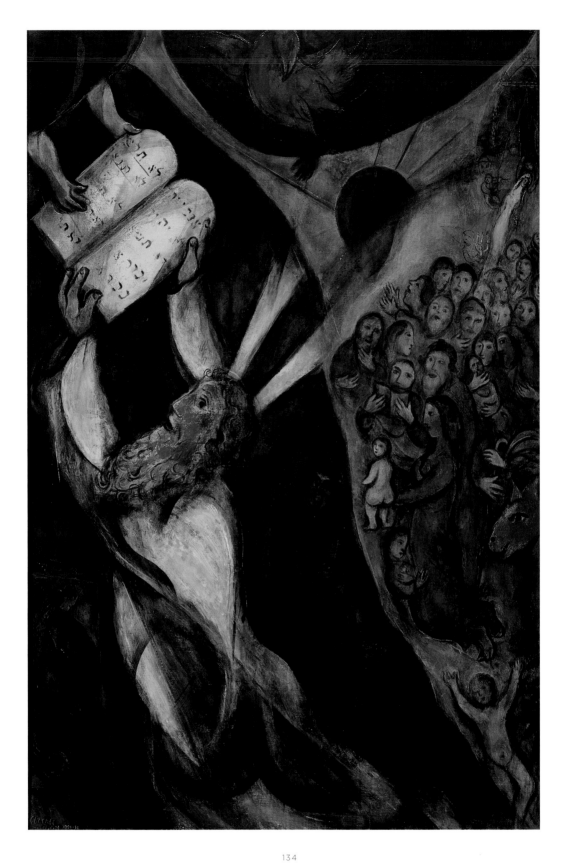

134

MOSES RECEIVING THE TABLETS OF THE LAW 1950–52
oil on linen
76 ⅝ x 51 ⅛ in. (194.5 x 129.8 cm)
Centre Georges Pompidou, Paris, Musée national d'art moderne/
Centre de création industrielle, dation 1988, on loan to the Musée
National Message Biblique Marc Chagall, Nice

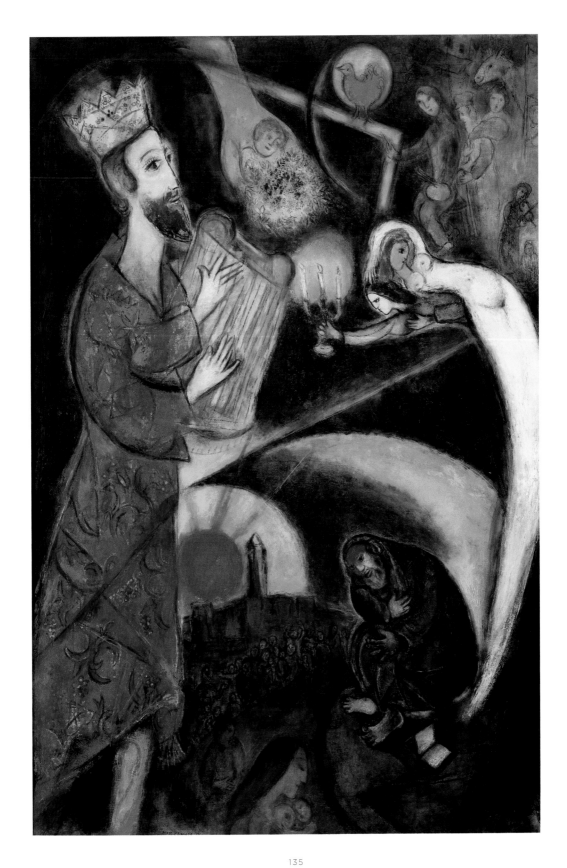

135

KING DAVID 1951
oil on linen
77 ⅞ x 52 ⅜ in. (198 x 133 cm)
Centre Georges Pompidou, Paris, Musée national d'art moderne/
Centre de création industrielle, dation 1988, on loan to the Musée
National Message Biblique Marc Chagall, Nice

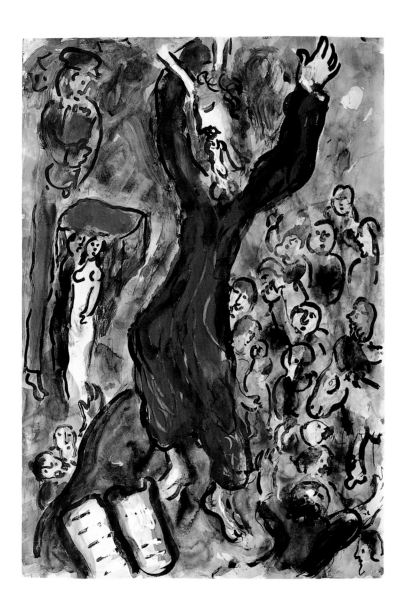

STUDY FOR MOSES BREAKING THE TABLETS OF THE LAW 1955
india ink and gouache on paper
42 ⅜ x 29 ⅜ in. (107.8 x 74.8 cm)
Private collection, Paris

MOSES IN FRONT OF THE BURNING BUSH

138

1960–66

pastel and india ink on paper

8 ⅞ x 12 ⅝ in. (22.5 x 32 cm)

Musée National Message Biblique Marc Chagall, Nice

139

ABRAHAM AND THE THREE ANGELS

1960–66

pastel and ink on paper

9 ⅞ x 12 ⅝ in. (25.1 x 32 cm)

Musée National Message Biblique Marc Chagall, Nice

146

SONG OF SOLOMON 4 1958
pastel, pencil, and watercolor on paper
11 x 16 7/8 in. (28 x 43 cm)
Musée National Message Biblique Marc Chagall, Nice

The catalogue below is arranged chronologically and represents the exhibition's presentation at the San Francisco Museum of Modern Art, which varies from the original exhibition at the Galeries nationales du Grand Palais, Paris.

1. *Musiciens de la rue* (Street Musicians), 1907 (pl. 10)
gouache and india ink on paper
11 ⅝ x 9 ⅛ in. (29.7 x 23 cm)
Private collection, Paris

2. *La Naissance* (The Birth), 1909
ink on paper
3 ⅝ x 3 ⅝ in. (9 x 9 cm)
Private collection, Paris

3. *Nu rouge* (Red Nude), 1909 (pl. 28)
oil on canvas
33 ⅛ x 45 ⅝ in. (84 x 116 cm)
Private collection, Paris

4. *La Noce* (The Wedding), 1910 (pl. 12)
oil on linen
39 ⅛ x 74 ⅛ in. (99.5 x 188.5 cm)
Centre Georges Pompidou, Paris, Musée national d'art moderne/Centre de création industrielle, dation 1988

5. *Personnage devant la voûte bleue* (Figure in Front of Blue Vault), 1910 (pl. 29)
gouache on paper
10 ⅝ x 15 ¾ in. (27 x 40 cm)
Private collection, Paris

6. *Étude pour* Le Saoul (Study for *The Drunk*), 1911
watercolor on paper
8 ⅜ x 6 ⅝ in. (21.4 x 16.8 cm)
Private collection, Paris

7. *La Naissance* (The Birth), 1911 (pl. 16)
oil on canvas
18 ⅛ x 14 ⅛ in. (46 x 36 cm)
Private collection, Paris

8. *Nu dans le jardin* (Nude in the Garden), 1911 (pl. 27)
oil on canvas
13 x 15 ⅞ in. (33 x 40.5 cm)
Private collection, Paris

9. *Le Poète aux oiseaux* (The Poet with Birds), 1911 (pl. 4)
oil on canvas
28 ½ x 39 in. (72.4 x 99 cm)
The Minneapolis Institute of Arts, bequest of Putnam Dana McMillan

10. *Vitebsk*, 1911 (pl. 11)
pencil, ink, and gouache on paper
6 ¾ x 9 ⅛ in. (17.1 x 23.1 cm)
Centre Georges Pompidou, Paris, Musée national d'art moderne/Centre de création industrielle, dation 1988

11. *Nu au peigne* (Nude with Comb), 1911–12 (pl. 30)
ink and gouache on paper
13 ⅛ x 9 ¼ in. (33.5 x 23.5 cm)
Private collection, Paris

12. *Golgotha* (Calvary), 1912 (pl. 1)
oil on canvas
68 ¾ x 75 ¾ in. (174.6 x 192.4 cm)
The Museum of Modern Art, New York, acquired through the Lillie P. Bliss Bequest, 1949

13. *Tentation* (*Adam et Ève*) (Temptation [Adam and Eve]), 1912 (pl. 2)
oil on canvas
65 ½ x 46 ¾ in. (166.4 x 118.7 cm)
The Saint Louis Art Museum, gift of Morton D. May

14. *Présentation* (Introduction), 1912–13 (pl. 7)
gouache on paper
9 ¼ x 6 ½ in. (23.5 x 16.5 cm)
Archiv Baumeister, Stuttgart

15. *L'Homme dans la neige* (Man in the Snow), 1913 (pl. 13)
gouache on paper
16 ⅛ x 12 ⅛ in. (41 x 31 cm)
Centre Georges Pompidou, Paris, Musée national d'art moderne/Centre de création industrielle, gift of Charles Wakefield-Mori, 1938

16. *L'Acrobate* (Acrobat), 1914 (pl. 14)
oil on paper mounted on canvas
22 ⅛ x 18 ⅜ in. (56.1 x 46.9 cm)
Albright-Knox Art Gallery, Buffalo, New York, Room of Contemporary Art Fund, 1949

17. *La Bonne et l'enfant* (Servant and Child), 1914 (pl. 17)
oil on board
20 ⅛ x 14 ⅞ in. (51 x 38 cm)
Collection of David McNeil

18. *Esquisse pour* Jour de fête (Le Rabbin au citron) (Sketch for *Feast Day* [*Rabbi with Lemon*]), 1914 (pl. 20)
gouache and watercolor on paper
16 ⅞ x 13 ⅝ in. (42.7 x 34.4 cm)
Private collection, Paris

19. *Au-dessus de la ville* (Above the Town), 1914–18 (pl. 26)
oil on canvas
54 ¾ x 77 ⅝ in. (139 x 197 cm)
The State Tretiakov Gallery, Moscow

20. *L'Anniversaire* (The Birthday), 1915 (pl. 22)
pencil and watercolor on paper
8 ⅝ x 10 ½ in. (22 x 26.6 cm)
Centre Georges Pompidou, Paris, Musée national d'art moderne/Centre de création industrielle, dation 1988

21. *Bella sur le pont* (Bella on the Bridge), 1915 (pl. 18)
oil, colored pencil, and ink on paper mounted on canvas
25 ⅛ x 11 ⅝ in. (64 x 29.5 cm)
Private collection, Paris

22. *Le Juif rouge* (The Jew in Red), 1915 (pl. 21)
oil on board
39 ⅜ x 31 ⅝ in. (100 x 80.5 cm)
The State Russian Museum, Saint Petersburg

23. *Le Poète allongé* (The Poet Reclining), 1915 (pl. 5)
oil on board
30 ⅜ x 30 ½ in. (77 x 77.5 cm)
Tate, London, purchased 1942

24. *Bella de profil* (Bella in Profile), 1916 (pl. 23)
oil and gouache on board
12 x 10 ⅝ in. (30.5 x 27 cm)
Private collection, Paris

25. *Les Amoureux en gris* (Lovers in Gray), 1916–17 (pl. 32)
oil on paper mounted on canvas
27 ⅛ x 19 ⅜ in. (69 x 49 cm)
Centre Georges Pompidou, Paris, Musée national d'art moderne/Centre de création industrielle, gift of Ida Chagall, 1984

26. *Les Amoureux en vert* (Lovers in Green), 1916–17 (pl. 31)
oil on paper mounted on canvas
27 ⅜ x 19 ½ in. (69.7 x 49.5 cm)
Centre Georges Pompidou, Paris, Musée national d'art moderne/Centre de création industrielle, dation 1988

27. *Esquisse pour* Pourim (Sketch for *Purim*), 1916–17 (pl. 48)
watercolor on paper
18 ⅛ x 24 ⅜ in. (46 x 62 cm)
Private collection, Paris

28. *Bella au col blanc* (Bella with White Collar), 1917 (pl. 24)
oil on linen
58 ⅝ x 28 ⅜ in. (149 x 72 cm)
Centre Georges Pompidou, Paris, Musée national d'art moderne/Centre de création industrielle, dation 1988

29. *Le Cimetière* (The Cemetery), 1917 (pl. 15)
oil on canvas
27 ⅜ x 39 ⅜ in. (69.3 x 100 cm)
Centre Georges Pompidou, Paris, Musée national d'art moderne/Centre de création industrielle, dation 1988

30. *Le Miroir* (The Mirror), 1917 (pl. 6)
oil on board
39 ⅜ x 31 ⅞ in. (100 x 81 cm)
The State Russian Museum, Saint Petersburg

31. *L'Apparition* (The Apparition), 1917–18 (pl. 3)
oil on canvas
61 ⅞ x 55 ⅛ in. (157 x 140 cm)
Private collection, Saint Petersburg

32. *La Promenade* (Promenade), 1917–18 (pl. 25)
oil on canvas
66 ⅞ x 64 ⅜ in. (170 x 163.5 cm)
The State Russian Museum, Saint Petersburg

33. *Le Cavalier soufflant dans une trompe* (Rider Blowing a Horn), 1918 (pl. 47)
watercolor, pencil, and gouache on paper
9 ⅛ x 11 ⅞ in. (23 x 30 cm)
Private collection, Paris

34. *La Danseuse, Esquisse pour* La Danse (The Dancer, Sketch for *Dance*), 1918 (pl. 40)
pencil on paper
9 ¾ x 5 ¼ in. (24.8 x 13.4 cm)
Private collection, Paris

35. *En avant, en avant* (Onward, Onward), 1918 (pl. 8)
pencil and gouache on vellum
9 ⅛ x 13 ¼ in. (23.4 x 33.7 cm)
Centre Georges Pompidou, Paris, Musée national d'art moderne/Centre de création industrielle, dation 1988

36. *L'Acteur Michoels (Esquisse pour costume)* (The Actor Michoels [Costume Sketch]), 1919 (pl. 50)
pencil, ink, and watercolor on paper
10 ⅝ x 10 ⅝ in. (27 x 27 cm)
Private collection, Paris

37. *La Danseuse, Esquisse pour* La Danse (The Dancer, Sketch for *Dance*), 1919 (pl. 41)
pencil and gouache on paper
9 ½ x 5 in. (24.1 x 12.7 cm)
Private collection, Paris

38. *Grand décor pour* Mazeltov de Sholem Aleichem (Set Design for Sholem Aleichem's *Mazel Tov*), 1919 (pl. 46)
oil on paper mounted on board
18 ⅝ x 25 in. (47.5 x 63.5 cm)
Private collection, Paris

39. *Homme à la tête renversée* (Man with His Head Thrown Back), 1919 (pl. 9)
oil on board
22 ⅜ x 18 ½ in. (57 x 47 cm)
Private collection, Paris

40. *Maquette de costume* (Costume Design), 1919 (pl. 54)
watercolor and pencil on paper
10 ⅝ x 8 ⅛ in. (27.2 x 20.5 cm)
Private collection, Paris

41. *Maquette de décor pour* Les Agents de Sholem Aleichem (Set Design for Sholem Aleichem's *Agents*), 1919 (pl. 45)
pencil, gouache, and ink on paper
10 x 13 ⅝ in. (25.4 x 34.6 cm)
Private collection, Paris

42. Mazeltov, *première version* (Mazel Tov, First Version), 1919
watercolor and pencil on paper
10 ⅛ x 13 ⅝ in. (25.5 x 34.5 cm)
Private collection, Paris

43. *L'Acteur Michoels dans* Mazeltov (The Actor Michoels in *Mazel Tov*), 1920
pencil and watercolor on paper
14 ⅛ x 10 ⅜ in. (36 x 26.3 cm)
Private collection, Paris

44. *Costume d'homme (Maquette de costume)* (Man's Suit [Costume Design]), 1920 (pl. 51)
pencil, gouache, and ink on paper
10 ⅝ x 7 ⅝ in. (27 x 19.3 cm)
Private collection, Paris

45. *La Danseuse, Esquisse pour* La Danse (The Dancer, Sketch for *Dance*), 1920 (pl. 42)
watercolor and pencil on paper
9 ⅞ x 6 ⅛ in. (25 x 15.5 cm)
Private collection, Paris

46. *Étude pour* Introduction au Théâtre juif (Homme pissant) (Study for *Introduction to the Jewish Theater* [Man Urinating]), 1920 (signed and dated 1917; pl. 43)
watercolor and gouache on paper
14 x 6 ⅞ in. (35.5 x 17.4 cm)
Private collection, Paris

47. *L'Homme au long nez (Maquette de costume)* (The Man with the Long Nose [Costume Design]), 1920 (pl. 53)
pencil and gouache on paper
10 ⅜ x 7 ⅛ in. (26.5 x 18 cm)
Private collection, Paris

48. *Introduction au Théâtre juif* (Introduction to the Jewish Theater), 1920 (pl. 34)
tempera, gouache, and clay on canvas
111 ⅞ x 309 ⅞ in. (284 x 787 cm)
The State Tretiakov Gallery, Moscow

49. *Maquette de décor pour* Le Mensonge de Sholem Aleichem, deuxième version (Set Design for Sholem Aleichem's *It's a Lie*, Second Version), 1920 (pl. 49)
pencil, watercolor, and india ink on paper
8 ⅞ x 11 ⅞ in. (22.5 x 30 cm)
Private collection, Paris

50. *Projet de rideau pour le Théâtre juif* (Curtain Design for the Jewish Theater), 1920 (signed and dated 1918; pl. 44)
pencil, gouache, and ink on paper
5 ½ x 19 ⅝ in. (14 x 49.9 cm)
Private collection, Paris

51. *Théâtre juif, L'Amour sur scène* (Jewish Theater, Love on the Stage), 1920 (pl. 33)
tempera and gouache on canvas
111 ⅜ x 97 ⅝ in. (283 x 248 cm)
The State Tretiakov Gallery, Moscow

52. *Théâtre juif, La Dance* (Jewish Theater, Dance), 1920 (pl. 35)
tempera and gouache on canvas
84 ¼ x 42 ⅝ in. (214 x 108.5 cm)
The State Tretiakov Gallery, Moscow

53. *Théâtre juif, La Littérature* (Jewish Theater, Literature), 1920 (pl. 37)
tempera and gouache on canvas
85 ⅛ x 32 in. (216 x 81.3 cm)
The State Tretiakov Gallery, Moscow

54. *Théâtre juif, La Musique* (Jewish Theater, Music), 1920 (pl. 36)
tempera and gouache on canvas
83 ⅝ x 40 ⅝ in. (212.5 x 103.2 cm)
The State Tretiakov Gallery, Moscow

107. *Le Traîneau* (The Sleigh), 1943 (pl. 80)
gouache on paper
20 ⅛ x 30 ⅝ in. (51 x 78 cm)
Private collection

108. *L'Œil vert* (The Green Eye), 1944 (pl. 88)
oil on canvas
22 ⅞ x 20 ⅛ in. (58 x 51 cm)
Private collection, Paris

109. *Autour d'elle* (Around Her), 1945 (pl. 97)
oil on canvas
51 ⅝ x 43 ⅛ in. (131 x 109.5 cm)
Centre Georges Pompidou, Paris, Musée
national d'art moderne/Centre de création
industrielle, gift of the artist, 1953

110. *La Crucifixion mexicaine* (Mexican
Crucifixion), 1945 (pl. 96)
pastel and gouache on paper
22 ⅜ x 20 ⅝ in. (57 x 52.4 cm)
Private collection

111. *Le Bœuf écorché* (The Flayed Ox),
1947 (pl. 99)
oil on canvas
39 ⅜ x 31 ⅞ in. (100 x 81 cm)
Centre Georges Pompidou, Paris, Musée
national d'art moderne/Centre de création
industrielle, dation 1997

112. *Le Coq aux amoureux* (Rooster with Lovers),
1947–50
oil on canvas
27 x 34 in. (68.6 x 86.4 cm)
Collection of Richard Goldman and Lisa and
Douglas E. Goldman

113. *Le Poisson volant* (The Flying Fish),
1948 (pl. 82)
oil on canvas
26 x 25 ½ in. (66 x 64.8 cm)
Albright-Knox Art Gallery, Buffalo, New York,
Room of Contemporary Art Fund, 1949

114. *Les Amants au ciel rouge* (Lovers in the Red
Sky), 1950 (pl. 83)
oil on canvas
25 ⅝ x 26 ⅛ in. (65.1 x 66.4 cm)
San Francisco Museum of Modern Art, gift of
Wilbur D. May

115. *Moïse recevant les Tables de la Loi*
(Moses Receiving the Tablets of the Law),
1950–52 (pl. 134)
oil on linen
76 ⅝ x 51 ⅛ in. (194.5 x 129.8 cm)
Centre Georges Pompidou, Paris, Musée
national d'art moderne/Centre de création
industrielle, dation 1988, on loan to the Musée
National Message Biblique Marc Chagall, Nice

116. *Le Roi David* (King David), 1951 (pl. 135)
oil on linen
77 ⅞ x 52 ⅝ in. (198 x 133 cm)
Centre Georges Pompidou, Paris, Musée
national d'art moderne/Centre de création
industrielle, dation 1988, on loan to the Musée
National Message Biblique Marc Chagall, Nice

117. *Dieu apparaît en songe à Salomon qui lui
demande le don de la sagesse* (*I Rois, III, 5–9*)
(God Appearing in a Dream to Solomon, Who
Asks for the Gift of Wisdom [1 Kings 3:5–9]),
1952–56 (pl. 128)
etching with watercolor
12 ⅞ x 8 ⅜ in. (32.7 x 21.4 cm)
Private collection, Paris

118. *Élie du haut du mont Carmel, annonce la pluie
prochaine avant qu'un seul nuage paraisse dans le ciel*
(*I Rois, XVIII, 41–46*) (Elijah on Mount Carmel,
Announcing the Next Rainfall before a Single
Cloud Appeared in the Sky [1 Kings
18:41–46]), 1952–56 (pl. 131)
etching with watercolor
12 ⅞ x 10 ¼ in. (32.9 x 26 cm)
Private collection, Paris

119. *L'Homme guidé par l'Éternel dans la voie droite*
(*Isaïe, LVIII, 8–11*) (Man Guided by the Eternal
on the Path of Righteousness [Isaiah
58:8–11]), 1952–56 (pl. 132)
etching with watercolor
11 ¼ x 10 ⅛ in. (28.6 x 25.5 cm)
Private collection, Paris

120. *Josué, successeur de Moïse à la tête d'Israël,
s'apprête à passer le Jourdain sur l'ordre de l'Éternel*
(*Josué, I, 1–6*) (Joshua, Successor to Moses as
the Leader of Israel, Prepares to Cross the
Jordan on the Order of the Eternal [Joshua
1:1–6]), 1952–56 (pl. 130)
etching with watercolor
13 x 9 in. (33 x 22.8 cm)
Private collection, Paris

121. *Le Pardon de Dieu annoncé à Jérusalem*
(*Isaïe, LIV, 6–10*) (God's Pardon Announced in
Jerusalem [Isaiah 54:6–10]), 1952–56 (pl. 127)
etching with watercolor
13 x 9 in. (33 x 22.8 cm)
Private collection, Paris

122. *Prise de Jérusalem par Nabuchodonosor selon la
prophétie de Jérémie* (*Jérémie, XXI, 4–7*) (The
Capture of Jerusalem by Nebuchadnezzar
According to Jeremiah's Prophecy [Jeremiah
21:4–7]), 1952–56 (pl. 129)
etching with watercolor
12 ⅜ x 10 ¼ in. (31.5 x 26 cm)
Private collection, Paris

123. *La Bastille* (The Bastille), 1953 (pl. 106)
oil on canvas
31 ⅞ x 39 ⅜ in. (81 x 100 cm)
Private collection, Paris

124. *Le Monstre de Notre-Dame* (The Monster of
Notre-Dame), 1953 (pl. 105)
oil on canvas
41 ¾ x 33 ¼ in. (106 x 84.5 cm)
Private collection, Paris

125. *Étude pour* Moïse brisant les Tables de la
Loi (Study for *Moses Breaking the Tablets of the
Law*), 1955 (pl. 137)
india ink and gouache on paper
42 ⅜ x 29 ⅜ in. (107.8 x 74.8 cm)
Private collection, Paris

126. *La Traversée de la mer Rouge* (The Crossing
of the Red Sea), 1955 (pl. 133)
oil on linen
85 ¼ x 57 ½ in. (216.5 x 146 cm)
Centre Georges Pompidou, Paris, Musée
national d'art moderne/Centre de création
industrielle, dation 1988, on loan to the Musée
National Message Biblique Marc Chagall, Nice

127. *Les Saltimbanques dans la nuit*
(Acrobats in the Night), 1957 (pl. 103)
oil on canvas
37 ⅜ x 37 ⅜ in. (95 x 95 cm)
Centre Georges Pompidou, Paris, Musée
national d'art moderne/Centre de création
industrielle, dation 1988, on loan to the Musée
d'art moderne de Saint-Etienne

128. *Le Cantique des Cantiques IV* (Song of
Solomon 4), 1958 (pl. 146)
pastel, pencil, and watercolor on paper
11 x 16 ⅞ in. (28 x 43 cm)
Musée National Message Biblique Marc
Chagall, Nice

129. *Le Cantique des Cantiques I*
(Song of Solomon 1), 1960 (pl. 144)
pastel and pencil on paper
9 ⅜ x 11 ¾ in. (24 x 29.9 cm)
Musée National Message Biblique Marc
Chagall, Nice

130. *Le Cantique des Cantiques III*
(Song of Solomon 3), 1960 (pl. 145)
pastel, pencil, and gouache on paper
7 ⅝ x 11 ⅛ in. (19.2 x 28.2 cm)
Musée National Message Biblique Marc
Chagall, Nice

131. *Moïse* (Moses), 1960 (pl. 136)
india ink and ink on paper
16 ⅝ x 13 ⅛ in. (42.2 x 33.4 cm)
Private collection, Paris

132. *Abraham et les trois anges*
(Abraham and the Three Angels),
1960–66 (pl. 141)
pastel, pencil, ink, and fabric on board
10 x 13 ⅜ in. (25.4 x 34 cm)
Musée National Message Biblique Marc
Chagall, Nice

133. *Abraham et les trois anges*
(Abraham and the Three Angels),
1960–66 (pl. 139)
pastel and ink on paper
9 ⅞ x 12 ⅝ in. (25.1 x 32 cm)
Musée National Message Biblique Marc
Chagall, Nice

134. *Le Frappement du Rocher* (The Striking of the
Rock), 1960–66 (pl. 143)
pastel, india ink, and watercolor on paper
13 ¾ x 12 ½ in. (35 x 31.7 cm)
Musée National Message Biblique Marc
Chagall, Nice

135. *Moïse devant le Buisson Ardent*
(Moses in Front of the Burning Bush),
1960–66 (pl. 138)
pastel and india ink on paper
8 ⅞ x 12 ⅝ in. (22.5 x 32 cm)
Musée National Message Biblique Marc
Chagall, Nice

136. *Le Songe de Jacob* (Jacob's Dream),
1960–66 (pl. 140)
pastel and ink on paper
9 ⅛ x 11 ⅜ in. (23 x 29 cm)
Musée National Message Biblique Marc
Chagall, Nice

137. *Le Songe de Jacob* (Jacob's Dream),
1960–66 (pl. 142)
pastel and india ink on board
13 x 11 in. (33 x 28 cm)
Musée National Message Biblique Marc
Chagall, Nice

138. *La Fuite: Coq et bouc au-dessus du village*
(The Escape: Rooster and Goat above the
Village), 1962 (pl. 89)
gouache and ink on paper
29 x 22 ⅛ in. (73.7 x 56.2 cm)
Private collection, Paris

139. *Esquisse pour* Clown et son ombre
(Sketch for *Clown with Shadow*), 1964 (pl. 117)
paper collage with india ink and color imprints
12 ⅞ x 10 in. (32.7 x 25.4 cm)
Private collection, Paris

140. *L'Arc-en-ciel* (The Rainbow), 1967 (pl. 108)
oil on canvas
63 x 66 ⅞ in. (160 x 170 cm)
Centre Georges Pompidou, Paris, Musée
national d'art moderne/Centre de création
industrielle, dation 1988, on loan to the Musée
d'art moderne et contemporain de Strasbourg

141. *Esquisse pour* Nu mauve (Sketch for *Mauve
Nude*), 1967 (pl. 116)
paper and fabric collage with gouache, pastel,
and india ink
14 ⅞ x 10 ⅞ in. (37.7 x 27.7 cm)
Private collection, Paris

142. *Nu mauve* (Mauve Nude), 1967 (pl. 104)
oil on canvas
55 ⅛ x 58 ¼ in. (140 x 148 cm)
Private collection, Paris

143. *Esquisse pour* L'Apparition au cirque
(Sketch for *The Apparition at the Circus*),
1968 (pl. 118)
fabric and paper collage with gouache
and india ink
7 ⅜ x 5 ⅜ in. (18.5 x 13.5 cm)
Private collection, Paris

144. *Esquisse pour* Les Comédiens (Sketch for
The Players), 1968 (pl. 119)
fabric collage with gouache on paper
13 x 10 in. (33 x 25.4 cm)
Private collection, Paris

145. *Esquisse pour* Village fantastique
(Sketch for *Fantastic Village*), 1968 (pl. 110)
paper and fabric collage with india ink
6 ¾ x 5 ⅛ in. (17.2 x 13.2 cm)
Private collection, Paris

146. *Les Pâques* (Easter), 1968 (pl. 109)
oil on canvas
63 x 63 in. (160 x 160 cm)
Centre Georges Pompidou, Paris, Musée
national d'art moderne/Centre de création
industrielle, dation 1988, on loan to the Musée
National Message Biblique Marc Chagall, Nice

147. *Esquisse pour* L'Arlequin
(Sketch for *The Harlequin*), 1968–70 (pl. 113)
paper and fabric collage with gouache, colored
pencil, and india ink
11 ⅜ x 9 in. (28.7 x 22.8 cm)
Private collection, Paris

148. *Le Couple dans le paysage bleu* (Couple in
Blue Landscape), 1969–71 (pl. 107)
oil on canvas
44 ⅛ x 42 ½ in. (112 x 108 cm)
Private collection, Paris

149. *Couple à la chèvre rouge* (Couple with Red
Goat), 1970 (pl. 115)
paper collage with gouache, colored pencil,
india ink, and twigs
12 ⅝ x 9 ⅝ in. (32.2 x 24.5 cm)
Private collection, Paris

150. *Danseuse sur fond mauve* (Dancer on Mauve
Background), 1970 (pl. 114)
paper and fabric collage with watercolor,
india ink, gouache, and pastel
12 ⅝ x 9 ⅞ in. (32.3 x 25 cm)
Private collection, Paris

151. *Esquisse pour* Rencontre (Sketch for
Meeting), 1970 (pl. 112)
fabric collage with pencil, colored pencil, and
india ink on printed board
8 ⅛ x 5 ⅞ in. (20.5 x 15 cm)
Private collection, Paris

152. *Femme aux mains rouge et verte*
(Woman with Red and Green Hands),
1970 (pl. 120)
fabric and paper collage with gouache
and india ink
14 ¾ x 10 ⅝ in. (37.4 x 26.9 cm)
Private collection, Paris

153. *Profil au coq* (Profile with Rooster),
ca. 1970 (pl. 111)
paper and fabric collage with watercolor and
india ink on newspaper
13 ⅞ x 11 ½ in. (35.4 x 29.2 cm)
Private collection, Paris